DISCARD

THE ART
OF
THE CON

THE ART OF THE CON

THE MOST NOTORIOUS FAKES, FRAUDS, AND FORGERIES IN THE ART WORLD

ANTHONY M. AMORE

palgrave
macmillan

First published in 2015 by PALGRAVE MACMILLAN® TRADE in the
United States—a division of St. Martin's Press LLC, 175 Fifth Avenue,
New York, NY 10010.

Palgrave® and Macmillan® are registered trademarks in the United
States, the United Kingdom, Europe and other countries.

ISBN: 978-1-137-27987-3

Library of Congress Cataloging-in-Publication Data

Amore, Anthony M.
 The art of the con : the most notorious fakes, frauds, and forgeries in
the art world / Anthony M. Amore.
 pages cm
 ISBN 978-1-137-27987-3 (hardback)
 1. Art—Forgeries. 2. Art thefts. I. Title.
N8790.A46 2015
702.8'74—dc23

 2014046676

Design Letra Libre, Inc.

First edition: July 2015

10 9 8 7 6 5 4 3 2 1

Printed in the United States of America.

For Gabriela and Alessandra—

My life, my sweetness, and my hope

CONTENTS

INTRODUCTION

GILBERT STUART'S ICONIC PORTRAIT OF GEORGE WASHINGTON IS LIKELY one of the most-often-viewed images in the world. Painted in 1796 and often referred to as the Athenaeum portrait, the unfinished rendering of the newly constituted republic's first president has been featured on the American one-dollar bill for more than a hundred years. The painting is shared by the National Portrait Gallery in Washington and the Museum of Fine Arts in Boston, with each institution having the honor of displaying it at three-year intervals. It's an eye-catching work and a true national treasure.

The painting certainly caught the attention and imagination of Captain John E. Swords, a merchant seaman from the Southwark neighborhood of Philadelphia. On March 1, 1801, Captain Swords approached Stuart, asking to buy a copy of the painting of the beloved Washington, who had died little more than a year before. Though he struggled with debt for much of his life, Stuart was only willing to sell provided the captain would agree to a non-negotiable condition: Swords must not make copies of the painting.

It was an understandable demand. Washington was still very much in the hearts of the nation he helped found, and selling his highly regarded portraits of esteemed Americans was how Stuart supported himself and his family. Captain Swords easily agreed to

the demand, promising Stuart that he would not have the painting copied. Instead, he wished to buy the portrait in order to present it to a gentleman in Virginia. Taking the good captain at his word, Stuart sold him the work.

Soon thereafter, in that same year, Captain Swords boarded the *Connecticut,* a ship owned by Philadelphians James Barclay and George Simpson, with his *George Washington* in tow. However, his destination was not Virginia—it was the Far East. And he brought with him no intention of keeping his word to Gilbert Stuart. Instead, upon arrival in Guangzhou (Canton), China, Captain Swords turned to the well-practiced copyists of that nation and placed his order: one hundred copies of the portrait, measuring 30 × 25 inches, painted in reverse on glass.

Such a betrayal wasn't completely out of character for the hardy seaman. Letters to his mother, back home in Philadelphia, told of his smuggling, and according to historian E. P. Richardson, Swords's was an age of a "free-and-easy attitude toward customs regulations and other such petty legalities."[1] So it is perhaps unsurprising that upon its return to America, the inbound foreign manifest of the *Connecticut* did not declare the 100 portraits of George Washington. Instead, it made mention of only "one case painting," which, Richardson speculates, might have been the original painting that had been purchased from Stuart.

Captain Swords was able to easily find customers eager to procure a painting of the man who the citizenry saw as the greatest man in the world, their own American Cincinnatus, and went about selling the works. Provenance was no more an issue to the buyers than it was to the seller: they simply couldn't resist the opportunity to own a work by the man who was arguably the new nation's greatest artist. Eventually, word that the captain was selling the portraits made its way to Stuart, who was, understandably, outraged. And so the artist

resorted to that most American of actions in response: he took Captain Swords to court. On May 14, 1802, Stuart swore a complaint with the Circuit Court of the United States in and for the Eastern District of Pennsylvania. In it, Stuart, who was still a British subject, told the court of the guarantees he demanded and to which Captain Swords had agreed. He also laid out the scheme as he understood it, asking the court to subpoena and interrogate the captain as to the agreement, his actions with the paintings, and the extent of the breach of contract, requesting that they determine "how many of them [he brought] into the United States with intention to vend or dispose of the same or some and how many of them and where they now are and in whose hand." Finally, Stuart asked the court "that the said John E. Swords may, by the decree of this honorable court, be enjoined and restrained from vending or any way disposing of any of the said copies and may be ordered to deliver up all that remain unsold or otherwise" so that the court might dispose of them as it saw fit. Before the day was out, the court acted on Stuart's complaint, ordering Captain Swords and any associates to "desist from selling or otherwise disposing of the same copies of the Portraits" and to have the remaining portraits ready for further action from the court.

Captain Swords's betrayal of Gilbert Stuart is the first major art scam in American history. While fraudulent schemes involving art of all sorts is quite a common occurrence in the United States, it is a not a uniquely American problem. Instead, tens of millions of dollars in illicit art changes hands every year around the world. And the dodgy captain was not the first to the game of producing rip-offs of others' art, as the practice of misrepresenting the authorship or authenticity of an artwork is a centuries-old practice. In fact, no less than the great Michelangelo himself is said to have sculpted a sleeping cupid figure and used his artistic genius to manipulate it into appearing ancient so that he could sell it to Cardinal Riario of San Giorgio.[2]

The innocent Cardinal Riario wanted so badly to believe that he had come upon a truly special piece, something that perhaps no one else had found, that he was easy prey for Michelangelo's fake. His desire to own a true object of beauty was so great as to blind him to its authenticity—much the same way one of Adolf Hitler's most trusted accomplices, Hermann Goering, was.

The founder of the Gestapo, the art-loving Goering was not a man to cross. Though he was suspicious of attempts by his enemies to deceive him, his eyes opened wide when he saw Johannes Vermeer's *Christ and the Adulteress.* With only 35 or 36 known paintings attributed to the great Dutch master (scholars will probably argue over the actual number forever), a "new" Vermeer would be a crowning addition to his growing, awe-inspiring, and completely ill-gotten art collection. Even Hitler, himself a failed artist who at the time was building his *Führermuseum* to display the greatest art collection he could steal and loot, hadn't scored such a coup as a heretofore unknown Vermeer. It didn't matter that *Christ and the Adulteress* didn't look at all like the work of Vermeer. And according to Jonathan Lopez's excellent book *The Man Who Made Vermeers,* it also didn't matter that Goering doubted the painting's provenance, believing the painting might have come from "a Jew, who would try to blackmail him later."[3] The *Reichsmarschall* wanted to believe he had come upon the find of a lifetime.

Goering had to have the painting for his burgeoning collection and paid 1.65 million guilders—the equivalent of about $19 million today—for this so-called "missing Vermeer," which was, in truth, created by an unsuccessful artist named Han van Meegeren.[4] Because the painting was inauthentic, there was no genuine provenance the forger could provide. So, to assuage his concerns about provenance, Goering accepted a letter describing the painting's history. Later, with the war over and facing execution for plundering

Dutch national treasures (which were, in fact, his own counterfeit paintings), Van Meegeren admitted that he had forged the alleged Vermeer and proved so by painting another in the presence of court-appointed witnesses. So great was his delusion that when Goering, facing his own trial in Nuremberg, was informed that his beloved Vermeer was actually a forgery, the stubborn Nazi steadfastly refused to believe it.[5] In examining the works of Van Meegeren today, it is somewhat difficult to understand how anyone could see Vermeer in them. But it wasn't just the twisted, morphine-addicted Nazi who was fooled by the faux Vermeer. Even some experts of the day who examined Van Meegeren's forgeries were convinced the paintings were by the great master painter. The opportunity to be part of the important new find seems to have clouded their judgment, a pattern that has been repeated several times throughout history.

There has been no shortage of accomplished fraudsters in the annals of art crime, and many of their stories have been told in books and on television. One of the most notorious was certainly John Drewe, a British scam artist who sold the forgeries of a talented but previously unsuccessful artist named John Myatt to unsuspecting dupes for millions of dollars. Their backstory: the paintings were the newly rediscovered works of major artists. Drewe was ultimately convicted and jailed for his frauds in 1999 and served six years. Upon his release, the compulsive con man went right back to work, scamming a 71-year-old widow out of more than a million dollars by taking money from the sale of her property and transferring the deed to her home. "In my view you are the most dishonest and devious person I have ever dealt with," the judge told him at sentencing for this latest crime.[6]

Con men the likes of Drewe are only successful because of their ability to find their marks—specifically, those in whom they can sense a strong desire to believe, against all indications to the contrary, that they have actually stumbled upon the rare deal that is

both too good *and* true. And a key component of the scammer's ruse is the development of a strong backstory to explain how he came into possession of such valuable art. When it comes to phony art, the con man will typically develop a story that involves a collection that had been hidden away for years, perhaps by a relative who has just died. Maybe the art was hidden from the Nazis, or perhaps it was a gift from the artist himself. Whatever the case may be, the con man must create a plausible story to account for the fact that the paintings he is selling haven't already been claimed by another collector, especially considering the bargain prices. Indeed, the con man's one stumbling block is accounting for the art's provenance.

In its simplest terms, provenance is the historical record of the ownership of a work of art. While that may sound basic, it is in fact quite tricky. The history of a piece could be hundreds if not thousands of years old, and there has been no standard, consistent, and regulated method for keeping such records. Thus, confusion ensues. Megan M. Fontella, associate curator of collections and provenance at the Solomon R. Guggenheim Museum, writes, "Ideally, one seeks to secure documentary evidence—such as receipts or bills of sale—for every time that an object changed hands, whether it was by gift, sale, inheritance, exchange, or another form of transaction. However, archival records are sometimes fragmentary, difficult to interpret, or worse—lost. There may be stretches of time during which the possessor and whereabouts of the object are completely unknown."[7] Combine this with the fact that each piece's history can be as unique as the work itself, and it becomes clear that establishing solid provenance free of gaps can become daunting.

It's into these cracks and chasms of time that many con men insert their "newly discovered" collections, and a clever story to explain away the gap in clear provenance becomes essential to the ruse. Indeed, while the art of art theft is said to be in the selling of the art, not

the thievery, the art of art scams is in the backstory, not in the picture itself. Take the story of the forger David Stein, for instance. Stein began his art scams in the mid-1960s, posing as a wealthy dealer to sell paintings by famous artists—which he had, in fact, rather deftly painted himself. Where had these paintings been up until their sale? Surely Stein, who in fact was a man of meager means and was actually born Henri Haddad in Egypt, couldn't have bought them. So he created a persona his dupes found irresistible, provenance be damned. One of his victims, a wealthy Palm Beach collector named L. D. Cohen, attributed Stein's success not simply to his skill at producing faked paintings, but also to his faked life story. Though Stein was in fact destitute, Cohen said, he introduced himself to Palm Beach society as a suave, attractive conversationalist. To sell himself to the well-to-do of the affluent resort town, Stein "immediately bought a Rolls Royce, which he never paid for. He ensconced himself in a beautiful apartment in the finest hotel . . . he surrounded himself with beautiful women, and before you knew it he was giving great paintings to charity to get in the limelight, and he enticed a lot of people to buy art. He really was a master showman," said Cohen.[8] Clearly, it was his act as much as his art that led to sales.

For his part, Stein attributed another factor to his success. He told *60 Minutes'* Morley Safer that dealers were willing to overlook signs that his paintings were not what they were purported to be "because they want to make money. They are not very scrupulous about making money. They close their eyes even if they have some suspicion about a painting . . . the whole art market is like that." But greed aside, this was the work of a man whom Cohen described as "a con man par excellence."[9] Ultimately, Stein's frauds resulted in arrests, imprisonment, deportation, and years spent evading creditors.

History is filled with men who, in their day, were described as possibly being the greatest forger ever to have lived. Rather than

being viewed as criminals, they somehow come to be seen through an almost romantic lens. Van Meegeren's own popularity is said to have increased after he was exposed as a fraud, with the forger thought of as a "misunderstood genius who fooled the world," according to Lopez.[10] Prolific 1970s and '80s American art fraudster Tony Tetro maintains a website to this day in which he immodestly bills himself as "the Official Website of the World's Greatest Living Art Forger."[11] The nineteenth-century forger of sculptures, Giovanni Bastianini, has been called "the greatest sculptor of Italian Renaissance portrait busts" without irony.[12] Briton Eric Hebborn's 1996 obituary in the *Independent* called him "the most successful art forger this century."[13] Artist and bookseller Michael O'Kelly goes as far as to boast that he "Studied with World's [*sic*] greatest art forger, Thomas Keating, England" as part of his resume of experience on his LinkedIn page.[14] Publicity for Ken Perenyi's book *Caveat Emptor: The Secret Life of an American Art Forger* claims that "America's first and only great art forger" is none other than Perenyi himself.[15] Of late, the work and deceptions of Mississippian Mark Landis (called "the world's greatest forger" by the *Daily Beast*'s Justin Jones) have come into vogue, with the eccentric artist the subject of a documentary film that explores his penchant for posing as a clergyman and donating his forgeries to museums across the country.[16] The forger Elmyr de Hory, who is perhaps most famous for his faux Modiglianis, was the subject of a book by Clifford Irving titled *Fake!*, which describes him as "the greatest forger of our time."[17] (Incredibly, in 2014 two forgeries said to be painted by de Hory were pulled from a New Zealand auction when his sole legal heir, the ironically named Mark Forgy, discovered that the paintings were actually fakes of de Hory's forgeries.[18])

Similarly, patterns emerge among forgers. They appear to typically be middle-aged men frustrated by their own failures as artists (or perhaps the failure of the art world to recognize their greatness).

They are often brazen braggarts and perhaps overconfident of their own skills. They tend to gravitate away from the Old Masters and toward Impressionists and Abstract Expressionists, simply because they are much easier to make. They also operate in the realm of oil paint and sketches, staying away from watercolors. According to professional artist Meghan Weeks, there's a good reason for this. "When you make a mark in oil, it is, in some sense, in stasis; the texture of your brushstroke holds on the canvas, and you have plenty of time to evaluate and change it before drying. If it doesn't meet the desired 'look,' you can always scrape it away or paint over it. A brushstroke in watercolor, on the other hand, feels completely volatile . . . the pigment can dance around after you apply it to a surface."[19] Thus, there is too great a chance of error and, thus, too much skill and effort required.

The notable connoisseur and onetime director of the Metropolitan Museum of Art Thomas Hoving famously claimed in 1996 that approximately 40 percent of all art in museums is either a fake or a forgery.[20] More recently, Yann Walther, the chief of Switzerland's Fine Art Expert Institute claimed that estimates of 50 percent of art on the market being forged or misattributed are likely conservative.[21] Whether or not these figures are accurate, there clearly exists in the art world a problem with fraud.

Fortunately, there are devoted people with brilliant minds working to combat it. Dedicated researchers around the world continue to make advances in the field of provenance research. The International Foundation for Art Research conducts authentication research for museums, private owners, and virtually all others that it can accommodate. IFAR's services are in high demand, due in fact to their excellent reputation and, as they state, their status as a nonprofit educational institution "free to render objective opinions independent of the marketplace."[22] Moreover, a number of institutions seem to have

come to recognize the importance of provenance research in a wider context. Jane C. Milosch, a Smithsonian Institution curator, recently formed a team of provenance specialists from across the institution, and the Museum of Fine Arts in Boston appointed a first-of-its-kind curator of provenance, Victoria Reed, to research works both in the existing collection and those considered for acquisition with histories that might be questionable.

If the field of provenance research has grown steadily in terms of activity in recent years, scientific advances in the art authentication process are traveling at light speed, to the point where science now provides us with the capability to catch even the cleverest fraudster. To lend some perspective as to how far the scientific analysis of paintings has progressed, a 1997 article from *Newsweek* magazine is illustrative. The piece, which centered around concerns about as many as 100 paintings attributed to Van Gogh that might not have been painted by the great Dutchman, makes the claim that "the only way to authenticate a Van Gogh is through stylistic analysis, which is always a bit subjective," depicting the prospects for authentication as bleak.[23] Today, the possibilities are much greater.

Drs. Nicholas Eastaugh and Jilleen Nadolny are at the forefront in the field of combining science with extensive training in the fine arts. As they have adeptly pointed out in a paper discussing the results of their work on recent noteworthy art forgeries, the work of the technical art researcher is too demanding to be left to one whose expertise lies only in science while lacking experience examining fine art. Instead, the technical art researcher "ideally has mastered skills in technical art history and art technology science." To do otherwise and limit the field to pure "science," they argue, "is to ban such professionals from a club composed of *art* historians, *art* dealers, *art* conservators and so forth."[24] In other words, what makes the work of the technical art researcher so unique is that the analysis of a questionable painting is not merely

the work of a person trained solely in the sciences reading printouts produced by a computer. Instead, it is the work of the scientist who understands the nuances of paintings, of the artists, of the materials. They write, "It is not simply the use of 'science' as it exists in the popular imagination, but a deep and rigorous interdisciplinary analysis of materials and historical technology that should be applied, and recognized, as the appropriate protocol in cases when potential forgeries are studied."[25] Such protocols are useful not just in finding fakes, but also in attributing authenticity. In the summer of 2014, the National Trust in Great Britain used such techniques to verify as authentic a Rembrandt self-portrait that had been in doubt for half a century. Researchers were able to use advanced technology to prove that Rembrandt's signature on the painting, long thought to be questionable, was in fact applied to the canvas at the time the painting was executed.

Armed with this sort and breadth of expertise, technical art researchers like Eastaugh and Nadolny are able to turn to a wide array of diagnostic tools. But first, they carefully examine the canvas, the stretcher, or the panel; markings, seals, or labels found on the work; layers or ground and priming on the canvas; underdrawing or preparatory work; the pigments used as well as their binding agents; the artist's technique; patina and signs of aging; and conservation treatments.[26] In tandem with the collection of this information, the technical art researcher is then able to consider the result produced by futuristic-sounding technologies like positioning scanners, high-performance color/multispectral imaging, infrared reflectography, dual-laser Raman spectroscopy, and digital X-ray. When this level of technology meets the sort of training in fine arts that experts like Nadolny, Eastaugh, and their colleagues have undergone, the prospects for forgers grow dim with every passing day.

But of course, before science can be used to detect fraud, the defrauded must submit it to examination. And the one thing that

science cannot combat is the desire many people have to believe they have discovered the fine art find of a lifetime. Technical art researchers cannot compel duped art buyers to submit their acquisitions to analysis. In fact, in many cases, they likely would rather not know. And it's that sort of wide-eyed attitude toward art—and well-known artists—that is the chief symptom of the art dupe.

Research undertaken to determine the authenticity of works of art isn't always done in the name of ethics and integrity. There's often a lot of money and potential embarrassment at stake, whether it be for a private collector or a well-known institution. A solid provenance and analysis to back up the authenticity of a work pays dividends in terms of the dollar value of a piece of art. But whatever the motive for advances in authentication, the work done by leading minds in the field will only help to protect the artists and owners alike.

A NOTE ABOUT TERMINOLOGY: throughout this book, the terms *forgery* and *fake* are used quite often. In popular media, the two are often used interchangeably when discussing art. In a piece titled "Fakes and Deception: Examining Fraud in the Art Market," criminologists Kenneth Polk and Duncan Chappell expertly parse the meanings of the words. They clarify that often times "there is a tendency to apply the term 'fake' when there is no demonstrable intention to defraud."[27] For the purposes of this book, the term *fake* is used only in instances when fraud is intended. Furthermore, Polk and Chappell explain that, in a legal context, forgery applies only to the forging of documents or writing. For instance, *forgery* is a more legally correct term for a manufactured document used as provenance than it is for the actual painting it purports to support. Nevertheless, contemporary parlance has co-opted the word *forgery* to describe a painting executed in the style of an artist and then fraudulently sold as having come from his hand. Throughout this book, whether an artist creates

paintings that are "fakes" (exact unauthorized replicas of existing works passed off as the original) or "forgeries" (paintings created by an artist in another's style and name without authorization), I adhere to the conventional use of the term *forger* to describe him—and it is virtually *always* a "him." While women are frequently active if not integral players in the schemes used to sell fraudulent art, the most notorious of history's forgers are almost exclusively men.

I suspect that those fraudsters listed earlier, and surely others, will scoff at the fact that their story is not told in detail in these pages: modesty is not the strong suit of the forger. There are countless scams that have been perpetrated against innocent—and not so innocent—art buyers over the years, and there is no indication that they are decreasing. Furthermore, it's not possible to cover every conceivable scheme; it would take a mind much more corrupted than my own to imagine them all. Rather, this book explores the most noteworthy and illustrative of frauds from a multitude of angles within the art world, with a wide variety of inventive cons all focused on illicitly monetizing the creative genius of others. And this much is sure: there will be more scams and new criminally imaginative approaches to them. Moreover, it's likely that there are forgers, even prolific ones, whose stories have not and might not ever be told, while their works hang in galleries, homes, and even museums bearing the signatures of better-known artists. In the pages to follow you will find art scams from a variety of unique angles, as well as the clever investigative efforts that undermined them. Even as you read this sentence, someone somewhere is concocting a new scheme to use art to make a fortune by bypassing the hassle of ethical behavior.

ONE

THE FORGER

WOLFGANG BELTRACCHI WENT OUT ANTIQUING WITH A LIST OF VERY PAR-ticular items in mind. Searching diligently through the goods at a local flea market, he soon found just what he was looking for: a vintage 1920s camera and a few rolls of old film to go along with it. He also picked up some enlargers and trays to develop the film. Beltracchi had a bit more difficulty finding 80-year-old paper from the prewar era, but eventually he succeeded there too. With his photographic wares in hand, he headed home and studied the items, intent on creating authentic-looking period pictures.

Beltracchi's wife, Helene, a slim woman with strong features and graying light-brown hair, was excited by her creative husband's find and a willing and eager subject for his foray into period photography. Donning what she described as "the kind of blouse that grandmothers used to wear"[1] and a strand of pearls, she pulled her long hair back, adopted the somewhat dour expression of her grandmother Josefine Jägers, and sat up straight at a simple two-chair table upon which rested a cup of tea and a small bouquet of flowers. Wolfgang snapped a few photos of her, careful to include the paintings that

hung behind her on the wall—works attributed to masters of surrealism, including Max Ernst and Fernand Léger. These paintings, and many others, were part of a large collection of art that was said to be long absent from the waiting eyes of art lovers everywhere, and that would soon be unleashed to the world from the "Jägers Collection."

Wolfgang developed the black-and-white photographs of Helene-as-Josefine and closely examined the results. That they were slightly out of focus only added to the impression that they were taken in a bygone era. The finished product lacked but one feature, which he quickly and masterfully improvised by taking scissors and crimping the edges. The couple, who proudly described themselves as hippies, looked at their finished product, quite pleased with their results. But this wasn't some fun little project for a scrapbook, or a simple form of cosplay between the pair. Instead, the Beltracchis had created something more cunning, and even devious. They had created *provenance*.

Provenance is proof of the ownership history of a work of art. It is invaluable in establishing authenticity and, in turn, plays a vital role—perhaps *the* vital role—in determining value. While ironclad scientific proof of authenticity can often be extremely difficult to establish, solid provenance can make or break the sale of a painting. Because Helene had taken to selling valuable artwork that she claimed her grandfather—Josefine's husband—had left her, the Beltracchis were well aware of the need to prove that the paintings were what they purported them to be. Helene—the salesperson of the pair—had no sales records or receipts for the paintings, no decades-old titles to the works left behind by her family. Nothing aside from Helene's story of her grandfather and, of course, the obvious skilled handiwork and creativity displayed by each artist in the treasure trove of Impressionist paintings she had for sale. And, thus, the need to produce a record of ownership—like a historic family photograph—became important. After all, the story behind each and every artwork in the

world is different, and the art world can be a very murky place, costly to enter and often subject to intrigue.

THERE ARE A LARGE NUMBER of missing paintings in the world. Some have simply been misplaced by cash-strapped museums unable to retain a skilled registrar on staff to manage the many paintings bequeathed to them by generous art lovers. Others have been destroyed, perhaps by an unfortunate fire or some other accident. Some are in the possession of anonymous collectors who do not wish to make public the value of their irreplaceable works, or have obtained the art under less-than-ethical circumstances. Still others have been stolen and simply disappeared, the thieves unable or unwilling to return them to their rightful owners, even in cases where "no questions asked" and rewards are offered.

Other perilous conditions for cultural property include wars and political upheavals. And while national crises can mean jeopardy for collections both public and private, the evils of the Nazis during World War II marked a particularly vulnerable time for the world's great art and antiquities. From widespread looting, to collectors hiding their fine art, to the bombing of buildings and churches holding untold beauty, the scale of the disruption to the world's art is difficult to comprehend, never mind measure. With a large portion of the Second World War fought in European nations rich in masterworks, it's no surprise that an enormous number of paintings were put at risk under a variety of circumstances, including the wicked looting of art conducted by Hitler's *Sonderauftrag Linz* (Linz Special Commission) in an effort to meet his vision for the world's greatest museum— the *Führermuseum*—in his Austrian hometown. The Third Reich also implemented a program to rid the world of what it described as *Entartete Kunst,* or "degenerate art." This term was used to describe the work of the Modernists of the era, including such notables as

Paul Klee, Marc Chagall, and Wassily Kandinsky. Such was the Nazi contempt for Modernism that the party curated an exhibition of the so-called degenerate art featuring 650 works, each accompanied by a label describing for the viewer exactly what was wrong with coexisting with such deviant works. Never mind the fact that one of National Socialism's leading figures, chief propagandist Joseph Goebbels (who himself utilized a perverse form of bigoted Impressionism in an effort to pollute the national mood), had expressed approval for some pieces in the degenerate art show; this paradoxical exhibition was meant to show the people what the party believed they should no longer see. As the art writer James Gardner writes, "How ironic, however, that in their desire to purge the nation of this Expressionist threat, the Nazis set out to destroy what was, in fact, the first truly original form of German art . . . to have emerged in nearly five centuries, since the time of Dürer and the elder Cranach."[2]

The Nazi effort to purge its burgeoning yet doomed empire of degenerate art resulted in the confiscation of thousands of works, with a relatively small but unknown number of them being destroyed. It was against this historical backdrop that the breathtaking collection of Werner Jägers was introduced to the world by his granddaughter, Helene Beltracchi.

According to Helene, Jägers was a frequent and faithful customer of Alfred Flechtheim, a renowned Berlin art gallery owner. Flechtheim enjoyed enormous success dealing in works by the biggest names in the art of his day, including Van Gogh, Picasso, Matisse, and Cézanne, as well as representing important up-and-comers in Germany such as Paul Klee and George Grosz. So great was Flechtheim's influence in the art world in his time that today a commemorative plaque marks the spot of his Berlin apartment. After a first gallery collapsed while he fought for Germany in World War I, Flechtheim reestablished a gallery in Düsseldorf in 1919 and

opened another in Berlin in 1921.[3] By then, Flechtheim was a leader in the art scene in Germany, living as extravagantly as the clients he served. As was the case with virtually all Jewish businesses, though, the rise of Hitler meant the demise of Flechtheim's galleries and collection, and his road from celebrity art dealer to exile was, of course, paved by the Nazis. Within just six months of their rise to power, Flechtheim was broke and living in France, his life reduced to one of intense panic and loss. His friend Thea Sternheim would write, "What horrifies me the most is the senseless fear that has taken hold of Flechtheim. In a completely empty restaurant, he looks left and right, even during the most harmless conversations, to make sure that no one is listening to us."[4]

It's hard to blame Flechtheim for his paranoia. His impressive and important collection of art was gone, with most of it auctioned off by his requisite Aryan partner. To make matters worse, no documentation survived the sale of his property. And when he died suddenly in 1937 after contracting an infection, Flechtheim left no estate behind. Even his widow's art collection was lost to the Gestapo after she committed suicide rather than be deported to Minsk in 1941.[5]

Now, decades later, some of the art that had been dealt by the great but tragic Flechtheim was emerging from darkness, as Helene Beltracchi began to offer for sale the paintings her beloved grandfather Werner Jägers had bought from him. But despite the fact that Flechtheim's story was well known among a wide array of European art dealers, some still demanded provenance from Helene, backing her into a corner to come up with some sort of proof that her family had owned the Modernist paintings she was selling. Thus, for the Beltracchis, the falsified photographs that she and her husband produced were a necessary evil. It was clearly fraud, but millions of dollars were at stake, and the staged pictures seemed a rather harmless crime considering the fortune at stake.

Additional efforts were made to prove the authenticity of the paintings in Helene's Jägers Collection. For instance, the Beltracchis paid esteemed art historian Werner Spies a huge sum—rumored at over half a million dollars—to appraise seven of their works attributed to Max Ernst.[6] Spies's stamp of approval on the paintings would make their authenticity ironclad; the influential historian was not just well schooled and experienced, but had also been friendly with Ernst himself.[7] Spies's conclusion: all seven were unquestionably painted by the late surrealist Ernst. Spies's fee was money well spent: the certificates of authenticity the expert provided proved to be a boon for the Beltracchis, allowing them to sell at least five of the Ernsts from the Jägers Collection, including *La Forêt (2)*, which was purchased from the pair for $2.3 million and ultimately sold for $7 million.[8]

Helene's first sale was much more modest. In the early 1990s, she approached one of Europe's leading auction houses, Lempertz, with a painting she said was by Georges Valmier, a French painter whose styles evolved from Impressionism to Cubism and finally to Abstractionism. Almost immediately, the appraiser sent by Lempertz was ready to make a deal, and Helene settled on a final price of 20,000 deutschmarks (about $15,000). Years later, the painting would sell for $1 million.[9] Though it would be a few more years before she would present the Jägers Collection to the world, Helene was intoxicated by the thrill of selling her Valmier to Lempertz. As she would later tell *Vanity Fair,* "The first time, it was like being in a movie. It was like it had nothing to do with me. It was another person—an art dealer, whom I was playing."[10]

If she saw herself as an actress, she had found herself a dream role. And Helene rose to the occasion. She offered a painting called *Mädchen mit Schwan (Girl with Swan)* to Christie's, and when they raised the topic of provenance, Helene smoothly explained the story

of her grandfather Werner's collection; to bolster the provenance, she pointed to a label that was affixed to the reverse of the painting that read "*Sammlung Flechtheim*" (Flechtheim Collection), and beneath it, "Heinrich Campendonk." This was more than enough to convince the esteemed auction house's expert, Dr. Andrea Firmenich, who authenticated the work. Christie's proceeded to include *Mädchen mit Schwan* in its October 1995 auction of German and Austrian art, featuring it in its catalog and writing in the lot notes section: "This large colourful work is typical of Campendonk's style between 1917 and 1919 when Flechtheim was his dealer." It goes on: "The composition of a nude in a landscape with animals, a recurrent theme in Campendonk's work, stands as a symbol of purity—both of Man's unity in his natural state with Nature and of his original innocence in Paradise." The lot notes conclude "Dr. Andrea Firmenich has kindly confirmed the authenticity of this work." The catalog lists the provenance of the painting as "Alfred Flechtheim, Dusseldorf" and "Werner Jaegers, Cologne" and states that the painting was exhibited in Düsseldorf at the Galerie Flechtheim in 1920. At the October 11, 1995, auction, held on King Street in London, the painting, lot number 158, sold within its estimated range at a price of $106,178.[11]

Works by Heinrich Campendonk figured prominently in the Jägers Collection. While the German Expressionist's paintings regularly fetch prices in the six figures and more, he struggled with financial woes early in his career, falling out of favor with his parents, who had urged him to follow a more profitable path as a clothing designer. Fortunately, the break Campendonk needed soon came: in 1911, he caught the eye of none other than Alfred Flechtheim, who convinced him to move to Bavaria. Flechtheim provided him with a monthly stipend that brought stability to his life and allowed him to live in Sindelsdorf, near the homes of Wassily Kandinsky and Franz Marc.

This new setting and community had a positive impact on Campendonk's career, influencing his work and elevating his place among the famous German Expressionists.[12] So it's certainly no surprise that a number of his masterpieces would end up in the hands of Flechtheim and, in turn, Werner Jägers.

Helene had other Campendonks for sale, one of which would eventually be purchased by legendary comedic actor Steve Martin. Aside from his success on the big screen, Martin is a passionate art collector and the author of a highly successful art-based novel, 2011's *An Object of Beauty.* The book showcases the comic's incisive observations of the world of fine art dealing in Manhattan, telling the story of a young art broker grappling with the moral issues of her chosen line of work; it also dabbles in art crime. At the center of the story is the world's most valuable stolen painting: Johannes Vermeer's *The Concert,* stolen in 1990 from Boston's Isabella Stewart Gardner Museum. In 2004, the fine art–loving comedian paid $860,000 to Cazeau-Beraudiere, a Paris gallery, to add Campendonk's *Landschaft mit Pferden (Landscape with Horses)* to his private art collection, which already included works by Picasso, Francis Bacon, Lucien Freud, and Edward Hopper.

The Campendonk painting from the Jägers Collection that made the most significant splash in the art world was undoubtedly *Rotes Bild mit Pferden (Red Picture with Horses).* Presented to Lempertz for auction by Helene's sister Jeanette on behalf of the Jägers family, the painting was offered at auction on November 29, 2006, at its modern arts auction. Lempertz described the painting in its catalog as having been completed in 1914 and featuring "an incomplete vertical composition of a profile, half-length female nude with yellow mask and rooster" on back. The Lempertz lot notes went on to describe a woodcut label affixed to the reverse from the Flechtheim Collection: the same *Sammlung Flechtheim* label seen on the back of

Mädchen mit Schwan. This one included the handwritten inscription in ink, "Heinrich Campendonk/Seeshaupt/Rotes Bild mit Pferden." There were also stickers from the Sturm Gallery in Berlin and the Emil Richter Gallery in Dresden.

Based on the labels and the Jägers family's backstory, Lempertz described the provenance of *Rotes Bild mit Pferden* as "Alfred Flechtheim; private collection, France, purchased from Flechtheim ca. 1930, since then in family possession." Again, Dr. Andrea Firmenich's work—this time in terms of her published study on Campendonk—was cited. Clearly, Jeanette, like her sister Helene, had done well in establishing the provenance of key pieces of her inheritance. And it paid dividends: Lempertz, which had listed an estimated price of 800,000 to 1.2 million euros for the painting, sold it at a "World Record Price" of 2.9 million euros to Trasteco Ltd. of Malta.[13]

Trasteco had no intention of taking chances with its huge investment. After speaking with Modern Art experts in Geneva from Artvera's Gallery, the buyers decided to contact Lempertz seeking paperwork to establish solid provenance. Lempertz replied that they had authenticated the painting by speaking directly with none other than Heinrich Campendonk's own son. Unsatisfied with this as the only testament as to the painting's authenticity, Trasteco decided to contact an expert on Campendonk and looked no further than the painting's lot notes. Dr. Andrea Firmenich had written her doctoral thesis on Campendonk and authenticated *Mädchen mit Schwan* for Christie's. And while she had raved about that painting's "intense, shining, expressive colorfulness,"[14] something about *Rotes Bild mit Pferden* didn't quite sit right with her. So she turned to science for answers and submitted the painting to the Doerner Institute in Munich, where results of their testing left chemists skeptical about the authenticity of the painting. They stopped short, however, of an outright condemnation.

WITH QUESTIONS STILL UNANSWERED, another technical analysis was commissioned through Friederike Grafin von Bruhle, who was working on behalf of the buyers.[15] This time, the paintings were submitted to Dr. Nicholas Eastaugh. Dr. Eastaugh's credentials for such work were impeccable. Before studying art conservation and art history at the esteemed Courtauld Institute of Art in London, he was trained as a physicist. Perhaps most significant to the task at hand, Eastaugh had a world-class background in the study of pigments. He cofounded the Pigmentum Project, a program dedicated to using a combination of science and art history to study pigments, and had been called upon by a number of museums, galleries, auction houses, and collectors to analyze works.[16]

Eastaugh's results were definitive and startling: *Rotes Bild mit Pferden* could not be the work of Heinrich Campendonk. The testing confirmed the presence of a pigment—titanium dioxide white—used in the painting that was not available in 1914, when the painting was supposed to have been completed. Even the unfinished sketch on the back of the painting and described in the lot notes was a forgery, containing another period-inappropriate pigment, phthalocyanine green. "It was a normal job," Eastaugh said. "It came in for analysis, I did my job, I wrote a report. The report came to the conclusion that it couldn't possibly be what it was representing itself to be. So, to that end, the report was essentially saying that this painting's a fake."[17]

Still curious about the "Sammlung Flechtheim" labels, Firmenich had another idea: she reached out to modern art expert Ralph Jentsch in October 2008 to get his assessment of the sticker on the back of the painting. Jentsch was also a wise choice. As the managing director of the estate of Modernist painter George Grosz, Jentsch was well schooled in the subject of Flechtheim, from whose gallery Grosz paintings were confiscated by the Nazis. He knew well the appearance

of the Flechtheim Gallery labels. Jentsch took a close look at the garish caricature of Flechtheim on the label on the reverse of *Rotes Bild mit Pferden* and his reaction was immediate: he burst out in laughter.[18]

Jentsch had no doubt that the label was a fake. Alfred Flechtheim was a man of impeccable taste and elegance. He'd never have used a label with such an image. Moreover, Jentsch knew that the labels the art dealer did use bore no image of him whatsoever. "There is no way he would have permitted such a silly portrait," Jentsch said.[19] Firmenich asked Jentsch what he knew of the art collector Werner Jägers, who was said to have purchased a large collection of paintings from Flechtheim. Jentsch had never heard of him. Everything about the painting was faked. Yes, industrialist Werner Jägers did live in Cologne at the time of Alfred Flechtheim, but if the two had ever truly crossed paths, Jägers would have been but 16 years old and hardly in a position to amass a world-class collection of paintings. And though Jägers was, in fact, the grandfather of Helene, virtually everything else about her story was fiction. Far from an associate of Flechtheim, Jägers was a member of the Nazi Party with no known serious art collection.[20] Furthermore, the art she offered for sale was not part of an old family inheritance, accumulated in a home belonging to the Jägers dynasty near Cologne in the Eifel Mountains. Rather, the entire collection was being created on the spot by her husband, Wolfgang Beltracchi. The attribution to Campendonk, the sketch on the reverse, and even the labels were all the creation of this master Modernist who also happened to be a master forger.

THAT WOLFGANG BELTRACCHI IS a skilled artist is beyond dispute. Now in his early 60s, he is an intriguing figure.[21] With his shoulder-length graying hair and matching Vandyke beard, he looks every bit the master painter. Though a criminal, the man who is perhaps the world's greatest living forger seems an almost endearing figure. He's

full of wit and playfulness and has an almost impish attitude toward the years he spent creating frauds for an untold number of willing dupes all too eager to hand over a fortune for what he created in the name of another.

The young Wolfgang, whose surname was Fischer before he adopted the name of his wife, took up painting in his preteen years. The son of a man he described as a church painter and restorer, he tells of watching his father copy the works of the Old Masters and vividly recalls pointing out his father's mistakes and questioning his process. He describes himself as a sort of prodigy who displayed signs of talent so striking that his father stopped painting for two years after seeing his son's first effort, completed in just an afternoon. Later, when he was admitted as a highly gifted student at the school of applied arts in Aachen, he again stunned older artists with his mastery of his medium, even prompting one instructor to accuse him of turning in work that couldn't have been his own. He was ultimately expelled from school at the age of 17 while he was working at—of all places—a strip club for supplying his fellow students with less than appropriate reading material, but he took it in stride. "I wasn't overly interested in going to university. I spent most of my time in a café on Südstrasse. I liked sitting in that coffeehouse." Seeking another way to support himself, he turned to the thing he could do best: painting.[22]

Wolfgang produced a variety of works for money, and also began his career as a forger, producing paintings for sale at flea markets, with some frauds among them. He traveled Europe, creating paintings in downtown areas and finding that he could make a decent income selling his works. His oeuvre at this point consisted of "the unpainted works of Old Masters at first, and later Art Nouveau and the Expressionists."[23] It was a harbinger of a career to come.

In the 1980s, Wolfgang gave the working world a try, co-owning an art gallery. Predictably, he found a day job unfulfilling and fraught

with the sort of pressure to which he was unaccustomed. "I had to sit in an office, which wasn't for me," he said. "Suddenly I had a guy breathing down my neck who was mainly interested in making a lot of money fast."[24] So he returned to producing highly profitable forgeries, earning so much money that he soon bought an 80-foot sailboat he named *Voodoo Child* and hired a crew to man it. A few years later, when the money stopped flooding in due to a drop in the art market, he turned to a film project. And that's when he met his future partner in crime, Helene.

On the first day he met her in 1992, Wolfgang told *Vanity Fair*, he decided that he would marry Helene and have a family with her. By the second, he had introduced her to the world of art forgery. "So you're an art counterfeiter?" she asked. "Exactly. That's my work. That's my métier," he replied.[25] With the art market on the rebound, Wolfgang knew there was more money to be made. Impressed that she took the news of his vocation in stride, he asked Helene to join him in his fraud. Apparently taken by the challenge and excitement of selling fakes, the working-class girl jumped at the chance. They married in February 1993 and had a child within a year. It was around this time that Helene sold the phony Valmier to Lempertz, and a legend in illicit art was born.

Wolfgang worked hard at the art of forgery, taking great pride not only in his skill but in his historical accuracy. He went so far as to research important books on the topic of pigments, like Max Doerner's *The Materials of the Artist and Their Use in Painting*, and returned to flea markets again and again to find historical artists' supply catalogs.[26] He hunted down his materials with an eye for detail, an effort he described as more difficult than executing the actual painting. "What was really complicated was finding old canvases and frames. Sometimes they could be had for €30 and sometimes for €5,000. Some of them were really beautiful paintings, and I still have

them in my head today. If I couldn't get the old paint off, I incorporated details of the old image into the new one."[27]

Wolfgang's painting was equal parts remarkable hand skill, stunning imagination, and astonishing boldness. And while he said that the pictures could be completed in as little as two or three hours, the finished products were impressive forgeries. He fooled not only some of the most esteemed and reputable auction houses, museums, experts, and buyers in the world, but even surviving family members of the artists. Max Ernst's expert and friend, Werner Spies, wasn't alone in falling victim to Wolfgang; Ernst's widow did as well. According to Helene, when Dorothea Tanning saw Wolfgang's *La Forêt (2)*, she called it the most beautiful picture Ernst ever painted.[28] And of course, Campendonk's son had authenticated *Rotes Bild mit Pferden*.

Perhaps the key to his success was his technique of researching an artist to the extent that he could stand before the canvas and, as he described it, essentially channel him. According to Wolfgang, this was not, as some have described, merely method acting. Rather, his works were the result of the forger taking brush in hand and imagining what the artist might have—but never did—paint. His dedication to becoming the artist he was "channeling" was such that he claimed, "If the artist was left-handed, then I painted with my left hand."[29] As he told *Spiegel Online International,* "Every philharmonic orchestra merely interprets the composer. My goal was to create new music by that composer. In doing so, I wanted to find the painter's creative center and become familiar with it, so that I could see through his eyes how his paintings came about and, of course, see the new picture I was painting through his eyes—before I even painted it."[30] Such was the extent of this vision that Wolfgang claims he never employed underdrawings or preparatory sketches on canvases before applying paint.[31]

Fortunately for the art world, the ingenuity of Wolfgang Beltracchi more than met its match in the expertise of Eastaugh and, later, his colleague Jilleen Nadolny. Eastaugh's thorough, science-based examination of Wolfgang's works not only exposed *Rotes Bild mit Pferden* as a fraud, but also cast the artist in the same light as his paintings: he was not exactly what he purported to be. For instance, when they subjected his works to infrared reflectography, the pair found that Wolfgang did, in fact, use full underdrawings in a number of his works.[32]

By 1995 he already had the police on his heels when a number of forgeries—including a Campendonk—were linked to art dealers from Aachen and were painted by a certain Wolfgang Fischer from Krefeld. But thanks to the statute of limitations, he couldn't be prosecuted.[33] Soon thereafter, the couple and their first child, a daughter, took the fortune they had amassed, sold their Viersen, Germany, home for more than a half-million dollars, bought a motor home, and headed for the south of France, where they purchased and renovated a lavish estate known as Domaine des Rivettes. They spent their money and entertained lavishly, enjoying the company of friends and hanging what visitors believed to be a bevy of masterpieces on the walls. All the while, the Beltracchis continued to capitalize on their fictitious collection. They sold an unknown amount—at the very least many dozens—of paintings, including *Bateaux à Collioure,* attributed to Fauvist Andre Derain, for $2 million. Another forged Derain, *Matisse Peignant à Collioure,* sold for the equivalent of more than $6 million.[34] Meanwhile, a former partner of Wolfgang's, Otto Schulte-Kellinghaus, was also enjoying successful sales of Beltracchi's paintings, creating a provenance story similar to Helene's: his grandfather, Johann Wilhelm Kops, had also tucked away important paintings and they were now back on the market. Life was good for

the Beltracchis. That is, until Eastaugh applied his expertise to the Trasteco painting.

IT IS IRONIC THAT WOLFGANG was undone by the forged Campendonk *Rotes Bild mit Pferden,* a painting in which he took great pride. Interviewed about it by Paraic O'Brien of the United Kingdom's *Channel 4 News,* he said, "I love my paintings, all of them. And my best Campendonk was the Campendonk they [caught] me with. That was the Campendonk with the red horses. That was the most expensive Campendonk ever sold. Nearly 3 million Euros." Reminded by O'Brien that it wasn't truly a Campendonk, Wolfgang replied, "Yeah, yeah, it was not a Campendonk. It was from me, yeah, yeah, sure. It was the best one." O'Brien, seeking to parse Wolfgang's words, asked, "Do you mean the best one of yours?" The artist clarified: "The best Campendonk." Taken aback, O'Brien asked, "Is that what you think? You think that your Campendonk was the best Campendonk?" Wolfgang said, "Yeah, that's a little bit difficult. It was sold as the best Campendonk that was ever sold." O'Brien, refusing to let Wolfgang off the hook, pushed him for a definitive answer. "But was it the best Campendonk?" To this the master forger replied, "Yeah. Sure."[35] And his claims were hard to argue, given the record price the painting garnered.

The rave reviews and millions of dollars *Rotes Bild mit Pferden* earned, however, could not overcome scientific analysis. Wolfgang's biggest mistake—using titanium dioxide white—caused his undoing. Incredibly, the tube of paint that he used on the painting did not mention that it contained this post-Campendonk pigment in the list of ingredients on the label. Like the painting and artist, it was not exactly what it was purported to be. Armed with both scientific and expert analysis debunking the authenticity of *Rotes Bild mit Pferden,* Firmenich delivered the bad news to Trasteco. They immediately

took action, hiring a Berlin lawyer to sue Lempertz to annul the sale. The lawyer also filed a criminal complaint over the sale of the painting, naming Helene's sister in the complaint. The German authorities then began listening in on her phone calls, and subsequently became aware of the scheme and the people behind it.

Meanwhile, Ralph Jentsch set about identifying other paintings featuring the faux Flechtheim label, and he quickly identified 15 paintings with the phony stickers. The elaborate Beltracchi scheme was now suddenly and quickly falling apart. Eastaugh and Nadolny set about examining another six works that were brought to them at Art Access & Research in London. All the paintings analyzed by the pair contained one or more pigments that were inconsistent with their alleged dates of creation.

On the evening of August 27, 2010, as part of the biggest operation that the German art fraud unit ever conducted, Wolfgang and Helene were arrested while on their way to dinner in Freiberg. Though theirs were not violent crimes, the pair was separated and placed in solitary confinement. Life for the bon vivant Beltracchis had now taken a hard turn. Helene was diagnosed with breast cancer and the pair rarely saw each other or their children. Wolfgang spent his 14 months of pretrial detention with what he described as "real criminals: murderers, child molesters, people convicted of manslaughter."[36] And the news of their wide-ranging frauds set the art world on its head. Paintings whose provenance included the Jägers Collection popped up across Europe and the United States. Steve Martin's name emerged in the press as having once been the duped owner of a forged Campendonk, *Landschaft mit Pferden*. Martin told the *New York Times*, "The fakers were quite clever in that they gave it a long provenance and they faked labels, and it came out of a collection that mingled legitimate pictures with faked pictures." While he was not exactly correct—the Jägers Collection did not, in fact,

contain authentic works—Martin was realistic about the problem of forgeries in the art world, adding that this was not the first time he had been tricked by a forger: "Each time you become more and more cautious."[37] Even the renowned Metropolitan Museum of Art in New York was found to have displayed a Beltracchi on its walls. Werner Spies, the Ernst expert who incorrectly identified Beltracchis as Ernsts, contemplated suicide.[38] He would later be sued by one of the buyers who claimed they purchased an Ernst based on his authentication. The negative attention and liability has had a chilling effect on authenticators around the world, who have become fearful of making mistakes like Spies and suffering the same fate.

As experts examined works determined to be Wolfgang's forgeries, some other tell-tale signs of his work were uncovered. For instance, Eastaugh and Nadolny found that the works contained an "obviously fake patina . . . visible only as scattered deposits, not a coherent layer"; anomalies concerning the paintings' "stretcher/strainer bars, and the various stamps and labels applied to them"; inconsistencies in the age of the nails used on the canvases and stretchers; a "disjuncture . . . between paint and ground due to the processing of the priming of the old canvas"; and "a range of physical anomalies related to the removal of the paint from an old canvas."[39] So while the forgeries were very convincing to so-called experts, they were no match for scientific analysis.

These findings, however, were made only because of the problems detected with pigments during the initial examination of the painting *Rotes Bild mit Pferden*. It's very difficult to know if these other inconsistencies would ever have emerged had Wolfgang not been done in by titanium dioxide white. As Eastaugh would later write, "The toughest call though is the first one, which perhaps goes some way towards explaining why it took so long to recognize the first Beltracchi fake and so little time to identify many more."[40] Eastaugh

has also stated that "it is also rare to see a whole group together, so an individual anomaly may not be read as significant. There were though plenty of other material use anomalies that would probably have been picked up sooner or later."[41] In other words, in the opinion of a renowned expert on the matter, it was likely only a matter of time before the Jägers Collection would have been exposed.

THE TRIAL OF THE BELTRACCHIS was held in Room 7 of the Cologne District Court before Judge William Kremer. At the outset, it appeared the trial would last for more than a month, with 168 witnesses scheduled to appear over 40 court sessions. But after just 9 days, a deal was struck: Wolfgang, Helene, her sister, and Schulte-Kellinghaus would receive shorter sentences than the prosecutors originally sought in return for full confessions from all. The German courts decided it was not in the best interests of the public to spend a lot of money prosecuting the forgery ring, much to the chagrin of the German police involved in the investigation. On October 27, 2011, Judge Kremer declared all four guilty and sentenced Wolfgang to six years in prison. Helene, who was frail but in recovery from her breast cancer, received a four-year sentence. Though the trial was short, Wolfgang's charming personality was on full display in the courtroom, and the press ate it up. "The media—and this I find upsetting—has not been critical. Huge amounts of taxpayers' money has been wasted bringing this criminal to justice," said Dr. Nadolny. "He confused the record on some artists, defrauded people and abused trust."[42] Nevertheless, he sat at the defendant's table eating candies and smiling at onlookers, and both he and Helene appeared comfortable and unafraid, affectionate with each other and even making jokes. At the conclusion of the proceedings, Wolfgang declared himself appreciative of the "fairness and good spirit" of the trial and "that everyone smiled so often."[43]

Not everyone was taken with the merry fraudsters, though. One onlooker, an auctioneer who had handled a Beltracchi, said, "I wish they'd applied sharia law at his trial."[44] "This was a man who . . . made his money from stealing," art dealer Michael Haas told a German news outlet. "Yet in the press and even in the courtroom, this is treated as something comedic. That's just too much."[45]

The sentences handed down by the court were based on just 14 of Wolfgang's forgeries, which sold for nearly $22 million. This limited number was presented to the court for two reasons. First, many of Wolfgang's frauds were perpetrated outside of the statute of limitations. According to *Spiegel*, "Old criminal police investigations in Berlin suggest that Beltracchi had passed on at least 15 forgeries by the 1980s."[46] Second, it wasn't until after the charges and trial that more of his paintings came to light. Ultimately, German police would release a growing list of forgeries that reached 60 by 2014, and art historians believe there may be as many as 300 Beltracchi forgeries in circulation.[47]

Wolfgang has said that he has created works by about 50 artists. And he has the ego to match his obvious charm. In fact, his hubris may have been the essential part of his success. After all, taking on the challenge of not just copying but dreaming up works by history's most successful artists takes confidence. James Martin, a conservator and scientist who has examined hundreds of paintings, says of his forgeries, "His fakes are among the best fakes I've seen in my career. Very convincing. Very well done."[48] In numerous interviews, Wolfgang has claimed that there is no artist, except for Bellini, whose works he could not forge. Whether all this is true or not is open to some skepticism. When told of this claim, Eastaugh replied, "I supposed he could try copying any artist; whether it would pass any form of scrutiny is another matter." Nadolny was more direct. "It's easy to claim after the fact. He's never passed off a successful Rembrandt

or a Titian . . . I think most likely, he's just bragging. He stuck to a very specific type of art work—expressionists and modern."[49] In any event, copying the Old Masters was not for him. "He knew his limits and did his homework: he stuck to a very specific type of art work—lesser known expressionist and modern painters, those that have not been subject to much technical study, which were easier to obtain 'authentication' for than say a Van Gogh or a Monet."[50]

The Beltracchis served their sentences in a sort of home confinement called "open prison," in which Wolfgang could spend the day with Helene, painting and working on projects such as an autobiography titled *Self Portrait* and a German-language documentary. The courts have ordered him to pay half of his income to recompense damages. And the paintings he produces nowadays are signed "Beltracchi" (and can earn as much as $46,000).[51] He has also launched "The Beltracchi Project," in which he paints over pictures taken by photographer Manfred Esser. But his own creations cannot compare to the paintings he completed by emulating the great Modernists. What people want are his forgeries. Even the owner of the $7 million Max Ernst forgery decided to keep it, calling it one of the best Ernst paintings he's ever seen.[52]

A FINAL NAGGING QUESTION remains concerning Wolfgang Beltracchi, and that involves his motivation. Both he and his wife have said on a number of occasions that their enormous scam was not motivated strictly by money. But when asked why he didn't merely paint his imagining of a Campendonk over his own signature, he is frank and honest: "Because then I don't get 600,000 euros from the painting."[53] And there can be no doubt that he and Helene loved the lavish living that the fortune they amassed afforded them. But at the same time, it is also clear that Wolfgang enjoyed the game, the challenge of showing up those who are celebrated as art experts. "I am too good for

them. That's their problem. And the problem is they think they can look at the painting and say 'that's this or that.' And therefore I have shown them a mirror, you know."[54]

But Wolfgang was not, in fact, too good for Eastaugh. As he and Nadolny showed, Wolfgang's success was as much the result of authenticators and buyers who wanted to believe they had found a masterpiece as it was a matter of his artistic acumen and criminal cunning. Had those who were so willing to pay astronomical amounts for new finds been just as eager to seek authentication from technical experts, Wolfgang never would have been able to earn the vast sums of money he and Helene so happily spent living the high life. According to Eastaugh and Nadolny, "The technical means employed by Beltracchi were . . . conventional from a forger's standpoint." Wolfgang was merely a "talented copyist" whose only "vaguely unique" approach was his "willingness to engage with the problems of historical materials, a skill which he honed towards the end of his career."[55] Nadolny says, "Rather than allowing him to recreate a Max Ernst for the fiftieth time, why didn't anyone ever say 'OK then, make us a Da Vinci'? Now that would be interesting to see."[56] What truly set him apart were the willing dupes who enthusiastically parted with millions of dollars based on the myth of the Jägers Collection, forgetful of the ancient admonition *caveat emptor*.

TWO

THE BROKER

THE MASSIVE FRAUD THAT WAS THE JÄGERS COLLECTION LEFT THE ART world more than a little embarrassed over the relative ease with which two self-described hippies were able to con some of the most esteemed dealers, collectors, authenticators, and auction houses in the world. With nothing more than a clever backstory as provenance and a talented yet devilish artist at the easel, the Beltracchis set in motion tens of millions of dollars in deals and devastated reputations. It would seem that all of the major players in the field would have reexamined their practices and cast a cautious—if not doubtful—eye on high-value art coming on scene, especially that said to be from a previously unknown collection mysteriously hidden from the world for decades.

But such was not the case.

Manhattan's Knoedler & Company was one of the oldest commercial art galleries in the United States, having operated in New York for 165 years. Situated in a stately, early-twentieth-century townhouse on East 70th Street—on the same block as the Frick Collection—Knoedler clients read like a who's who of American wealth, including the Rockefellers, the Astors, the Vanderbilts, and

the Mellons. In a headline, the *New York Times* called it a "gallery that helped create the American art world."[1] It's hard to imagine a more venerated gallery or an institution with better access to the best minds in the field of art authentication. It's harder still to believe that on the heels of the lessons that should have been learned by dealers large and small across the world from the Beltracchi affair, Knoedler would almost immediately thereafter fall victim to an American version of the Jägers Collection: the so-called David Herbert Collection.

David Herbert's connections to the artists who were purported to have created the art in his "collection" were solid. Unlike Werner Jägers, Herbert's chosen avocation was in the world of artists and art galleries, and his credentials were excellent. As a young man, Herbert spent the better part of a decade working with two influential and legendary art dealers: Betty Parsons and Sidney Janis. Parsons and Janis shared not only the fourth floor of 15 East 57th Street in Manhattan, they also shared connections to some of the most important artists and collectors of the day, including major figures in the Abstract Expressionist movement like Jackson Pollock, Mark Rothko, and Robert Motherwell. Thanks to his work with giants in the New York art gallery scene, Herbert gained a great deal of experience working with these and other artists. In fact, during his time working with Janis, he established a reputation as a leading salesman of New York School artists, selling Pollock's *Arabesque* and Franz Kline's *Wanamaker Block* to major collector Richard Brown Baker.[2]

After his work with Parsons and Janis, Herbert set out on his own as an independent dealer in 1959. He would eventually become what has been described as a significant force in helping to launch the careers of a number of artists, including Ellsworth Kelly.[3] Most famously, it was Herbert who introduced a then unknown Andy Warhol to Irving Blum and Walter Hopps, founders of the renowned Ferus Gallery in Los Angeles. Though he closed his own gallery

in 1962, Herbert remained very active as a private dealer, traveling throughout the United States, Europe, and Latin America.[4] In 1963, Herbert took on a protégé of his own, a young émigré to the United States from Colombia named Jaime Andrade. Soon, the pair would be hosting informal exhibitions at Andrade's Manhattan apartment. A lifelong relationship was formed, and Andrade developed into a respected gallery figure in his own right, working with a number of famous collectors while also cultivating a personal interest in contemporary Spanish and Latin American art. In 1967, Andrade went to work at the Lawrence Rubin Gallery and later followed Rubin to Knoedler & Company. It would be the start of another enduring relationship, and he remained at Knoedler for 40 years as a senior associate.[5]

In the mid-1990s, Andrade introduced his boss, Knoedler president Ann Freedman, a tall, thin woman with striking gray curls, to a woman he described as "a very good friend," Glafira Rosales, an art dealer who ran a small operation with her live-in boyfriend Carlos Bergantiños.[6] Given Andrade's connections to the Latin American and Spanish art communities, it probably came as no surprise to Freedman that Andrade would know Rosales, who is of Mexican descent, and Bergantiños, a native of Spain. The pair made a particularly good team for dealing in art: Rosales, a convincing and impeccably dressed middle-aged woman with long, dark hair and rimless glasses, and Bergantiños, a man with an eye for artistic talent.

IN 1981, A CHINESE PAINTER named Pei-Shen Qian came to the United States from China with a student visa to study at the Art Students League in New York City. Before coming to America, Qian's early years as an art student in China were not unlike those of fellow forger Wolfgang Beltracchi in Germany. The works he produced in school were so good that his teachers doubted their authenticity, accusing

him of tracing his drawings from originals. He persevered despite his teachers' skepticism and went on to become a professional artist, albeit producing the mundane: during China's Cultural Revolution, he was directed by the government to produce portraits of Chairman Mao Zedong for use in schools and factories.[7] Though it was honest work, it was hardly the sort of creative outlet dreamed of by many aspiring artists.

Years later, after the Cultural Revolution, a dozen artists in Shanghai—including Qian—staged an exhibition that would come to be credited as playing an important part in a rebirth of sorts for Chinese art, and he received special attention for an abstract piece he produced for the show. When a viewer of the piece told him that he could earn the equivalent of about two years' pay for that one painting in New York, Qian sought and obtained a student visa.[8] He struggled to earn a living in America, however, resorting to work as a construction worker and a janitor for some time to supplement the very modest income he eked out as a painter. His plight was a cause for consternation for Qian, at the time in his mid-40s. As his friend and fellow artist Zhang Hongtu recalled, "He was kind of frustrated because of the language problem, the connection problem. He was not happy." Another friend described him as "homesick" and "lost."[9] While his modest earnings in New York far exceeded the $42 per month he made in Shanghai, the success and acclaim he had experienced back home were now gone, and Qian found himself reduced to peddling his paintings on the streets of New York City.

In the early 1990s, with Qian adrift in a sea of artistic obscurity, Carlos Bergantiños came across the Chinese painter selling his works downtown. While it's not clear whether Bergantiños set out looking for a skilled forger or if he fell victim to an on-the-spot devious epiphany, something about Qian's work stood out to Bergantiños. Here was an artist with true skill who might be willing to

earn a few extra dollars. According to Qian, Bergantiños offered him $200—the equivalent of a very long day's work—to imitate a work of modern art by a master artist. The offer was too good to turn down, and Qian produced the painting his new patron requested. Impressed with Qian's work, Bergantiños came up with dozens of additional projects for him, each involving paintings in the style of world-famous Abstract Expressionist artists, including Jackson Pollock, Mark Rothko, Willem de Kooning, Robert Motherwell, Barnett Newman, and Franz Kline. On each, either Qian or Bergantiños would forge the signature of the artist.[10] But of course, mimicry of a painting style is but one aspect of a convincing forgery. The right materials were essential to the creation of a convincing fake. So Bergantiños visited flea markets and art auctions to purchase old paintings purely for the sake of procuring period-appropriate canvases for Qian. In order to artificially "age" newer canvases, Bergantiños would stain them with tea bags—a smart approach to take considering that tea, as an organic material, would not be easily detected by scientists examining the works. In a further attempt to make the works appear older, Bergantiños would subject the finished paintings to heating and cooling and experimented with exposing them to the elements outdoors. Ever the innovator, Bergantiños tried propping a blow-dryer over one of the forgeries in an attempt to heat it. He would seek out older paints for use by Qian in his works. And he'd even purchase old furniture at flea markets and elsewhere in order to obtain Masonite, a board used in some furniture as well as in some works by Abstract Expressionists.[11]

Still, the scam was not complete without some semblance of provenance. No matter the efficacy of Qian's brushwork or Bergantiños's aging techniques, Glafira Rosales would need a backstory for the paintings that she would present for sale. She would have little success selling art whose origins could not be explained—that would

set off red flags that she was trying to sell fakes or fence stolen works. Thus the David Herbert Collection was created.

Rosales pitched an elaborate story to explain the fortune in Abstract Expressionist paintings she sought to broker, one that evolved as needed. Initially, she said the David Herbert Collection had been amassed by an anonymous collector who would come to be known only as "Mr. X," and his wife. The couple, she said, knew the artist Alfonso Ossorio, and he would take them to artists' studios where they would buy works that would be added to their collection, which was maintained in storage. Soon after, however, this story fell apart when (the now deceased) Ossorio's longtime companion, Ted Dragon, was vehement in his assertion that this could not have occurred without him knowing about it—and he didn't. So Rosales adjusted the story, adding additional intrigue to make it yet more difficult to vet and, therefore, disprove. The second iteration of the collection's provenance involved an affair between the married Mr. X, a deeply closeted homosexual, and David Herbert. It was Herbert, not Ossorio, who steered his lover to artists' studios where Mr. X bought his collection of masterpieces. To make the story yet more difficult to confirm or deny, Rosales said the deals were always—conveniently for her purposes—made in cash, thus there was no money trail.[12]

Rosales used this story for only approximately 50 of the works she had available for sale. For an additional 13 or so, there was another fantastic tale. In this instance, Rosales claimed she was working on behalf of a Spanish collector who had received the works from a gallery in Spain. Rosales claimed that she and her boyfriend Bergantiños had interviewed the Spanish dealer to obtain details about his life to bolster provenance. The pair and Bergantiños's brother Angel produced not just the forged paintings but forged documentation stating that the purported Spanish collector had certified the works as authentic.

ARMED WITH THE FAUX PROVENANCE, Glafira Rosales approached two es-
teemed galleries: Julian Weissman Fine Art and Knoedler & Company.
At the latter, Rosales's introduction through Jaime Andrade meant a
solid start to her relationship with the gallery's head, Ann Freedman.
In 1994, Freedman bought from Rosales two works by the artist Rich-
ard Diebenkorn, who had a long relationship with the gallery and had
died the previous year. A problem arose, however, just a few months
after the acquisition when Diebenkorn's widow and daughter, accom-
panied by art scholar John Elderfield, visited Knoedler and expressed
to Freedman their skepticism that the works were authentic. Richard
Grant, Diebenkorn's son-in-law and executive director of his founda-
tion, told the *New York Times,* "They didn't look quite right, and we
said, 'The provenance is wacky and the story behind the provenance
makes no sense.'" Though Freedman has disputed the family's recol-
lection, Elderfield, a former curator at the Museum of Modern Art,
remembers expressing doubt about the work to her.[13]

It was later that same year that Rosales presented the story of
Mr. X and described her previously undiscovered treasure trove of
Abstract Expressionist works to Freedman. Rosales even produced an
authentication document to be used by Knoedler, which stated that
she was "the authorized agent, as well as a close family friend, of a
private collector residing in Mexico City and Zurich [ostensibly, Mr.
X]." It continued: "For various personal reasons the owner prefers to
remain strictly anonymous as the seller. The art works [*sic*] were ac-
quired by the current owner's father directly from the artist and were
passed by inheritance to his immediate heirs (son and daughter)."
She further claimed "that the owner has absolute clear legal title to
the [works]."[14] With little additional inquiry or investigation into the
story, Knoedler was all-in on the opportunity to consign the works,
regardless of the sketchy provenance and changing tales.

IN MARCH 2001, Knoedler purchased a supposed Jackson Pollock painting from Rosales for $750,000. Nine months later, Knoedler sold the painting, *Untitled, 1949,* to Jack Levy, cochairman of mergers and acquisitions at Goldman Sachs, for $2 million. Ever the savvy businessman, Levy wisely included a provision to the purchase that stated that he would submit the painting to the well-respected International Foundation for Art Research in New York for authentication. Should IFAR find that the painting was not an authentic Pollock, he would be entitled to a refund. In October 2003, IFAR issued its report on *Untitled, 1949,* stating that it had conducted archival research, expert analysis, and interviews about the painting and found the provenance story to be "inconceivable," "improbable," and "difficult to believe." IFAR concluded that it "believes that too many reservations exist to make a positive attribution to Jackson Pollock." Levy returned the forged Pollock to Knoedler for a full refund.[15] It's a source of continuing wonder why more art buyers don't take the same precautions as Levy when spending exorbitant amounts of cash on paintings, especially considering the long history of forgeries throughout the ages. A common response involves the fact that when one approaches a gallery with the esteem and history of Knoedler, they should have a high level of confidence in their purchase.

Knoedler was left red-faced after this mishap, and one might suspect that this would have led the gallery to end its relationship with Rosales and the paintings she was offering. IFAR's reputation was well established over decades of outstanding work in the field of art authentication and assisting the art community and law enforcement in fighting art crime, and its results are accepted as the gold standard for provenance work. At the very least, one might expect that Knoedler would subject any future offerings from Rosales to intensive provenance research, including scientific analysis. But rather

than distance itself from Rosales, Knoedler continued to buy and sell works from the contrived collection, including additional Pollocks she had produced.

For her part, Freedman has stated that in considering any artwork for sale, it had been her consistent practice throughout her four decades of experience to enlist "scholars to research the provenance of a work that has been brought to my attention." She said, "I have consulted preeminent experts to view the work and express their opinions about it, both orally and in writing. I make every reasonable effort to learn as much as possible about a work of art that is being offered for sale, and I then disclose to prospective purchasers the facts that I have learned—and the facts that I have not been able to learn—about the work."[16]

Not so, says Domenico De Sole. The chairman of luxury retailer Tom Ford International and former president and CEO of the Gucci Group, De Sole is a man with an undeniable eye for style and a keen business sense. In 2004, the Rome native De Sole and his wife, Eleanore, contacted Freedman about purchasing an abstract work by Irish artist Sean Scully. They figured they would spend in the neighborhood of $1 million. When they met in person to discuss such an acquisition, Freedman used her legendary sales skills to convince the De Soles to purchase a much more expensive Abstract Expressionist painting: a work by the famous artist Mark Rothko. It took less than a month for Freedman to close the deal, selling *Untitled, 1956,* to the couple for $8.3 million.

It is the contention of the De Soles that Freedman went beyond innocently selling a forged work to them. Instead, they claim, the Knoedler president, in meetings with them and their consultant and agent Jim Kelly, "affirmatively and knowingly made an array of material false representations to induce the De Soles to purchase the [Rothko]."[17] In addition to consistently representing that the Rothko

was authentic, the De Soles say that Freedman told them the painting had been authenticated by Christopher Rothko (the artist's son), Dr. David Anfam, who was the creator of Rothko's catalogue raisonné—the scholarly compilation of the artist's complete body of work—and other experts. They also claim that Freedman told them that Mr. X and Mr. X Jr. "were personally known to Knoedler" and that Mr. X Jr. wanted the painting to be sold to a collector as opposed to someone who planned to merely resell it.

When purchasing the painting, the De Soles remained somewhat concerned about the authenticity of the painting. Whether this was because of nagging doubts or simply because they were understandably cautious given the massive price tag is not clear. In any event, the couple requested a written assurance from Knoedler as to the authenticity of the work. In a letter addressed to the De Soles' daughter, Laura, Freedman attested to the legitimacy of the Rothko, stating that "the painting has been viewed by a number of eminent scholars on Rothko as well as specialists on the Abstract Expressionist movement." She added that Knoedler anticipated that Oliver Wick, who had previously curated a Rothko exhibition, would be requesting that the piece be loaned to him for an exhibition at the Fondation Beyeler, a famed repository of Rothko's works. She wrote, "Mr. Wick considers the Rothko painting, *Untitled, 1956,* to be of superior museum quality." She also included a bio of David Herbert.[18] The letter sealed the deal. The De Soles were now the owners of a multimillion dollar painting attributed to Rothko that had actually been painted in Queens by a Chinese immigrant.

LIKE A NUMBER OF HISTORY'S most famous artists, Robert Motherwell had to first meet his father's demands before embarking on his career as a professional painter and collagist. Though the well-educated Motherwell studied literature, psychology, and philosophy

at Stanford and did postgraduate work at Harvard, he decided to become an artist after visiting Paris and viewing the work of French Modernists. First, though, his father demanded that he complete his studies in art history at Columbia University in 1941 in order to ensure a "secure career."[19] Neither the artist nor his father could ever have dreamed that more than 60 years later (but just 3.5 miles away), forgeries carrying Motherwell's name would be sold from the Knoedler Gallery for millions of dollars.

One such painting was titled *Spanish Elegy,* a 1½ × 2–foot painting bought by Killala Fine Art, a respected gallery based in Dublin, Ireland, for $650,000. The painting was purported to be part of Motherwell's monumental series *Elegies to the Spanish Republic.* This time, Rosales had sold the painting to Julian Weissman, a well-established dealer and a former associate at Knoedler & Company who operates the Weissman gallery in the Wall Street area. In 2006, Weissman contacted Marc Blondeau, who operated Killala, to let him know that he had a Motherwell for sale. Interested, Blondeau visited Weissman's gallery to see the work and discussed provenance with the dealer. Weissman informed him that the owner of the painting he was consigning—Mr. X Jr.—did not wish to be identified but that his parents had purchased the painting directly from Motherwell. It was the classic Rosales fabrication. Though Weissman and Blondeau had done business together successfully for a decade, Blondeau knew this was shaky provenance and told Weissman that he would require certifications from both Weissman and the Dedalus Foundation.

In 1981, Motherwell established the Dedalus Foundation to foster an understanding of modern art. After his death, the foundation took control of the copyrights of Motherwell's art and went to work establishing a catalogue raisonné of his work. Surely they held the expertise to authenticate one of Motherwell's paintings for Weissman.

In January 2007, the Dedalus Foundation's president, Jack Flam, and the foundation's executive director, Morgan Spangle, visited Weissman's gallery and visually examined the painting, but did not subject the work to scientific testing. The results were just what Weissman had hoped: the pair declared the work to be a Motherwell and issued a letter of authenticity, writing, "It is the opinion of the Foundation that the Work is the work of Robert Motherwell." Blondeau had an additional question: Would the work be included in the foundation's coming catalogue raisonné of Motherwell's works? Spangle wrote a clarification to Weissman for Blondeau stating, "Here is the letter of authenticity which is issued by the Foundation. While it does not say directly that the painting, *Spanish Elegy,* 1953, will be included in the catalogue raisonne which is being prepared by the Foundation, I can assure you that the painting *will be* included."[20]

While it is not uncommon for works to be discovered after the publication of a catalogue raisonné, it does serve as an essential source for researching provenance and authenticating works. The foundation itself described it as "a reliable corpus of authentic works."[21] Based on the fact that Spangle assured Weissman that the painting would be in the catalogue raisonné of Motherwell's works, Blondeau decided to purchase the painting from Weissman.

DESPITE SPANGLE'S ENTHUSIASTIC TONE, trouble loomed regarding the hasty authentication of *Spanish Elegy.* Later in 2007 and through January 2008, the Dedalus Foundation met with Ann Freedman three times to discuss the Motherwells from the David Herbert Collection. Seven purported Motherwells sold by Glafira Rosales—four to Knoedler and three to Weissman—were now thought by the foundation to be fakes because they found the explanation that the Motherwells were sold directly to Mr. X through Herbert implausible. In addition to provenance research that Flam would later describe as

"just kind of fluff,"[22] they told her that the Rosales Motherwells in-cluded stylistic anomalies. These findings were reiterated by Jack Flam in a meeting with Freedman on January 10, 2008.[23]

Unaware that these revelations had just recently been brought to Knoedler by the foundation about Rosales and the Mr. X prov-enance, Domenico and Eleanore De Sole contacted Freedman re-questing an insurance appraisal for the Rothko they had purchased with the same provenance. Knoedler quickly replied to the request, valuing *Untitled, 1956* at $9 million—an increase in value of more than a half-million dollars. Though Knoedler was now in posses-sion of information that the authenticity of no less than eight paint-ings sold by Rosales from the David Herbert Collection (the Pollock bought and returned by Jack Levy and the seven Motherwells) was, to say the least, questionable, Freedman did not inform the De Soles that there might be an issue with the Rothko the gallery had sold them using the same exact backstory. The De Soles went on to spend $64,000 insuring a painting that was, essentially, worthless—a fact that should have by now at least been on the minds of the leadership at Knoedler.[24]

WHILE THE DE SOLES were still under the illusion that they were in possession of a multimillion dollar painting from what they believed to be a credible source—the so-called David Herbert Collection—another wealthy collector, Pierre Lagrange, was also making a pur-chase from Ann Freedman at Knoedler & Company. The long-haired and wildly successful Belgian hedge fund manager had heard through dealers that Knoedler had a Jackson Pollock painting on the market. Eager to invest in a Pollock that he might later sell at a profit, Lagrange was intrigued. One of the dealers, Jamie Frankfurt, contacted Freedman on Lagrange's behalf and expressed his interest in the Pollock. To explain the authenticity of the painting, Freedman

told Frankfurt that the painting was from the private collection of Mr. X, who had obtained it from Jackson Pollock himself, through David Herbert. No mention was made of the Pollock with the same exact provenance that was returned by Jack Levy a few years earlier because of concerns as to its authenticity after an expert review. Rather, Freedman further told Frankfurt that the painting had been viewed favorably by a number of important experts—whose names she provided—and, according to Frankfurt, went on to say that the painting would appear in a soon-to-be-released addendum to the catalogue raisonné of Jackson Pollock. Nevertheless, Lagrange, who was based in London, wanted to see the painting before buying it. Excited at the prospect of a major sale, Freedman agreed to ship the supposedly valuable painting to Lagrange in London. It was a wise decision on Freedman's part—after seeing it, Lagrange decided to purchase the painting, called *Untitled, 1950*, for $17 million.[25]

The claim about the painting being added to the Pollock catalogue raisonné is the subject of dispute between Frankfurt and Freedman. Freedman claims she merely said that she was lobbying the Pollock-Krasner Foundation for the painting's inclusion. But in either scenario, the very idea of *Untitled, 1950* being added to a forthcoming Pollock catalogue raisonné should have raised red flags: The Pollock-Krasner Foundation disbanded its authentication board in 1995 and hadn't any plans to authenticate additional works, a fact well known to most insiders who make their business in the world of Abstract Expressionism. Furthermore, it appears that Freedman's list of experts who had viewed *Untitled, 1950* was just that—a list of viewers. Not a single one of them said they had come to Knoedler with the mission of inspecting the painting for the purpose of authentication.[26]

IN FEBRUARY 2009, Julian Weissman received a troubling letter from Jack Flam at the Dedalus Foundation. At issue was the Motherwell

Spanish Elegy, about which the foundation had earlier written to Weissman stating their intent to declare the painting authentic and their decision to include it in its catalogue raisonné of Motherwell's works. This time, Flam was the bearer of very bad news. "I am now writing to inform you that, based on new information, and per its right to withdraw the March 2, 2007 letter, the Catalogue Raisonné has determined to withdraw the letter per that right. We are at present not planning to include that painting, titled 'Spanish Elegy,' in the prospective Catalogue Raisonne of Paintings and Collages by Robert Motherwell."[27]

The Dedalus Foundation offered no basis for the reversal. But that drastic turnaround set into motion a series of events that would lead to the unraveling of the web of lies that were spun by Glafira Rosales to Weissman and Knoedler. Just a few months later, in the summer of 2009, Ann Freedman received an equally troubling document: a subpoena from the FBI. The bureau was now investigating the David Herbert Collection and the group behind it. By October, Freedman was no longer the president at Knoedler & Company, having allegedly been escorted out the front door of the legendary gallery after resigning.[28] She would not, however, be leaving the world of dealing fine art, and began working on plans for her own firm.

Freedman may have been committed to moving forward, but more trouble lay around the corner. In October 2010, Pierre Lagrange, who was ready to capitalize on his investment by reselling *Untitled, 1950,* approached Sotheby's to discuss a private sale. Citing concerns about the provenance of the painting, Sotheby's declined Lagrange's overture. Lagrange was understandably troubled by this response and contacted Frankfurt, who, in turn, was in touch with Freedman. Steadfastly standing by the painting, she expressed her willingness to sell the Pollock for Lagrange through her own new gallery, FreedmanArt. Curiously, she also wrote of the

Pollock-Krasner Foundation's "plans for a new revised CR [catalogue raisonné] to include the number of discovered Pollocks since the time of its now outdated black and white publication from the mid 70s." When asked by a representative of Lagrange's if this update was indeed in the works at the Pollock-Krasner Foundation, a representative replied "absolutely not."[29] Exactly where Freedman was getting her information about a nonexistent Pollock catalogue raisonné is unclear. But this, of course, was the key issue in Lagrange's efforts to deal his painting. As Christie's wrote in a letter to Knoedler, "It is our belief, and generally agreed in our industry, that Pollock paintings not listed in the *catalogue raisonné,* are rarely accepted in the marketplace."[30]

On February 1, 2011, Killala Fine Art filed suit against Julian Weissman and the Dedalus Foundation over the forged Motherwell painting *Spanish Elegy.* Three days later, Pierre Lagrange met with Freedman's replacement at Knoedler, Frank DeLeo, to discuss his Pollock purchase. Lagrange's demand was clear: rescind the sale of the Pollock and refund his money. DeLeo refused, citing the opinions of experts who had provided "positive opinions" about it.[31]

Hoping to rid himself of the problem painting, Lagrange then approached Christie's to see if they, unlike Sotheby's, would be willing to sell his problem Pollock. Again, questions about the provenance of the painting—Rosales's Mr. X story—caused consternation. Christie's was clearer still, outlining the issue related to the David Herbert story and requesting the name of the anonymous consignor (Mr. X Jr.). Knoedler stubbornly refused to furnish the information, with DeLeo informing Christie's that the gallery was "not able to provide you with any additional information with respect to this work other than what Mr. Lagrange already has in his possession."[32] Of course, it was becoming clear that what Lagrange had in his possession was not much at all. So he sought a scientific analysis of the painting.

NINE MONTHS AFTER KILLALA FINE ART filed its civil complaint against Julian Weissman and the Dedalus Foundation, a legal settlement over the phony Motherwell *Spanish Elegy* was concluded, and the agreement between the parties would prove to be the turning point for the Glafira Rosales scam. The settlement called for Killala to be reimbursed by Rosales and, to a lesser extent, Weissman. And most remarkably, the parties agreed that the spurious *Spanish Elegy* would be forever branded as a fraud with the following text permanently stamped on back: "After physical examination and forensic testing, the Robert Motherwell catalogue raisonne project of the Dedalus Foundation, Inc., has determined that this painting is not an authentic work by Robert Motherwell but a forgery."[33]

Meanwhile, analysts had concluded their examination of Pierre Lagrange's Pollock in November 2011. The examination proved the painting was not the work of the famous creator of priceless drip paintings. Analysts reported that two of the paint samples "that were clearly and unambiguously integral" to the painting were discovered in 1957 and not commercially available until 1970. Pollock, who died in an automobile accident in 1956, could not have used these pigments.

The results of the analysis were the death knell for the David Herbert/Glafira Rosales Collection, and Knoedler apparently knew it. One day after receiving the results of the Lagrange analysis, on November 30, 2011, Knoedler & Company released the following statement: "It is with profound regret that the owners of Knoedler Gallery announce its closing, effective today. This was a business decision made after careful consideration over the course of an extended period of time. Gallery staff will assist with an orderly winding down of Knoedler Gallery."[34]

The closing of Knoedler after 165 years of business sent shockwaves around the art world. Lucy Mitchell-Innes, president of the

Art Dealers Association of America, told the *New York Times,* "My reaction is one of tremendous sadness. This is a very venerable institution that provided great art to a number of the great collections and great institutions in this country."[35]

Venerable, true, but not without previous missteps related to the provenance of works it sold. In 1998, Knoedler was sued by the Seattle Art Museum when the museum itself was sued by the heirs of Jewish art dealer Paul Rosenberg. A painting in the SAM's collection, *Odalisque* by Henri Matisse, had been stolen from Rosenberg by the Nazis. In 1954, the painting was purchased from Knoedler by Prentice and Virginia Bloedel, with the couple unaware that the painting had been looted from Rosenberg. When the Bloedels sought further information from the Knoedler salesperson about the provenance of *Odalisque,* they received a letter from the gallery about which the court wrote, "For whatever reason, the facts set forth in that letter were false, despite the fact that Knoedler apparently had the correct information in its possession at the time the letter was written."[36] The Bloedels later innocently donated *Odalisque* to the SAM, but in 1996 the couple's granddaughter recognized the painting in the book *The Lost Museum: The Nazi Conspiracy to Steal the World's Greatest Works of Art* by Hector Feliciano, leading her mother to contact the Rosenbergs.[37] After the SAM spent two years researching the ownership of the painting, *Odalisque* was returned to the Rosenbergs. The SAM and Knoedler eventually settled their federal civil suit, with Knoedler agreeing to give to the museum one or more works from its inventory or the equivalent in cash.[38]

In 2003, Knoedler was sued again, this time by the Springfield Museum in Massachusetts. In 1955, the museum purchased *Spring Sowing* by Jacopo de Ponte from Knoedler, a painting that had been hanging in the Italian embassy in Warsaw until it was looted by the Nazis when they shut down the building. While the Italian

government long believed that the painting in Springfield was the same one taken from their Warsaw embassy, they were unable to prove it until an Italian official located a photo taken in 1939, which showed the de Ponte hanging in the embassy. It was a match for the Springfield painting. As a result, the Springfield Museum returned the painting to the Italians.[39] The museum sued Knoedler, seeking money damages and citing the gallery's claim that it had examined the painting's provenance and had clear title to sell it to the museum. In 2005 the parties settled out of court.

Domenico and Eleanore De Sole, clearly stirred by these events surrounding Knoedler and the fictitious David Herbert Collection, also sought scientific analysis of their painting, submitting the alleged Rothko to James Martin. Martin was a sensible, if belated, choice. Educated in the field of conservation at the esteemed Winterthur Program at the University of Delaware and a Samuel H. Kress Fellow at the University of Cambridge in England, Martin's expertise includes having conducted more than 1,700 analytical studies, as well as six years teaching paint analysis and infrared spectroscopy to the FBI's Counterterrorism and Forensic Science Research Unit. He founded Orion Analytical in 2000, based the firm in Williamstown, Massachusetts, and equipped it with the most advanced technology for the analysis of paintings. It's an art authenticator's paradise, with equipment ranging from a scanning electron microscope with backscattered electron imaging to confocal Raman microspectroscopy: things a conservator would love and a forger would likely not understand. Martin is among the most well-known art authenticators in the United States. His results, too, were conclusive: "In spite of his signature, 'MARK ROTHKO', and date, '1956', materials and techniques used to create the Painting are inconsistent and irreconcilable with the claim that Untitled was painted by Mark Rothko . . . in 1956 or any other date."[40]

Martin's work showed that the efforts to disguise Pei-Shen Qian's work as an original Rothko—undertaken by the artist and by Carlos Bergantiños—were no match at all for scientific analysis. In fact, the Orion Analytical report makes it clear that the painting bore indicators of fakery that were blatant. For instance, Martin's research of Rothko's technique helped him determine that the artist used temporarily fastened crossbars on the back of stretchers for the very purpose of retarding the development of stretcher-bar marks on the surfaces of large canvases. And while vertical crossbar marks from the painting's support structure appear on the front and back of the painting, the stretcher holding the canvas contained only a horizontal crossbar.

In addition, Martin discovered clear indicators that the painting was done after the crossbar marks formed, a sure sign that the canvas had been used previously. He also found the canvas to be strip-lined, a measure usually taken to compensate for a tear or weakness in a canvas. However, Martin found no reason for strip-lining. Finally, he found that "the presence of white opaque primers on the Painting (and no evidence of transparent pigmented size) is inconsistent with Rothko's technique," and other materials inconsistent with the artist's work.[41] In short, James Martin's analysis decimated the best and most creative efforts the Rosales forgery ring could imagine.

MEANWHILE, FBI AGENTS PAID a visit to the Queens home of Pei-Shen Qian to question him about his role in the fraud scheme that was unraveling virtually by the day. While Qian would eventually claim to be an innocent dupe in the scam—simply making copies of famous artists for people who could not otherwise afford them—findings by investigators indicate this was not the case. During questioning by the agents, Qian lied about matters that did not match his claims. For instance, Qian told the FBI that he did not recognize Rosales's name. He also denied having ever heard of famous artists about

whom he not only owned books, but whose names he had actually painted onto the forgeries. And, most tellingly, he stated that he had never attempted to mimic the style of Abstract Expressionist artists. During a search of his home, FBI agents found paintings completed in the style of Pollock and Barnett Newman; auction catalogs and books on Abstract Expressionist artists and techniques; and even an envelope of old nails marked "Mark Rothko."[42]

More than 60 forged paintings created by Qian and brokered through Rosales and Bergantiños were sold to just two galleries: Knoedler & Company and Julian Weissman Fine Art. In all, Rosales and her cohorts received over $33 million selling their faked art, an amount that pales in comparison to the $80 million taken in by the two companies. And while the largesse they made would lead to a mountain of lawsuits and badly damaged reputations for the galleries, Freedman, and Weissman, the millions that Rosales and Bergantiños made would prompt the feds to pursue the pair as they did Al Capone: they indicted them for tax evasion and related charges.

The U.S. government put together an airtight case against Rosales, showing that the money she received from the sales of the paintings did not, in fact, go to a Mr. X Jr. in Spain. Instead, she and Bergantiños kept the ill-gotten gains. And of course, they failed to claim this income on their tax returns either as individuals or business owners. The feds were also able to determine that Rosales kept her money in a foreign bank account, a fact that she failed to declare. Faced with 99 years in prison, Rosales decided to plead guilty in hopes of leniency from the court. She also agreed to forfeit the $33.2 million and her 5,000-square-foot, $2.4 million home in Sands Point, New York, and to pay restitution not to exceed $81 million, though it's not clear how she would do so.[43]

Carlos Bergantiños didn't stand by his girlfriend. Instead, he and his older brother Jesus Angel Bergantiños Diaz fled the United

States to avoid arrest and decades in prison, taking cover in Seville, Spain. Authorities sought the pair for months before finding them in a luxury hotel in April 2014. Carlos, overcome by the arrest and facing extradition to the United States to answer for his massive fraud, suffered an anxiety attack that landed him briefly in the hospital. Within days of their capture, the Bergantiños brothers were indicted by the United States for crimes including wire fraud and money laundering, with Carlos facing additional charges for defrauding the IRS, filing false tax returns, and willful failure to file a "Report of Foreign Bank and Financial Accounts," charges he shared with Rosales.[44]

Like the Bergantiños brothers, Pei-Shen Qian, now 75 years old with his name emerging in the media and up to his neck in trouble for the lies he told the FBI, left the United States and returned to his native China. It's an ideal choice for a fugitive from American justice: China and the United States do not share an extradition agreement, and it's quite unlikely that Qian will ever be forced to return to the United States to answer for his crimes.

Qian's departure came despite his insistence that he was innocent of any wrongdoing. Speaking to *Bloomberg News* in a rare interview with Western media in December 2013, he said, "I made a knife to cut fruit. But if others use it to kill, blaming me is unfair." Qian called the whole forgery scam "a very big misunderstanding." The paintings, he believed, wouldn't be taken seriously. "It's impossible to imitate [the masters]—from the papers to the paints to the composition."[45] But Qian's behavior runs contrary to his claims. Though he received a few thousand dollars per painting at first, prosecutors described a seminal moment in the relationship between the brokers and their artist: Qian spotted one of his creations in a booth at a Manhattan art show priced very far above his fee and then held out for more money from Bergantiños, who boosted Qian's payments to up to $7,000 per painting.[46] This, of course, was little more than

pennies on the dollar compared to the cuts that Bergantiños and Ro-
sales took in, but on the other hand, Qian was now obviously aware
that he was not producing cheap, obvious fakes. Still, he continued
to produce art for Bergantiños and Rosales. Further, Qian's lies to the
FBI and the evidence they unearthed (including the Rothko nails)
did not point to the behavior of an innocent man. But the world will
probably never see all of the evidence against Qian put before a jury
of his peers. Instead, he will likely spend the rest of his life in Shang-
hai in the studio where he still paints.

ASIDE FROM ROSALES AND the Bergantiños brothers, it appears un-
likely that anyone else will ever be prosecuted for the $80 million
David Herbert Collection forgeries. But the scam left a disaster in its
wake. A storied gallery was closed, buyers were defrauded, the courts
were flooded with enormous civil suits, and respected art dealers had
seen their reputations suffer.

In contrast to the sense of loss many felt with the loss of the ven-
erable gallery, the famous face of Knoedler, Ann Freedman, became
the subject of ire for some buyers. Pierre Lagrange was incensed at
her role in the sale of the phony Pollock. Domenico and Eleanore
De Sole filed suit against her and Knoedler over the fake Rothko,
accusing her of abdicating her responsibility and having reckless dis-
regard for the truth in a civil complaint. John Howard, the head of a
multibillion-dollar private equity firm, also sued Freedman, likening
the whole affair to "a joke on the art world."[47]

While some may question Freedman's integrity in legal filings
and interviews, it would be quite difficult to argue that after spend-
ing many decades building a first-rate career as an art dealer and ris-
ing to the top spot in one of the country's oldest and most venerable
galleries, she decided to take a criminal turn. Further to the point,
it was revealed that Freedman had herself purchased a 12 × 18-inch

Pollock from Rosales. The painting, which might seem like a bargain at only $280,000, was later found to feature an important error: Pollock's signature was spelled "Pollok."[48] In her defense, Freedman argues, "discreet sources are my stock in trade," and that throughout her career she had dealt with sellers who insisted upon anonymity. Besides, Rosales responded to one of Freedman's requests to know more about the mysterious X family by saying, "Don't kill the goose that's laying the golden egg," insinuating that Freedman's requests to meet him would irritate him. Worse yet, in Freedman's estimation, was the possibility that other dealers could be bidding against her.[49] Thus, she had to seize the moment.

After the fall of Knoedler, Freedman was subjected to widespread second-guessing in the media from colleagues in the world of art dealing. One such dealer was Marco Grassi, the owner of Grassi Studios in Manhattan, who was harshly critical of Freedman's role in the controversy, telling *New York Magazine,* "This has ruined one of the greatest galleries in the world. It has trashed a lot of people's money. It seems to me Ms. Freedman was totally irresponsible, and it went on for years. . . . A gallery person has an absolute responsibility to do due diligence, and I don't think she did it. The story of the paintings is so totally kooky. I mean, really. It was a great story and she just said, 'This is great.'"[50]

Freedman, unwilling to let her reputation be attacked any longer, filed suit against Grassi, alleging defamation, libel, and slander, and maintaining that she subjected the Rosales paintings to due diligence, sticking to her claim that numerous experts, scholars, and critics had agreed with her assessment of the works as being authentic. The embattled art dealer said that she went "well beyond what is customary" to ensure the art was authentic and that "few galleries would have sought even a quarter of the confirmation Freedman demanded before selling these works."[51] She cited one instance where the former

conservator of the Mark Rothko Foundation carefully examined every work Rosales brought to the gallery. "That conservator found the works to be classic works of the artists," Freedman argued. She also quoted art dealer Ernst Beyeler, who described one of the Rosales Rothkos as a "sublime masterwork."[52]

Ann Freedman is far from incompetent. But she also is no criminal. In fact, a former member of the FBI's Art Crime Team asked to review the case for an expert opinion described her actions as "inconsistent with a fraudulent intent."[53] Instead, it seems far more probable that she was intoxicated by the prospect of being part of the unleashing of a heretofore unknown collection on the world, just as so many others who have been duped by clever con men were. That's not to say she was acting altruistically: ego, greed, and acclaim were also possible components of what seemed like an ardent desire to believe that the unlikely was fact. How else to explain an expert dealer's willingness to buy into a provenance story that not only evolved drastically, but revolved around characters named Mr. X and Mr. X Jr.?[54]

THREE

THE ART PONZI SCHEME

WHILE SHE WAS BUSY SELLING WHAT TURNED OUT TO BE MILLIONS OF DOL-
lars in forgeries from Glafira Rosales, Ann Freedman was interviewed
by *New York Magazine* about another major figure in the Manhattan
art gallery world, Larry Salander. In what might or might not have
been a case of projection, she said, "Larry always has some mystery.
Success for him was to find the undiscovered painting, to prove this
was a masterwork against all odds."[1] If Freedman's evaluation may
have offered a glimpse into her own psyche, it was accurate none-
theless when it came to Salander. Salander was at the time working
feverishly on two major shows that he saw not only as a financial
necessity, but also as a grand moment for the art market the world
over. One exhibition, to be titled *Masterpieces of Art: Five Centuries
of Painting and Sculpture,* would feature the works of true classical
giants such as Rubens, Correggio, Botticelli, El Greco, Titian, and
Michelangelo.

 Masterpieces of Art represented Salander's deep interest in what he
saw as truly valuable art—that of the classical masters. Speaking to
the critic James Panero, Salander made a blunt comparison between

the prices fetched by the work of contemporary artists versus that of the Old Masters: "Our society now values a Warhol for three times as much money as a great Rembrandt. That tells me we're fucked. It's as if people would rather fuck than make love."[2]

Salander's other show, *Caravaggio*, which he curated with the art historian and dealer Clovis Whitfield, would not only further Salander's goal of emphasizing the value of the Old Masters: it was also a natural headline grabber. The show would be centered on a classical painting called *Apollo the Luteplayer*, which had last been sold in January 2001 at a Sotheby's auction of important Old Master paintings and arts of the Renaissance in New York. At the time, the auction house listed an estimate for the painting at a range of $100,000 to $150,000—a relatively low figure for the work based on the fact that experts consulted by Sotheby's deemed the painting to be from the circle of Michelangelo Merisi, called Caravaggio. The work was likely simply a copy based on existing Caravaggio works featuring a lute player hanging at the Metropolitan Museum of Art in New York and at the Hermitage in St. Petersburg, Russia.

When he saw the Sotheby's auction catalog—which stated that the work might have been created by Carlo Magnone—Whitfield was taken with the image of *Apollo*. Working on behalf of an anonymous American client, Whitfield went about examining the painting further. He was no novice: in addition to running a London art gallery, Whitfield was educated at both Cambridge and the Courtauld Institute of Art. He would go on to write *Caravaggio's Eye*, a detailed study of the artist's revolutionary approach to painting. Of *Apollo* he said, "We had an idea that it was something more interesting. When I went to New York to look at the painting and put a lens close to it, I thought it was electrifying."[3] So taken was he that Whitfield advised the American to buy it, and he did so for $110,000. It turned out to be quite a bargain. When Whitfield had it analyzed closely by

paintings conservators, they found evidence that the painting was not a copy at all. For instance, X-ray analysis revealed that the artist had made corrections to the picture that indicated he had changed course in the midst of painting it, including changes to the profile of the lute player's hands. That's not something an artist would do had he simply been copying an already-completed painting onto another canvas. Further analysis showed that the canvas bore preparatory incisions that were indicative of Caravaggio's technique.[4]

Despite the findings, Sotheby's remained unmoved. "Were we to take the painting in for sale today, we would definitely not catalogue it as by Caravaggio," a spokesman said.[5] But both Salander and Whitfield were undeterred by Sotheby's stubborn refusal to budge. After all, no one expected Sotheby's to suddenly tell the world that they had mistakenly undervalued a piece of art by tens of millions of dollars. And furthermore, the pair had to be buoyed by the approval they received from Sir Denis Mahon, one of the world's most respected experts in Italian art of the Baroque period, about the painting. With a newly attributed Caravaggio headlining his exhibition, Salander knew he had something the art world could not ignore. Here was a true Old Master who met all the criteria for top billing and a sky-high asking price: previous high prices, a very low number of available paintings, and an important place in art history. And added to this was the emerging information about his fascinating life. Put simply, Caravaggio was a rock star.

Today, Caravaggio is considered an innovator, described by British artist and photographer David Hockney as having "invented a black world that had not existed before, certainly not in Florence or Rome." "Caravaggio," Hockney adds, "invented Hollywood lighting."[6] Perhaps this was because the Milanese artist's life was filled with a great amount of drama and turmoil, which included a duel over a woman, a purported murder, and imprisonments. Despite

such turbulence, he did not want for commissions, and though his first works sold for very little, he eventually captured the eye of collectors, leading his fellow artist Giuseppe Baglione to complain that Caravaggio "was paid more for his individual figures than others for history paintings."[7]

Today, his paintings are worth astronomical figures. In 2006, almost a year to the day before Salander's planned exhibition, it was announced that the restoration of a Caravaggio that had been found in the attic of an Italian church was complete. The painting's value was estimated at more than $110 million. A similar value was attached to his painting *The Taking of Christ*.[8]

So Salander, emboldened by these estimates and eager to make a splash with his important shows, attached an ambitious price tag to Caravaggio's *Apollo the Lute Player:* $100 million—one thousand times its previous sale price. Salander's gambit was that the art buyers would—and should—return to putting their big bucks on what he saw as the true greats: the Old Master paintings made by Caravaggio, Rembrandt, El Greco, Tintoretto, and others. In his view, contemporary art—the conceptual and sometimes downright bizarre—had been commanding top dollar for too long, and Salander saw his exhibition as the pivotal moment where it just might turn course, or rather, get back on course. He told the *New York Sun* that his exhibition would mark the first time a Caravaggio was sold in public and, therefore, "I'm not sure what we're going to get for it, but $100 million is cheap. It's the most important painting ever sold." Apparently believing that the significance of the exhibition to his own career and the art world could not be overstated, he added, "There's not a lot left to do after a show like this. It's going to be a hard act to follow."[9]

THE MAN WHO WOULD REESTABLISH the classical masters as the marquee-grabbers of the art world was born in 1949 and grew up in a

respectable but modest middle-class neighborhood on Long Island. His father, the owner of a small gallery himself, died when Salander was a young man, and the tough, tenacious art lover took on the responsibility of providing for his mother and sisters. Though he didn't finish college, he became a self-taught expert in the world of art, impressing others with his voracious appetite for all things related to his field. In 1976, well before his thirtieth birthday, Salander and a partner opened the Salander-O'Reilly Gallery in Manhattan and built it into one of America's best known and regarded art galleries. And he himself became a major figure in the world of art, known for an unmistakable passion for his work. His friend and former employee Ron Gerston recalled that Salander "didn't sleep at night. He ate, drank, and breathed art. When he wasn't in the gallery selling art, he was in his office reading about art and writing about art."[10]

Salander was somewhat of an anomaly in the art world, as he was successful as both an art dealer *and* acclaimed as an artist. As a painter, his works were so well regarded that one of them, *Crucifixion,* painted in 1992, is in the collection of the Smithsonian American Art Museum. Eight feet tall, the painting is executed in the same American Modernist style upon which he first established himself as a dealer. His paintings were the subject of nine solo and ten group exhibitions. According to Gerston, "He was a painter and that's what he cared about."[11]

His background as an artist may have been the driving force behind his passion for the art he sold, but it was his forceful, dynamic personality that suited him well for wheeling and dealing with the powerful figures who created high-value art and those who could afford it. Salander made no attempt to conceal his background and upbringing as a regular guy, and his gift of gab made him an attractive figure to other powerful men. According to art critic and writer Judd Tully, the stocky, balding, somewhat unrefined yet charming

Salander was not what one envisions when they picture a high-profile art dealer in Manhattan. "He was very gruff-speaking and contrary to almost any profile you might think of in terms of what an art dealer might look like, sound like, dress like, and act like." Yet his status near the top of the New York art world spoke for itself. "When he was in the nice digs, the Wall Street people were able to look past his eccentricity and trust this guy's success and want to listen to him. The other people didn't mind the eccentricities; he was an artist like they were."[12] His friend Leon Wieseltier, the literary editor of the *New Republic,* said Salander is "a very unusual combination of street vitality and aesthetic refinement."[13]

It wasn't just Wall Street types who gravitated to Salander. He called many celebrities friends, including Robert DeNiro, Liam Neeson, and Bruce Springsteen. And when tennis legend John McEnroe was considering turning his SoHo residential loft into a gallery space, he turned to Salander for guidance. Salander brought him into his Upper East Side gallery in a nonpaying role to study the inner workings of the business. "You can't learn guitar without learning the basic chords, and you can't learn the art business without knowing the nuts and bolts," McEnroe later wrote in his autobiography *You Cannot Be Serious.*[14] The two became so close that McEnroe would eventually become the godfather to Salander's child.

Salander's opulent lifestyle matched that of the company he kept. Wieseltier described him as "a street kid who reads Ruskin. I don't know anybody else who so naturally recognizes the brutality of the world but lives in such a fine way."[15] He had two homes: one a 60-acre estate in Millbrook, New York, that included not just tennis courts but also a baseball field for his kids to play on; and a three-story brownstone on the Upper East Side of Manhattan that he purchased for nearly $5 million. His propensity for flying only on private jets was such that it left even DeNiro incredulous. When the pair

went to Portugal, DeNiro recalled, "I saw I had a plane and Larry had a plane. It just didn't add up to me."[16] And when his second wife, Julie, turned 40, Salander rented the Frick Collection museum for a $60,000 birthday bash. He also lavished her with a half-million dollars worth of jewels.[17]

As his business grew and became more successful, Salander decided to make another major acquisition. He expanded Salander-O'Reilly Galleries to incorporate a new location on East 71st Street in Manhattan, a 45-foot-wide neo-Italian Renaissance mansion that was nothing less than spectacular. Tully described it as "One of these beautiful nineteenth-century buildings with a big staircase, beautiful rooms, beautifully appointed. You walked in and you thought, 'Oh my god, this place is a palace.'"[18] The location featured three stories of exhibition space, a greenhouse roof, and skylight-illuminated upper levels. *New York Magazine* raved that it was "well worth a visit in itself with its arched front entrance, velvet-walled rooms, and inlaid wood floors."[19] Such space doesn't come cheap, especially in Manhattan. Rent for the new gallery space exceeded $150,000 per month.

Despite the sumptuous new gallery space, all was not as it seemed in the world of Larry Salander and Salander-O'Reilly. With six children, an ex-wife, two multimillion-dollar residences, and a lavish lifestyle—not to mention two Manhattan gallery locations—to support, pressure to earn large amounts of money was intense for the art dealer. Furthermore, Salander had now embarked on his quest to bring a rebirth to Renaissance art. This meant acquiring Old Master paintings, which required that he find additional large investments. An acquaintance told the *New York Post* that Salander "had delusions of becoming the major American dealer in Renaissance art. He would sign any piece of paper, he was buying everything in sight. He just went crazy."[20] While some saw craziness, however, Salander saw a quest for the soul. He wrote an unpublished manuscript titled *Soul*

Wars and told James Panero, "When I'm talking about the soul to people, they look at me like I'm nuts. But there has been a longtime manipulation of people who want to make money to dumb down the American society and rob us of the curiosity of our souls."[21]

WHILE SALANDER MAY HAVE SEEN himself on a mission of salvation, his chosen route to rescue the soul was a curious one. Burdened by intense financial pressures to support his personal and professional lives, he embarked on a number of schemes to stay afloat—which would put all he built at risk.

One such scheme involved the art of the well-known American artist Stuart Davis, the Philadelphia-born early American Modernist whose paintings ranged from political pieces to street scenes and cafes. Davis was something of a prodigy, leaving high school to study at the Robert Henri School of Art in New York. At just 19 years of age, five of his works were exhibited at the 1913 Armory Show. His most famous work was perhaps his abstract *Egg Beater* series (1927), one piece of which sold for $254,000 at Christie's in 2008.[22] While Davis also taught at Yale and at New York's New School for Social Research, he remained a lifelong artist.[23] When he died in 1964, Davis left hundreds of works in his estate, the entirety of which he entrusted to his only child, Earl.

Earl, who devoted much of his life to his father's art, was a friend of Salander's, and the gallery owner convinced him that he could promote and sell the collection for him.[24] According to Earl, he agreed to entrust his friend with his father's works, but he didn't want all of the works to be sold, as they held a great sentimental value to him. Instead, Earl wanted to keep some of his late father's works in his own private collection, and therefore directed Salander to notify him prior to putting any of them up for sale. He insisted on having a say not only in which pieces could be sold, but also at which price

they should be offered. He and Salander entered into an agreement in which the gallery would take a 20 percent commission on the sales of paintings up to $1 million. For sales over $1 million, the commission would be 10 percent. A similar agreement existed for Stuart Davis's works on paper, with Salander earning a commission of 30 percent of sales up $20,000 and 20 percent of sales in excess of that figure.

In early 2005, Earl Davis requested that Salander prepare for him a full inventory of his father's works. Several weeks passed before Salander provided his friend with a response, stating that he had personally verified the location of all of the Davis works and that all was in order. Months later, Earl received the inventory he requested. Nevertheless, Earl instructed Salander to stop selling any of his father's works and to collect any pieces that were off-site so that they could be returned to him. Despite Earl's concerns over the collection, Salander convinced him to sell one painting, *Punchcard Flutter,* for $2,250,000 and 12 other works for $650,000 in two separate sales. Earl recalls Salander telling him the buyers would be paying "cash on the table."[25]

It was to be a profitable sale for the works. But it would also prove too good to be true. First, Salander told Earl that *Punchcard Flutter* was sold for $2,125,000—$125,000 less than agreed upon. Then he told Earl that although the paintings had been released to the buyers, no payment had been received. In the end, Earl never received payment for the works. Eventually, he learned that 96 of his father's works had been sold without Salander informing him, and that other pieces may have been "lost."

It was a devastating blow for Earl Davis, who considered Salander a friend and confidant whom he truly loved. But Salander's corrupt dealing with his friend was hardly his only indiscretion. Instead, it was just one anecdote in a massive Ponzi scheme involving paintings that would leave the jaws of art power brokers agape, not

only for its scope but for Salander's willingness to victimize those who considered him a close, trusted friend.

Like Earl Davis, John and Neelon Crawford were the children of a famous artist, the painter and photographer Ralston Crawford. Crawford's work was so respected by Salander that his gallery hosted an exhibition of his paintings in 2001 called *Ralston Crawford: A Retrospective*. The show's catalog described Crawford as a "major American artist," and the show exhibited his range, including not just his Abstract pictures, but some of his Precisionist works as well, including *Overseas Highway* (1939), which was based on the road leading from Key West, Florida, to the mainland. In 2007, Crawford's sons also asked for an inventory of their father's works, which had been entrusted to Salander. Unhappy with a lack of response from the art dealer, the men took more immediate action than had Earl Davis. John Crawford, himself an artist, jumped into his old Dodge pickup truck and drove it into the city. He walked into Salander-O'Reilly Gallery and took all of his father's paintings he could find, packed them into the truck, and left. Meanwhile, his brother Neelon was also being ignored by Salander. Made aware that some of his father's works were about to be sold, Neelon called the New York Police Department. He was directed to Detective Mark Fishstein, who, as part of his work on the Major Case Squad, serves as the NYPD's top art cop. Fishstein is one of only a handful of city police officers in the United States with expertise in art theft, forgery, and fraud, and he made a short phone call to Salander in which he minced no words. Salander, apparently aware of Fishstein's skill as an investigator, sent off the paintings to Neelon Crawford by the end of the week.[26]

SALANDER DIDN'T LIMIT HIS FRAUD to just pilfering from artists' estates that had been entrusted to him by selling works without notifying or properly compensating his clients. He also preyed on collectors who

had come to consider him more than just a kindred spirit; for some, he was like part of the family.

In 2004, Dr. Alexander Pearlman passed away at the age of 91. A lifelong lover of art, he would visit galleries in Manhattan weekly with his daughters and take in the work of a wide array of artists. After frequent trips to Salander's galleries, Pearlman, a physician from Queens, formed such a close bond with Salander that the two would regularly embrace upon meeting. The sometimes gruff Salander attended Pearlman's funeral and cried over the loss of his friend.

Throughout their lives, the doctor's daughters were protective of the art collection their father had assembled. It had become so valuable that his daughter Dr. Ellyn Shander remembers being instructed to tell her friends that the paintings were the work of her father in order to keep secret the fact that the artworks—including paintings by Modigliani, Manet, Cézanne, and Picasso—were worth about $2 million. As Pearlman approached the end of his life, he and his daughters discussed the future of his collection. His plan was clear and sensible: the paintings would be entrusted to his close friend Larry Salander for safekeeping.

After the funeral, Salander saw to it that each and every painting was properly inventoried, crated, and shipped to his establishment. Shander's mind was at ease; that is, until she heard word in 2007 of problems at Salander-O'Reilly Galleries. She made the trip into the city to see Salander in person, and instead of being greeted by the caring friend she had come to know, she was met with a refusal to see her. She was escorted from the gallery by a security guard. She would later learn that much of the precious collection had been sold, and the works that had not became embroiled in legal proceedings.[27]

Not even his celebrity friends were safe from Salander's scams. Robert DeNiro had entrusted Salander with his late father's paintings, with an agreement on a 50–50 split on any sales. Salander had

hosted exhibitions of Robert DeNiro Sr.'s works and the painter had chosen Salander as his dealer. The younger DeNiro would recall that Salander gave him "the impression he liked my father's art, he was enthusiastic."[28] While he may have liked it, Salander and his associate Leigh Morse sold $77,000 of it to San Francisco's Hackett-Freedman Gallery in 2007 without sharing the proceeds with DeNiro as agreed. Morse, a dealer in Salander's employ, was found to have wired money from the sale into her own personal bank account. Ultimately, De-Niro was able to retrieve the paintings at some expense after complex legal wrangling in U.S. Bankruptcy Court.[29] Morse was convicted of scheming to defraud in April 2011.[30]

WHEN IT CAME TO JOHN McENROE, Salander had an entirely different scam at work. This one involved selling one piece of art to multiple buyers. In 2004, the dealer convinced his good friend McEnroe to invest $2 million to buy half the interest in two paintings, *Pirates I* and *Pirates II,* by the Armenian American Abstract Expressionist art-ist Arshile Gorky. Salander told McEnroe that he would then flip the paintings and split the proceeds with the tennis great. But Salander only followed through on part of that plan. First, he sold the same half-interest in the paintings that he sold to McEnroe to another in-vestor, a banker named Morton Bender. And then Salander boldly took the fraud a step further, selling *Pirates II* to yet another buyer and pocketing the $2.5 million proceeds. Manhattan district attor-ney Robert Morgenthau put it well when he summed up the scheme: "Why sell it once when you can sell it three times?"[31] Ironically, Sa-lander had once been quoted as saying that "art is the human attempt to make one plus one equal more than two."[32] Clearly, he had taken his own philosophy too literally.

While it appears that Salander's frauds were motivated at least in part by the debts he accumulated while trying to become the father

of Renaissance art in the gallery world, he also fleeced the group that was formed to finance his purchases of that dream collection. Renaissance Art Investors was one of the biggest investors in Salander-O'Reilly Galleries and paid out $42 million for about 328 works of art from the Renaissance. RAI then consigned the works back to Salander to be marketed and sold. Yet RAI soon learned that Salander had misrepresented nearly all aspects of the investment, including the cost and source of the artwork. Salander told the investors he was buying the works from private dealers and estates primarily in Europe, when in fact many of the works were obtained from public auction houses in Europe and the United States. He also failed to report or turn over millions in proceeds from the RAI artworks. And finally, in order to cover his fraud, Salander provided RAI with forged and falsified documents ranging from invoices to inventories.[33]

News of Salander's scams spread quickly as more of his clients became aware that their artistic assets might be in jeopardy. Nevertheless, he remained defiant. When Maurice Katz learned that Salander had sold one of his paintings for $125,000 and didn't pay Katz as agreed, Katz contacted the *Maine Antique Digest,* a major industry journal read by a large number of important collectors. He also spread the word that he had been cheated by the art dealer. Salander contacted Katz directly by e-mail and was apoplectic. "[You] have referred to me as a 'crook' among other things in conversation with a senior officer at my bank. This person and others will testify to your slanderous remarks and your balance due in your Maurer of $15,000 will seem like a pittance to the damages that that will have been caused to my business and for which I will ask for damages as well as the amount of loss actually incurred as a result of your out of bounds, unfounded and outrageous remarks . . . You have made it more difficult to put food in the stomachs of my children and I am extremely angry about it." Ever portraying himself as the common

man, he added, "If you were enough of a person it would be much more rewarding for me and less expensive for you if we settled this matter the way men did in the old days (although it would be much more painful)."[34]

When he became aware of the scheme perpetrated by Salander, RAI's head, Donald Schupak, was a force to be reckoned with—and he was not one to be bullied. In 2007, with Salander's dream Caravaggio exhibition on the horizon and a steady stream of stories about trouble at Salander-O'Reilly Galleries in the media, Schupak kicked into action. Working to stop the exhibition from happening, he and his attorney filed a motion in the New York State Supreme Court to limit Salander's control. He even sent a private security firm to videotape all activity at the gallery and to search people as they left.[35]

With lawsuits mounting, negative press attention snowballing, and doubts about Salander's actions and judgment at their high point, Clovis Whitfield, the man who had Caravaggio's *Apollo the Lute Player*—the cornerstone of Salander's plans—was pushed to the brink. In a scene out of a Hollywood movie, Whitfield went to Salander-O'Reilly Gallery on the afternoon of the Caravaggio exhibition and informed Salander that he was pulling his prized painting from the gallery. Salander's exhibition—and his dreams—were dashed.

ALL OF THIS ACTIVITY CAUGHT the watchful eye of district attorney Robert Morgenthau's office, and on March 26, 2009, he announced the arrest of Larry Salander and a 100-count indictment for stealing $88 million from a bank, art owners, and investors—many of whom were friends and longtime associates—from 1994 through 2007. In all, the district attorney's office stated that Salander had defrauded 26 victims, stealing from them essentially in two ways: first, he sold artwork he didn't own and kept the proceeds; and second, he lured

clients to invest in fraudulent opportunities. It was discovered that in one case he had sold half interest in one painting to seven people. And through the court battles and prosecution that would ensue, the enormous debts that Salander had accumulated become public. They included a $15 million mortgage on his Manhattan brownstone after racking up nearly $500,000 in costs for a series of unpaid home renovations; a $1.2 million personal loan; $1.7 million in back rent due on his original gallery (which he was forced to close not long after opening the palatial gallery on East 71st Street); and nearly $55 million due for paintings and investments, including the Stuart Davis and RAI paintings.[36]

From a criminal prosecution perspective, the D.A.'s office had a mountain of evidence against Salander, and he, like so many scammers, knew he faced an opponent he could not beat. In 2010, with new district attorney Cyrus Vance in office, Salander pleaded guilty to stealing over $120 million from investors and art owners. Photos of Salander were splashed across newspapers and the internet, depicting a ruffled, beaten man. In his long statement to the court, Salander stated, "I've lost my life, my business and my reputation." He sobbed as he apologized to his victims and his family and added, "I'm utterly and completely disgraced."[37] The court, however, was in no mood for his contrition. Judge Michael Obus hit Salander with the maximum sentence allowable under his plea deal: 18 years in jail, with the opportunity for parole after six served. But that wasn't all Salander faced: he is also responsible for $114.9 million in restitution, and was embroiled in dozens of civil lawsuits as well as complex bankruptcy proceedings. Summing up the Salander affair, Manhattan assistant district attorney Kenn Kern said, "Lawrence Salander is a pathologically self-absorbed con man who betrays friends, investors, heirs and living artists." He added that Salander was engaged in "a Ponzi scheme that would make Bernie Madoff proud."[38]

Incredibly, RAI head Donald Schupak had also been personally impacted by Madoff's Ponzi scheme. Schupak's then 94-year-old mother and blind sister were left penniless by Madoff's audacious fraud.[39]

Rather than rescuing souls, Salander left widespread devastation in his wake. Making matters even messier, a bankruptcy ruling out of federal court in New York related to the case caused yet more consternation for an owner when it was decided that a painting owned by a private interest but in possession of Salander-O'Reilly could be sold by the bankrupt gallery to pay creditors. But the hurt extended far beyond just finances. Decades-long friends were shocked, even crushed, by Salander's betrayal, in what many have called New York's biggest-ever art fraud. Onlookers were left astounded that one man could turn on those who considered him not just a friend but a trusted member of their extended family. And he left many wondering how they could have been so wrong about a person. Perhaps the answer is in the words of Dr. Ellyn Shander: "He is a sly, manipulative sociopath, a con man with no *soul*."[40]

FOUR

THE TRUSTING ARTIST

ON A FEBRUARY AFTERNOON IN 2011 IN WASHINGTON, D.C., JASPER JOHNS sat still in his chair on the dais in the East Room of the White House alongside notables such as poet Maya Angelou, basketball legend Bill Russell, cellist Yo-Yo Ma, and billionaire investor and philanthropist Warren Buffett. Barack Obama had just placed the Presidential Medal of Freedom around the neck of one of his predecessors, George Herbert Walker Bush, to thunderous and sustained applause, when the emcee called Johns to the fore. The artist, smartly dressed in a dark suit and matching polka-dotted tie, rose from his seat and stood next to the blue podium bearing the presidential seal as Obama stood behind him holding the white-enamel, star-shaped medal that would soon be presented to him. Johns—the first painter or sculptor to be awarded the medal in 34 years—smiled as the emcee read aloud: "Bold and iconic, the work of Jasper Johns has left lasting impressions on countless Americans. With nontraditional materials and methods, he has explored themes of identity, perception, and patriotism. By asking us to reexamine the familiar, his work has sparked the minds of creative thinkers around the world. Jasper Johns' innovative

creations helped shape the pop, minimal and conceptual art movements, and the United States honors him for his profound influence on generations of artists."[1]

The awarding of the Medal of Freedom to Johns was certainly apt. His influence, especially on American artists, is profound, and his body of work is widely respected. And the reference to his exploration of the theme of patriotism was especially significant. In 1954, he painted his first American flag, and the star-spangled banner became the image with which the artist has become most commonly connected. "One night I dreamed that I painted a large American flag," he recalls, "and the next morning I got up and I went out and bought the materials to begin it." He came home with three canvases, plywood for mounting them, newspaper that he cut into strips, and encaustic paint. This choice in pigment gives the painting a texture that, coupled with the barely discernible strips of newsprint, begs for closer inspection by the viewer.[2]

The painting was completed at a time in Johns's career during which he was experimenting with universally recognizable symbols: flags, targets, numbers, and letters.[3] As Museum of Modern Art curator Anne Umland pointed out, the subject matter was not a statement of blind patriotism or allegiance, but it did carry political overtones: "Underneath the pigment are strips of collaged newspapers. And when you really begin to look at these you can see that there are dates that are recognizable [and] they allow us to locate this painting, this flag, this timeless symbol of our nation within a very particular context, the 1950s in America, which is right in the midst of the McCarthy era and the beginning of the Cold War, when symbols such as the flag would have had a very particular and potent valence."[4] Johns's own comment on the work supports Umland's theory. He has said of the painting's creation, "Well, it certainly wasn't out of patriotism. It was about something you see from out of the side of

your eye and you recognize it as what it is without really seeing it. It is the thing itself, but there's also something else there." However, he remains somewhat coy about the true meaning of the work. "I don't think I want to describe it. . . . It's probably shifted its meaning over time."[5] Perhaps most fittingly, the Whitney Museum of American Art describes it as a work that "flatters or honors the nation without genuflection."[6] The price tag for the work is undeniably high: a version of *Flag* offered at auction by Christie's in the fall of 2014 was listed with an estimate of $15–$20 million, or about $100,000 per square inch.[7]

Another *Flag*—this time a sculpture made in 1960 by Johns— led to an earlier connection between the artist and the White House in the 1960s, when gallery owner Leo Castelli, who gave Johns his first one-man show, brought then president John F. Kennedy the bronze on Independence Day. From Johns's view, the gesture wasn't consistent with his vision. "I thought it was the tackiest thing I'd ever seen," Johns recalled.[8] The misstep by Castelli did not damage the relationship between the pair. In fact, they would go on to forge a decades-long association.

CLEARLY, JASPER JOHNS'S CONNECTION to art depicting the American flag is as indelible as Edgar Degas's connection to ballerinas or Andy Warhol's to cans of Campbell's Soup. And regardless of the message of the painting, the image of the most iconic president of the twentieth century posing with one of his sculptures certainly did not hurt the value and importance of *Flag*.

The original 1960 sculpted metal version of *Flag* was given by Johns to his partner Robert Rauschenberg upon completion.[9] Then, in the early 1960s, Johns had bronze sculptures of the work made by taking a mold of the surface of his painting, pouring plaster into the mold, and then removing the plaster, leaving him with a positive of

the painting's surface. He gave the positive of the surface to a foundry where a process called sand casting was used to make copies. Johns had the foundry create four bronze sculptures of *Flag*.

The four sculptures went very separate ways. There was the one given to President Kennedy by Castelli, which remains in the possession of Caroline Kennedy Schlossberg, and Johns kept one himself. A third was acquired by financier and art collector Joseph Hirshhorn and is currently on display at the Hirshhorn Museum and Sculpture Garden in Washington, D.C.—one of the top modern art museums in the United States. The fourth resides with the Art Institute of Chicago thanks to a bequest of Katharine Kuh, the art critic, curator, and author who also owned the eponymous Chicago gallery where she supported a large number of emerging modern artists.

In the 1980s, Johns decided to make additional sculptures based on the original sculpted metal work he gave to Rauschenberg, and for this project he turned to Vanessa Hoheb. Hoheb grew up in her father's sculpture studio, beginning her formal apprenticeship when she was just 16. In those early years she gained experience working on pieces for Johns and other leading artists, including Willem de Kooning, Frederick Hart, and Isamu Noguchi. Perhaps most notably, at around the time Johns approached her, she was leading the five-member team charged with restoring the skin of the Statue of Liberty.[10] Hoheb's approach was "completely different," said Johns, because she used a negative mold in which metal was poured to make the positive. In the earlier sand casting process, the positive mold was pressed into earth and the earth filled with metal to make the sculpture.[11] One other thing about the Hoheb version that made it different from the earlier sculptures was the fact that hers included the frame that was around the original; earlier versions did not.

Johns's project was not complete with the Hoheb mold. He then took it to the Polich Tallix fine art foundry in upstate New York

around 1987 to make a silver cast of *Flag*. Polich Tallix has a long tradition of working with the who's who of artists, including de Kooning, Urs Fischer, Jeff Koons, Roy Lichtenstein, and Alexander Calder—the last sculptor to win the Presidential Medal of Freedom before Johns. Upon completion at Polich Tallix, Johns elected to keep the silver cast in his home in New York.

In 1990, Johns had more plans for *Flag*. This time he turned to Brian Ramnarine, an émigré from Guyana and a trusted artisan with whom he had worked a number of times before, to make a wax positive in his silver mold. Ramnarine, who operated Empire Bronze in New York and whose work was considered by Johns to be excellent, had handled casts for numerous of Johns's small sculptures in the past. Johns's instructions to Ramnarine were simple: he told him to make only a wax impression—not an actual metal sculpture—of *Flag*. At the time, Johns thought he might have his sculpture cast in gold, and wanted to investigate how much metal would be needed and how expensive it would be, thus the direction to Ramnarine to make only a wax figure. Ramnarine obliged and produced the 1 × 1½–foot wax sculpture, which Johns refrigerated in his home on upscale East 63rd Street in Manhattan. Though Johns paid him in full, in cash, Ramnarine failed to return the mold from which he made the wax sculpture. Eager to get his important original mold back, Johns directed a longtime member of his staff, James Meyer, to retrieve it from Ramnarine's foundry. Meyer came back empty-handed.

YEARS LATER, JASPER JOHNS PAID a visit to Paige Tooker at New Foundry New York Inc. and gave her the Ramnarine-made wax mold with a request to make a new cast of *Flag* in white bronze. While Tooker is certainly a very skilled craftsperson, Johns's reasons for not returning to Ramnarine with the wax mold he had made were based on

ethics rather than aesthetics. In the early 1990s, after Johns had completed his work with Ramnarine, he was approached by an individual claiming to own an original *Flag* sculpture and requesting that Johns authenticate it. At one point, the collector forwarded to Johns's office a letter he had received from Ramnarine that read in part: "This is to certify that the following bronze sculpture is the contribution by artist Jasper Johns to Brian Ramnarine *Flag* bronze by Jasper Johns. I, Brian Ramnarine, is giving [*sic*] this bronze sculpture to Sewdutt Harpul.[12] Please note this bronze sculpture cannot be sold or displayed in any gallery without the authorization of Brian Ramnarine. All profits sold from this sculpture is 50/50 [*sic*] between Brian Ramnarine and Harpul."[13] Ramnarine, who is alleged to be illiterate,[14] was the apparent author of this letter, which claims that Ramnarine was gifted an authentic copy *Flag* by Johns.

After numerous increasingly anxious letters from the collector, the sculpture in question was sent to Johns for his review. The artist immediately recognized that the piece's source was his work, but that he had no hand in completing it. Examining the back of the sculpture, he found that a copy of his signature was affixed to it. He found it much too neat to be his actual signature, which he typically drew into the wax mold and thus was not as smooth as what he observed on this piece. He also found markings on the back that he had ostensibly put there, but which in fact meant nothing to him in relation to this work or any other of his creations. Unhappy with the discovery of a clear forgery, he took it upon himself to cross out the fake signature on the back of the bronze.

Though the phony signature was enough to prove to Johns that the piece was a fake, there were other telltale signs, lest there be any doubt. "It's finished in a way that I would not have finished it," he would later say. "One detail is . . . that the frame is smooth along the

outer edges, whereas the original piece . . . more or less imitates wood with a rough grain. That's been polished off and removed."[15]

As a next step, Johns contacted the Art Dealers Association in New York seeking advice as how to proceed with the work. Finding them "extremely unhelpful," he sent the work back to the collector after writing in ink on the sculpture that it was not his work. Thus ended Johns's association with Brian Ramnarine.[16]

This wasn't the first time that Johns had encountered a counterfeit of one of his works. Art dealer Michael Findlay tells of an incident from 1969 when a friend showed him a large charcoal drawing of a coat hanger signed "J.Johns." Something about the drawing didn't seem right to Findlay, and he convinced the owner to allow him to show it to Johns. According to Findlay, "Wordlessly, Johns examined the work then asked if he could remove it from the frame. When he did, and turned it over, we could see that the back was softly scored in pencil horizontally and vertically. A soft 'Ahh' escaped from Johns. He explained that what we were looking at was the design for a mailer advertising one of his prints." The artist was puzzled. "What should I do?" he asked aloud. After a few seconds, Johns found a red pen and across the bottom of the drawing wrote "This is not my work" and signed it with a large and distinctive signature. In a way, Findlay said, it became a work signed by the artist.[17]

KENNY SCHARF IS AN AMERICAN modern artist who became a success working in New York in the 1980s. Scharf, a contemporary of Keith Haring and Jean-Michel Basquiat, came east from California inspired by the art of Andy Warhol, whom he would eventually meet and appear alongside in a group exhibition called *New York/New Wave*.[18] A painter and sculptor, his works have consistently sold in a range up to six figures at Christie's. In around 2000, Scharf created

an edition of four sculptures titled *Bird in Space,* a futuristic bronze piece measuring more than three feet tall by two feet wide and inspired by popular cartoons—a frequent theme for the artist. He chose Brian Ramnarine's Bronze Foundry and Gallery to cast this work and others because he considered Ramnarine "a great artisan" and had worked with him since 1995.[19]

Unfortunately, and unbeknownst to Scharf, Ramnarine took it upon himself to make additional copies of Scharf's work, each of them unauthorized. He then took the illegitimate sculptures and sold them to unsuspecting collectors for the same prices that Scharf's originals would fetch. Eventually, Scharf was informed by other artists that they had seen separate copies of his works bearing identical edition numbers. It was then that he began to suspect Ramnarine of forgery and confronted him with the information. Dissatisfied with the response he received from Ramnarine, Scharf directed his lawyer to contact the district attorney's office.[20]

Producing unauthorized sculptures using the methods of Brian Ramnarine presents an especially difficult scenario to the investigation and uncovering of forgery. Whereas in most cases involving forgeries of drawings and paintings the forger has no access to the actual artist's canvas, brushes, and paints, Ramnarine's copies involved the use of molds willingly handed over to him by the artist himself. So when he made additional copies of Scharf's work, the key difference between the real sculptures and the forged sculptures was merely the artist's authorization to produce the piece.

Take for example yet another victim of Ramnarine's during the early 2000s, the Brazilian-born sculptor Saint Clair Cemin. Cemin preferred that his sculptures be made using the lost wax process, in which a mold is made of a sculpture in rubber and plaster. The mold is then filled with wax, which takes the exact shape of the original sculpture. The wax is put into a ceramic that hardens, at which point

it is placed into an oven to vaporize the wax, leaving a ceramic shell whose cavity is filled with molten bronze. The ceramic is then broken, and the result is a bronze sculpture.

Cemin preferred to be very involved in the process of casting his bronze sculptures: inspecting the wax mold, choosing the metals, deciding which items to cast and when, and prescribing the exact number he wanted produced. This last part is key. "The more rare a piece is, the more valuable it is. Also, in my personal case I don't like to make too many of all a single piece. I don't think that is necessary or there is any value to it. It devalues the work."[21] As a last step, Cemin would oversee the application of the patina to the final work by the foundry.

In 1987, Cemin used Brian Ramnarine's foundry to cast some sculptures for him. Cemin was directly involved in the work, as was typically his wont. Once the work was complete, he had the sculptures made by Ramnarine transported to his studio or directly to galleries. Cemin would sometimes pay Ramnarine for his work by giving him sculptures, including his works *Zeno* and *Homage to Darwin*. During this period of collaboration, Cemin worked out of a small studio and lacked adequate space to store his molds, so he left them at Ramnarine's foundry until 1993, when Cemin moved to a larger studio.

Two years later, unhappy with the work Ramnarine did for an exhibition in Milan, Italy, Cemin broke ties with him. When he and an assistant went to Ramnarine's foundry to retrieve the molds that he had stored there, they found that some were missing. He approached Ramnarine, who explained that he was looking for them and might have lost or discarded them. Busy with many other projects, Cemin moved forward and gave the missing molds little further thought.

A few years later, despite the problems with the Milan exhibition, Cemin could not find a foundry whose work was as high quality as

Ramnarine's, and he reestablished a working relationship with the foundry. Apparently pleased this time with Ramnarine's work, Cemin gifted him two candleholders from a work he called *Tree of Light*. It seemed things were going well between Ramnarine and Cemin.

Meanwhile, things were not so grand for another popular sculptor who had also employed the work of Ramnarine. In the early 1990s, Robert Indiana, the legendary Pop artist, discovered that Ramnarine had sold unauthorized sculptures he falsely attributed to him. Indiana, best known for his widely recognizable and iconic sculpture of the word LOVE (in red with the LO stacked atop the VE), took immediate action, sending associates to Ramnarine's foundry where they seized any Indiana-related molds, sculptures, and casts.[22]

Then in the spring of 2001, Saint Clair Cemin's secretary received what seemed like troubling news. The two went to the home of collector Dr. Neil Kolsky, where the artist was shown sculptures that resembled his works, including *Lady and Lion, II* and *Chimera*. Cemin instantly recognized that these were unauthorized copies. "There was something strange about the patina that I didn't like," he recalled. "There was something strange about the finish. It was . . . too shiny. There was something that I wouldn't like—I didn't like. It made me very uneasy."[23] Further, he noticed that Dr. Kolsky's version of *Lady and Lion, II* bore the same number as the copy he had given to a collector in Mexico who he knew well. Cemin also discovered that Dr. Kolsky's two candleholders from *Tree of Light* were also fakes. All of the pieces came from molds that had been in the possession of Brian Ramnarine.

Clearly disturbed by what he found, Cemin gave Kolsky an original sculpture that he had brought with him in exchange for the forgeries. He packed the bad copies into his car, took them to his studio, and destroyed them. Some months later, Cemin found another unauthorized copy of one of his works—this time a table—in

Ramnarine's foundry. Upset by what he had discovered, he confronted Ramnarine, who, remarkably, told Cemin he could take the table home if he paid for the cost of making it. Cemin responded by smashing the table to pieces right there in the workshop and left.

As it turned out, Ramnarine had made a large number of unauthorized copies of Cemin's work, some of which the fraudster dated before Cemin even began sculpting, and this amounted to criminal acts that impacted the artist greatly. "When pieces appear on the market with duplicate numbers, false dates, wrong names, no provenance, completely different finish . . . it is devastating to me, to my career, and to my credibility," said Cemin. "I think the worst part is the misrepresentation of my work. I work very hard to have . . . pieces that correspond to my vision . . . I am a very well known artist and all of a sudden you have [a] minor gallery that sells the work for a very low price that doesn't correspond to the reality of my prices with the wrong name, wrong date, and the sculpture is not authorized." He added, "This is devastating for my profession."[24]

On October 10, 2002, based on information provided by lawyers for Kenny Scharf, Saint Clair Cemin, and others, Brian Ramnarine was indicted by a Queens grand jury and charged with defrauding two art collectors of $140,000 by selling them what were essentially worthless unauthorized copies of sculptures. Five months later he avoided time in jail by pleading guilty to the charges. The 48-year-old artisan was sentenced to five years probation and was ordered to pay $100,000 in restitution.

Ramnarine's reputation took another hit after his guilty plea. At the time of his sentencing, the *Queens Chronicle* reported, a pair of his former foundry employees came forward with claims that Ramnarine hadn't paid them fully for years and was deeply in debt. Joseph and Miro Krizek, who made mold castings for him for five years, claimed that their paychecks often bounced and that he had

borrowed tens of thousands of dollars from them. In all, the Krizeks claimed that Ramnarine owed them more than $80,000. "He's a tremendously mean person," Miro said. "He has absolutely no shame."[25] Ramnarine's subsequent behavior would prove her right.

A CRIMINAL CONVICTION FOR FRAUD based on the creation of forgeries should have ended Brian Ramnarine's career as an owner of a fine art foundry. "It's a golden rule," Kenny Scharf said. "If you ever want to work again, you just can't do that."[26] But Ramnarine went back to work not long after his term of probation had expired. And the work he chose was again the peddling of unauthorized sculptures by famous artists.

In 2010, with the memory of earning illicit income selling forged works apparently more enticing than the prospect of another indictment and conviction, Ramnarine endeavored to sell an unauthorized version of *Flag* by Jasper Johns. According to a federal indictment, this time he asked an associate to contact an auction house regarding what he said was a bronze *Flag* created in 1989. He also utilized several art brokers who were in frequent contact with an art collector who lived in the western United States. Ramnarine, whose motive in his prior frauds was alleged to be an effort to overcome his debts, was looking for a big score. His asking price for the purported bronze *Flag:* $10 million. With that sort of money on the table, the West Coast collector understandably raised questions about the provenance of the sculpture. In response, Ramnarine provided his broker with a fictitious letter dated August 23, 1989, stating that the sculpture was a gift from Johns to Ramnarine. Ultimately, Ramnarine showed the potential buyer's representative the sculpture. He even falsely stated that he had an ongoing relationship with Johns and could facilitate a meeting between the two. In fact, Johns stated that at the time he hadn't been in contact with Ramnarine in 20 years.[27]

As a result of his attempt to bilk the West Coast collector out of millions with a forged sculpture, Brian Ramnarine was indicted for fraud on November 14, 2012, this time by a federal grand jury. The next day, FBI agents arrested the foundry owner, now 58 years old, at his home in Queens. At his arraignment, Ramnarine pleaded not guilty to the charges and was granted bail by the federal magistrate. Incredibly, while out on bail, Ramnarine continued his criminal ways, undertaking efforts to defraud an online gallery located in Queens by selling them two fake sculptures—*Two* and *Orb*—that he fraudulently claimed were made and authorized by Robert Indiana. He also again sold fakes attributed to Saint Clair Cemin to the gallery. In all, he swindled his victim out of $30,000.[28]

In January 2014, his case went to trial in federal criminal court in the Southern District of New York, with the subsequent crimes involving the online gallery added to the charges against him. The trial quickly gained national headlines when it was revealed that Jasper Johns, arguably America's greatest living artist, was set to testify as a government witness. In a remarkable—if not surreal—day of testimony, Johns and Cemin both took the stand and testified at the Daniel Patrick Moynihan Courthouse in Manhattan. Cemin told of the wide-ranging fraud that Ramnarine had committed involving the unauthorized reproduction of his works. And later in the day, after his secretary Sarah Taggart had testified, Johns took the stand.

Johns is notoriously terse, and the prospect of hearing the octogenarian artist answer direct and cross-examination was a rare opportunity for those in the courtroom (federal trials are not televised). But if the defense was hoping that Johns's legendary laconic nature and his status as a contemporary artist might make him difficult to discern for a jury, their hopes were dashed when he took the stand. Johns described the process of making sculptures, his activity surrounding the iconic sculpture, and the way in which Ramnarine had

betrayed him in clear and understandable terms. When asked by a prosecutor if he had given Ramnarine the multimillion-dollar painting as a gift, Johns replied with a chuckle, "No."

Little more was needed to convince Ramnarine and his attorneys that their prospects were dim. Facing a maximum term of 80 years in prison (including 20 for the crimes he committed after his arrest), he pleaded guilty just days after Johns's testimony, admitting to three counts of fraud. As part of the plea deal, he also agreed not to challenge any sentence of ten years or less in prison administered by District Court judge John G. Koeltl. In their sentencing recommendation to the judge, prosecutors sought a severe sentence, departing from the opinion of federal probation recommendations and arguing that Ramnarine's pattern of behavior warranted stiff punishment. "Here, the defendant pled guilty on the fifth day of trial, only after six witnesses had powerfully testified against him," assistant United States attorney Daniel Tehrani wrote. Arguing against the prospect of Ramnarine receiving a lesser sentence because he pleaded guilty, Tehrani continued, "Because the defendant did not admit to his criminal conduct until after the Government had compellingly begun to prove its case (including presenting virtually all of the evidence of the Cemin fraud), [an] acceptance of responsibility reduction is not merited."[29]

BEFORE HIS GUILTY PLEA, Ramnarine and his attorneys gave indications to Judge Koeltl that they intended to introduce an argument involving one of Jasper Johns's assistants as part of their defense. That assistant, James Meyer, was the man who had originally and unsuccessfully attempted to retrieve the mold for *Flag* back in 1990. Incredibly, Meyer had appeared in federal district court related to the theft of Johns's works within just days of the artist's testimony in *US v. Ramnarine*. But Meyer's appearance was not related to Ramnarine's

crimes. Instead, he was also arrested by federal agents in an unrelated investigation for selling works by Jasper Johns that he claimed were gifts from the artist.

James Meyer is an artist in his own right, albeit not in the same stratosphere as Johns. He has received some critical acclaim for his work, much of which addresses perceptions of suburban America. His love of creating art extends back to his grade school days, and he has said that school was where he "saw that drawing was the only thing [he] did well."[30] Soon, he would be asked to create murals while still a student and would eventually move to Washington, D.C., as a young man to begin his career as a professional artist. By the early 1980s, however, he had moved back to New York, where he would occasionally see his paintings shown at local galleries.[31] At 22, he was earning $6 an hour selling copies of other artists' masterworks to restaurants.[32] But soon he would win praise for his paintings and ultimately saw his works included in the collections of the National Gallery of Art and the Whitney Museum of American Art. By 2014 his work would appear in more than 50 group shows.[33] Undoubtedly, his work under Jasper Johns had a great influence on his career and would prove to be the key to his rise in standing as an American artist.

Meyer describes himself as barely aware of the work of Jasper Johns when he knocked on the door to the artist's studio looking to apply for a job as an apprentice in July 1985. With the artist unavailable to greet him, he left his resume and slides of his work with an assistant of Johns's and went home, whereupon he discovered that he had no other copies of his resume to use for other applications. He returned to the studio with a request to make a copy of the materials he had left and, by happenstance, met Johns in person. The artist, apparently intrigued by Meyer, told him he could have the materials back after the two spoke for a bit. "Two hours later, he hired me,"

Meyer said. "[He] told me to come back the next day."[34] Meyer went on to serve Johns as one of his small, select group of studio assistants for more than a quarter of a century, becoming so trusted that he was given the responsibility of traveling to St. Martin every year to prepare Johns's home studio for his annual three-month stay on the French side of the island.[35]

Meyer's skill set benefited greatly from his exposure to the techniques and style of his mentor. But it was Johns's mental approach to his work that impacted him greatest. "Most important, however, Jasper has taught me to think about what I'm making before I make it." He has also professed his own love for using encaustic painting—the same technique Johns used in creating *Flag*—after being taught his mentor's method. "For a long time I didn't work in it out of respect for his medium," Meyer told Matthew Rose in a long interview in 2005.[36]

Meyer's so-called respect for Johns came into question in 2014 when he was arrested by the FBI after being indicted by a federal grand jury for selling 22 works he stole from Johns's studio. According to the indictment, Meyer perpetrated a six-year scheme to defraud Johns that ultimately netted him $3.4 million. Meyer's scam, the FBI found, involved a component that was now all-too-familiar to Johns: he claimed that the 22 works he removed from the studio were gifted to him by Johns. He then told both gallery owners and potential buyers this fiction, and produced phony provenance by creating fake pages from the official ledger book of authorized works kept by Jasper Johns to present to buyers. Ultimately, a Manhattan gallery sold the works for about $6.5 million.[37] In August 2014, Meyer pleaded guilty to a fraud charge before Judge J. Oetken.[38] The gallery, unnamed in the indictment, was not charged with a crime.

While federal prosecutors did not charge the gallery with a crime in the scheme, at least one party did not see them as innocent dupes

of Meyer's scam. On May 8, 2014, Frank Kolodny filed a civil suit against James Meyer as well as the gallery involved in the sale of Johns's art—which he named as Dorfman Projects LLC—in federal district court, alleging fraud and seeking compensatory damages. In his civil complaint, Kolodny claimed that Meyer stole the artworks from Jasper Johns's private studio and, "with the aid and assistance of the Dorfman defendants," sold him the purloined piece for $400,000. Kolodny's suit also claimed that the affidavits produced by Meyer authenticating the works were notarized by Fred Dorfman's wife.[39]

Kolodny's suit alleged that aspects of both Meyer's story and the art he was selling should have raised red flags to Dorfman, considering that Dorfman Projects had been in business for more than three decades and that proprietor Fred Dorfman is a respected specialist in twentieth-century art. For instance, Kolodny stated that it "defies credulity" that the gallery believed Meyer would have received "gifts" from Johns valued at $6.5 million. (As to why he as the buyer would believe that the works were gifted to Meyer, Kolodny points to information he received that Johns had given his longtime administrative assistant an original work as a wedding gift.) Further, none of the 22 works, created in the 1970s, had an exhibition history, which, Kolodny stated, was simply implausible. But perhaps the greatest concern should have been raised by conditions that Meyer insisted upon, said Kolodny. These included a demand that the sale of the works remain confidential and that they "not be re-sold, loaned, or exhibited during Johns' lifetime."[40]

The civil case notwithstanding, with the evidence against him overwhelming and indisputable in the criminal case, James Meyer pleaded guilty in federal court to theft charges in relation to the 22 works he stole from Jasper Johns.

AS THE CHAOS SURROUNDING ALLEGATIONS of criminal activity swirled around Jasper Johns, he prepared for a new exhibition at the Museum of Modern Art in New York. The exhibition bore a relevant and poignant title: *Jasper Johns: Regrets.* The title referred to the words he used to sign most of the pieces in the show, which consisted of two paintings, ten drawings, and two prints he produced—probably not coincidentally—contemporaneous to the height of the Ramnarine and Meyer affairs. According to MoMA, the title of Johns's exhibition "call[s] to mind a feeling of sadness or disappointment,"[41] emotions that undeniably the artist must have experienced firsthand upon learning of the stories of alleged multimillion-dollar gifts that he never really gave, made up by once-trusted associates.

The show features images based on a photograph of the artist Lucien Freud seated on a disheveled bed, his head in his hand in an image that screams of dejection. Interestingly, Freud too was a victim of art crime when his painting of his friend Francis Bacon was stolen in 1988 and not seen since (Freud himself designed a "Wanted" poster for the painting that was posted around Berlin in 2001). In a 2014 interview with *FT Magazine,* Johns was asked his thoughts on the apparent betrayal by his longtime assistant Meyer. "Certainly not a pleasure," he said in his typically understated manner. Referring perhaps to both the ongoing litigation and the distress he had to feel over what had occurred in the past years, he added, "But I can't talk about it. I don't want to talk about it. I don't want to define it in any way." Apparently closing the book on the matter, he avoided self-pity by alluding to the title of his exhibition and saying, "Regrets belong to everybody, don't they?"[42]

FIVE

THE INHERITOR

MANY LIBRARIES THROUGHOUT THE UNITED STATES HAVE ON THEIR WALLS and in their archives impressive art collections that are often overlooked by their patrons. And central branches of libraries serving major cities aside, it is often a guessing game as to which boast art that is of great cultural or historical significance and, therefore, high monetary value. Sometimes, wealthy benefactors bequeath prized pieces of their collections to a cherished library. Other times, an artist who is the town's favorite son or daughter might decide to donate some works to the library in order to make an indelible mark in his or her hometown's venerable institution. These works can range in value from pieces worth little more than the canvas they are painted on to millions of dollars. In Boston, Massachusetts, the great artist John Singer Sargent didn't merely donate some of his priceless works to the main branch of the Boston Public Library, he turned a portion of the building into a work of art all its own.

The main branch of the BPL, designed by noted architects McKim, Mean & White, is one of the last American buildings whose design was an attempt to mirror the great buildings of Europe both

architecturally and artistically. And it succeeded, in large measure because of the breathtaking murals contained within, including one of Sargent's greatest accomplishments, his *Triumph of Religion*. Though considered perhaps the greatest portrait artist of his era, Sargent embraced the opportunity provided to him by the trustees of the BPL to secure his place among the great artists by embarking on an ambitious project in a genre considered to be superior to portraiture—the mural.[1] Temporarily turning his back on portrait painting completely, he chose a challenging time to embark upon this test, starting his project for the BPL shortly after the completion of another work by perhaps the best muralist of his time, Pierre Puvis de Chavannes, whose *Muses of Inspiration Acclaim Genius, Messenger of Enlightenment* adorns the library's grand staircase. And another acclaimed artist, Sargent's friend Edwin Austin Abbey, also contributed to the mural projects at the BPL, completing his most famous painting, *The Quest for the Holy Grail,* after 11 years of work. Sargent's decision to dedicate himself to a significant mural made sense—already established as the nineteenth century's premiere portrait artist, he understood that, especially during his era, murals were the standard by which artists were measured. Monumental wall paintings in public buildings or churches were considered the key to enduring fame as a great artist, continuing a tradition that went back centuries to the time of Michelangelo, Raphael, Giotto, and others whose classic frescoes endure today as landmark artistic accomplishments.

Sargent's decision to tackle the BPL commission was a prudent one, and it went a long way toward solidifying his place in the annals of great artists. Of *Triumph of Religion,* art critic J. Walker McSpadden wrote in 1923 that the "foundation of Sargent's popular fame was laid in 1890, when he received a commission to decorate a hall in the Boston Public Library." He added that the work "carried the name of Sargent into every corner of the United States."[2]

Triumph of Religion is regarded as a multimedia masterpiece, enhanced by reliefs consisting of plaster, papier-mâché, metals, stencils, glass jewels, and gilded or painted commercial wall coverings.[3] The BPL would later come to describe Sargent Hall as "'an American Sistine Chapel enshrined within a place of learning' . . . the object of 'worship' here, however, was not the Christian deity of the 'original' Sistine Chapel in the Vatican, but rather the informed and enlightened subjectivity that education could produce."[4]

In the concluding phase of Sargent's work, the hall was at last transformed into what conservators would later describe as "a highly ornate expression of [Sargent's] distinctive aesthetic vision."[5] Rather than creating frescoes for his murals, Sargent employed the marouflage technique. This allowed him to complete his paintings in his studios in Britain rather than scaling up scaffolding and working in awkward positions. Upon completion, his murals would be rolled and shipped to the United States and affixed to the library's walls.[6]

A key component to this vision was the installation of gilded plaster moldings patterned after flowers, vines, leaves, dolphins, and shells. Just as his painted works were affixed to the walls by craftsmen, Sargent's motifs were designed and molded by the artist himself, but their casting and installation was entrusted by Sargent to his young assistant, Boston sculptor Joseph Coletti.[7]

Coletti was described as a "gifted and personable young man" who hailed from the working-class suburb of Quincy, Massachusetts.[8] He soon became a protégé of Sargent's, who by that time was already established as one of the leading artists of his era. Coletti so impressed Sargent while assisting him on his murals at the BPL that Sargent later not only got Coletti into Harvard, he also paid his tuition.[9]

Coletti's talents are on display throughout greater Boston, and at least one of his works has been viewed by untold millions of people.

Since 1934, every driver entering the east end of the Sumner Tunnel, which provides access under the Boston Harbor from Logan International Airport and into downtown, has seen the bronze relief Coletti created to honor the famous Massachusetts abolitionist senator Charles Sumner. More than 75 years later, Coletti's work still adorns the facade of the tunnel, depicting two angels, each holding an automobile in her hands. His talents are also on display along the famed Charles River Esplanade, where his bronze sculpture of David Ignatius Walsh—the first Irish Catholic to serve as a governor and, later, a senator from Massachusetts—stands in the area adjacent to the Hatch Shell, where each Independence Day the Boston Pops performs the nation's most venerable birthday concert. To be sure, Coletti's career was in no small measure launched by the influence, mentoring, and direct assistance he received from the estimable John Singer Sargent.

ON A SEASONABLY WARM Florida day in May 2010, David Wilson traveled to Pompano Beach, Florida, to meet Luigi Cugini, 68, an art connoisseur and the president and director of Art Forum, whose collection of paintings would be the envy of a small museum. Wilson, a jewelry broker with an affluent clientele, had become interested in branching out into the world of fine art, and when a few of his clients inquired about his ability to find for them valuable paintings with the same aplomb with which he acquired gems, he was eager to please. Through a mutual friend, Wilson made contact with Cugini and informed him that he was in the market for some high-end art by well-known artists.

The meeting went as well as Wilson could have hoped. Cugini shared with him a sampling of his art collection, the highlights of which included works by the famed Edwardian era painter John Singer Sargent. The jewelry-broker-cum-art-buyer could hardly

believe his eyes. Wilson asked if the works were authentic, and Cugini assured him they were all originals. In order to assuage Wilson's concerns, Cugini explained the provenance of his collection. Most of the collection, he explained, came from his grandfather, the Boston-area sculptor Joseph Coletti.

According to Cugini, his grandfather's relationship with Sargent was a key reason that he was able to accumulate such an impressive array of valuable art. Wilson was duly impressed with the provenance claimed by Cugini and the collection he had amassed. Clearly, here were the sorts of works his wealthy clients had in mind.

Wilson and Cugini would kick the relationship into high gear soon thereafter, a clear sign that Wilson was serious about making a deal. Just five days after their initial meeting, Wilson phoned Cugini at home to talk more about possible purchases. He wondered: Could these paintings by Sargent and other notable artists, including Picasso, be authentic? This wasn't like the jewelry business, where a true gem could quickly and easily be distinguished from a fake by an expert with a loupe. Authenticating a painting—especially an older one—is usually an incredibly painstaking process, and in many cases, the validity of works attributed to the likes of even Rembrandt remain in dispute indefinitely. Cugini allayed Wilson's concerns. Not only are they authentic, Cugini told him, but they came along with paperwork to prove so. Satisfied for the moment by the prospect of proper provenance, Wilson asked about the prices for some of the choice works. Cugini provided prices ranging up to $1,250,000. He told Wilson that a bank wire transfer would be the preferred method of payment for any works he purchased. With all of this amenable to Wilson, the two parties made plans to meet at Cugini's home the following week.

On June 8, 2010, Wilson again traveled to Pompano Beach and to the Cugini home. Together they examined some of the more

valuable pieces in the collection, and then Cugini put on the hard sell. He presented a painting depicting a portrait of a beautiful young brown-haired woman, her hair accentuated by a red flower that matched her full lips. "This," Cugini told Wilson, "is *A Venetian Woman*." To Wilson's untrained eye, the painting appeared to be the real deal. And lest Wilson have any remaining doubt, Cugini directed him to the upper left portion of the canvas, where an inscription bearing Sargent's signature read, "Dedicated to my friend Joseph Coletti." Cugini explained the close relationship that his grandfather, the famed sculptor Coletti, had with Sargent. Then there was the letter from Sotheby's, the famous international auction house, dated five years earlier and offering to consign the painting for sale with an asking price of $310,000. Cugini offered *A Venetian Woman* to Wilson for the bargain price of just $175,000.

The Sotheby's letter, dated May 10, 2005, was one of four letters Cugini produced from the fine art auctioneers with offers to consign his Sargents. There was also *Conversation (Emily Sargent and Friend)*, which they would consign for a sale price of $300,000 and which Cugini offered to Wilson for $140,000; *Emily Sargent and Eliza Wedgewood in Majorca*, painted by Sargent in 1908, which Sotheby's would offer to the public for $275,000 but could be had by Wilson for $170,000; and finally, *Judith Guatier* aka *A Gust of Wind*, which Sotheby's would sell on consignment for $350,000 but could be Wilson's for only $250,000. All of the Sotheby's letters addressed the issue of provenance, stating that the artworks once had been owned by Joseph Coletti. Excited by what Cugini had showed him, Wilson took detailed photographs of the four masterpieces. While snapping pictures, he noticed a number of other pieces that Cugini had stored in cardboard boxes, one of which showed that it had been shipped via UPS from a store in Waltham, Massachusetts: an unusually unsafe way to package and transport such highly valuable art. This caused

Wilson to take pause, but Cugini was the art pro. He must have known what he was doing.

Eager to do business, Wilson called the art dealer later that same day. He informed him that he had written up a sales contract and already mailed it to Cugini. The contract was for the purchase of three of the offered Sargent works: *A Venetian Woman, Conversation (Emily Sargent and Friend)*, and *Judith Guatier* at the agreed-upon price of $565,000—a savings of nearly $400,000 off the prices that Sotheby's prescribed for the works. The contract also spelled out the wire transfer method of payment that Cugini desired. Within days, Cugini received the contract in the mail and contacted Wilson to inform him that he had a deal. Cugini told him he would ship the items directly to Wilson and mail back the signed contract.

As promised, Cugini's signed contract arrived in David Wilson's post office box on July 17, 2010. In addition, Cugini included a detailed pamphlet about the art of John Singer Sargent, which displayed a number of the works in the possession of Cugini that were available for purchase. The pamphlet included a biography of Sargent, and incredibly, though Cugini had just earned over a half-million dollars, he failed to add sufficient postage to his mailing. Wilson's business partner Jason Richards put up the extra 25 cents for the envelope upon receipt.

With the signed contract in hand, but no money yet transferred, Wilson cautiously went to work seeking experts who could speak to the authenticity of the three paintings Cugini agreed to sell to him. Wilson and Richards brought the photos Wilson had taken of the art when he last visited Cugini's Pompano Beach home to the Adelson Galleries in New York. There, they met with Elizabeth Oustinoff, the galleries' director and a renowned expert on John Singer Sargent, in order to get an objective third-party opinion on Cugini's paintings. A half-million dollars was a big price tag for a first-time foray

into fine arts. But Wilson and Richards had good reason to feel some sense of surety, for the photographs of Cugini's proffered paintings were not the only things with which they were armed when they traveled to New York City for their meeting with Oustinoff. They were also carrying their standard-issue Glock semi-automatic handguns and their Federal Bureau of Investigation badges and credentials, both bearing the title "Special Agent."

IT IS NO SURPRISE that Luigi Cugini was on the FBI's radar, especially as someone who might be dealing in fraudulent art. Cugini, by trade a licensed barber, had a long history of complaints against him for misrepresenting artwork as originals by some of the world's most esteemed artists. Twenty-five years earlier, in 1985, Cugini was a defendant in a counterfeit art case in New York in which he and a co-defendant, Dr. Vilas Likhite, attempted to sell art that they allegedly represented as the works of such luminaries as Willem de Kooning, Jackson Pollock, and Hans Hoffman—artists whose paintings fetch many millions of dollars. Though that case was ultimately dismissed, by 2004 Cugini and Likhite were in hot water again, and the latter was arrested in California for selling art alleged to be counterfeit—a painting falsely attributed to the great Mary Cassatt—for $800,000 to undercover Los Angeles police officers.[10] It is believed that Cugini may have had a hand in acquiring the phony Cassatt.

Together, Cugini and Likhite formed a sort of dream team of art scammers. Likhite had moved to California after being convicted of selling fake art in Massachusetts in 1989, and in that same year he saw his medical license revoked for injecting experimental drugs into two patients.[11] According to the Los Angeles Police Department's Art Theft Detail, headed by legendary art theft detective Don Hrycyk, Likhite—a former Harvard professor—had claimed to be in possession of 700 pieces of art valued at $1 billion. Though Likhite claimed

that the works came from the estate of the late artist William Horace Littlefield in Massachusetts, the story proved to be "a fabrication."[12]

Littlefield was a Massachusetts-born, Harvard-educated artist with an eclectic style that favored Abstract Expressionism. However, he painted subjects ranging from pugilists in the boxing ring to classical murals. Of particular note, Littlefield at one time studied under the great Hans Hoffman (whose works Likhite claimed to own). A veteran of World War II, he tried unsuccessfully to join the American Commission for the Protection and Salvage of Artistic and Historic Monuments in Europe, commonly known as the Monuments Men. He returned home to Massachusetts after the war, and in 1946 converted an old barn on Cape Cod into a studio where he worked for most of the rest of his life. After his death in 1969, a Connecticut antiques dealer bought Littlefield's estate and sold off more than 3,000 of Littlefield's works, with none of them apparently fetching head-turning prices. A decade later, a large number of Littlefields were auctioned off by the estate of his friend Thomas G. Ratcliffe Jr., and yet another auction of his works was held in 1983 in Cambridge. Littlefield's paintings brought much less than the estimated values from the sparse crowd of buyers.[13] Sources believe that Cugini obtained a number of works from Littlefield's auctioned paintings and signed the names of famous artists on them. When Likhite was arrested, a number of the works seized from him and falsely attributed by the scammer to famous artists were thought to actually be works by Littlefield.[14]

Likhite's further claim that he also inherited some of the art from his father, who himself had allegedly obtained it from a maharajah in India, also proved to be false. Likhite, the LAPD reported, "used brokers to sell art to private parties and to invest money in his art collection. He avoided major auction houses and art dealers and preyed on people less knowledgeable about fine art. His art was accompanied

by official looking paperwork that gave the appearance that the art was professionally authenticated and appraised."[15] The scheme used by Likhite—developing elaborate stories of art obtained through late local artists and the presentation of official-looking documents to accompany the works—was neither unprecedented nor the product of particular ingenuity. But it did take nerve, and lots of it. And Likhite's level of audacity was so high as to eventually lead the CNBC television series *American Greed* to devote an entire segment of a February 2008 episode of the show to his bold exploits.[16]

In 2005, Luigi Cugini found himself in legal difficulty yet again, this time involving a Picasso drawing. The black-and-white sketch, titled *Personage Endormi et Femme Accroupie* (*Sleeping Person and Squatting Woman*), was sold by Cugini through Charles Locke, a Duluth, Georgia, art dealer who first learned of the purported Picasso via an e-mail from San Francisco art broker Henry Hernandez. A payment of $145,000, though, was intended to be held in escrow until a client of the buyer, Manhattan art dealer Chantal Park, accepted the work. That's where the deal fell apart. The client rejected the drawing based on its condition. Undeterred, Park decided to seek another buyer, but first sought authentication of the drawing by soliciting the opinion of no less than Picasso's own daughter by Marie-Therese Walter, Maya. Maya's appraisal allowed for no gray area. "You can be sure," she wrote, "that this *l'oeuvre* is not from my father's hand."[17]

Based on Maya's definitive thumbs-down, Park sought the return of her $145,000 from Locke and Cugini, but neither was willing to reimburse her (this despite the fact that prior to Maya's de-attribution, Cugini had offered to return $65,000 of his $110,000 share when the issue was merely the drawing's condition). Apparently, Cugini was willing to admit that the Picasso was in less-than-perfect condition but not that it wasn't authentic, even in the face of Maya Picasso's

assessment. As a result, Park filed a $5 million lawsuit in New York State Supreme Court against Cugini and the Duluth dealer, Locke. Park sought punitive damages beyond the original sale price because, as her attorney Malcom S. Taub stated, "it appears as if this is not an accident. When people engage in conduct that is wanton, the court can impose punitive damages to dissuade other parties as well as the particular defendants from engaging in that type of conduct." Taub added that the matter had been "referred to the FBI" as well.[18] In May 2009, the New York State Supreme Court found in favor of Park and against Cugini (and Locke) to the tune of $175,498.84.

Apparently unfazed by this experience and the complications of dealing in questionable Picassos, Cugini in 2010 entered into a trade with another individual later described by the FBI as a "confidential human source"—or CHS—who would obtain from Cugini a painting by the Dutch Master Peter Paul Rubens, *Susanna and the Elders,* plus $35,000 in cash in exchange for a watercolor purportedly by Picasso titled *Femme Et Arlequin au Bassin de Nenuphards.* Unbeknownst to Cugini, the services of Maya Picasso were again sought, and again, she declared Cugini's Picasso unauthentic.

The CHS then served as a broker for a buyer in Europe who was seeking to purchase a number of paintings from Cugini, including particularly valuable works by the French impressionist Henri Matisse. The total sale price: $28 million, $23 million of which Cugini wanted wired to a bank account in Italy. The broker obtained images of the Matisse works and sought the opinion of Wanda de Guebriant, who once served as an assistant to Matisse's daughter, Marguerite Duthuit, before becoming the Matisse family's official archivist. Small wonder she was described by *Forbes* magazine as being "designated the expert [on Matisse] by the person who, for years, was indisputably the expert."[19] The expert examined the works and informed the FBI that they were forgeries. Worse yet, they were

accompanied by paperwork forged to report that the paintings were authenticated by none other than Wanda de Guebriant herself! Just as incredibly, the very same works had been submitted for review to de Guebriant twice before: once by art collector Damien Roten after he had visited the United States specifically to view Cugini's purported Matisses, and once prior to that by a Gino Cugini (an alias used by Luigi) of Maynard, Massachusetts. Interestingly, "Gino" did not make reference to his grandfather Joseph Coletti when disclosing the known provenance of the works to the Archives Matisse.

WHEN SPECIAL AGENT RICHARDS met with Oustinoff in New York, he clearly had good reason to be deeply suspicious of Cugini's claims about his collection of valuable Sargent paintings. And as they did by working with Wanda de Guebriant, the FBI made a wise decision in choosing Oustinoff and the Adelson Galleries. Oustinoff is a member of the John Singer Sargent Committee, and the galleries she directs sponsor the John Singer Sargent Catalogue Raisonné, the comprehensive annotated compilation of all of Sargent's works. Agent Richards presented Oustinoff with photographs taken by Agent David Wilson of the Sargents Cugini was trying to sell to him. Using the catalogue raisonné, Oustinoff quickly identified the status of the actual, authentic paintings by Sargent that Cugini displayed to Agent Wilson. *Judith Guatier* was found to be number 77 in the catalogue raisonné. The painting depicts a dark-haired woman holding her large hat against the breeze as she walks against a blue sky and was listed as being held in a private collection and not in the possession of Cugini. Another work, *Under the Willows,* was not in the printed catalogue raisonné of Sargent's works . . . yet. Instead, the watercolor and pencil work was scheduled to be included in the next publication of the catalogue. And it wasn't in Cugini's possession. In fact, it was bequeathed by Raymond J. and Margaret Horowitz to

the Museum of Fine Arts in Houston, Texas, where it was hanging at that very moment.

As if these discrepancies weren't enough, the final blow to Cugini's claims about his Sargents was as definitive as the bureau could hope. *A Venetian Woman,* listed in the catalog under number 635 and the title *Head of a Young Woman* (with alternate titles including *Head of a Lady, A Spanish Gypsy, Marie-Genevieve Duhem,* and *Head of a Venetian Woman*), did include an inscription from Sargent. However, it was not "Dedicated to my friend Joseph Coletti." Instead, it read "a mon ami M. Van Haanen/John S. Sargent." To add a nail to the coffin, Oustinoff pointed out that the paintings listed in the Sargent catalogue raisonné had different dimensions than those shown by Cugini.

Richards showed Oustinoff the pamphlet that had been sent by Cugini to Wilson in the mail along with the signed contract, and she found striking similarities between it and an exhibition catalog prepared by the Tate Gallery in London. Richards then found that the chronology that Cugini prepared was practically identical to that of the book *John Singer Sargent* by Elaine Kilmurray and Richard Ormond, that is, except for a typo on Cugini's pamphlet that spelled "Gust" as "Gustl."[20]

Cugini's story was clearly bogus, and Richards sought to make an airtight case against him. He contacted Sotheby's and shared with them the May 10, 2005, letters that Cugini presented as Sotheby's offers to consign the Sargent paintings. Their American Paintings Department easily determined that the letters did not originate with their organization; in fact, the particular letterhead presented had been discontinued four years before the letters were allegedly written.

WITH ALL OF THE FACTS pointing to fraud on the part of Luigi Cugini regarding his claims about the Sargent paintings, the inevitable

question arose: Was he truly the grandson of sculptor Joseph Coletti? To answer this question, Richards sought out Coletti's only two children: Donatta Coletti Mechem and Miriam Dow. Mechem and Dow informed the FBI agent that Luigi Cugini was neither a grandson nor an heir to the late sculptor. And not only didn't Coletti have any Sargent paintings, he didn't collect paintings at all.

ON AUGUST 19, 2010, Luigi Cugini was arrested by the FBI at his home in Pompano Beach without incident. Cugini waived his Miranda rights and provided federal investigators with a complete confession. "He stated that the paintings were reproductions and that he knew that they were not original Sargent artworks," Agent Richards reported. Along with the arrest, the FBI seized more than 65 pieces of fraudulent art, including 47 fake Picassos, 18 phony Sargents, and single counterfeits falsely attributed to Renaissance master Raphael, Francis Bacon, Robert Henri, and Boldini. And finally, the FBI seized the legitimate *Susanna and the Elders* by Rubens that was obtained by Cugini in the trade for his fake Picasso.

Cugini appeared before a federal judge in West Palm Beach on August 23 and was charged with a single count of mail fraud. That single charge carried a maximum term of up to 20 years in prison. But despite a staggering history of involvement with scams and swindles exactly like the one the FBI sting operation exposed, the U.S. Attorney's Office for the Southern District of Florida agreed to recommend that Cugini receive a sentence reflecting a two-level reduction from the federal sentencing guidelines that matched his offense, provided that he accept "personal responsibility" for the crime to which he had pleaded guilty. Cugini's full confession at the time of his arrest had made this a sure thing. So, on January 27, 2011, Federal District Court judge Kenneth L. Ryskamp ordered him committed to the custody of the U.S. Bureau of Prisons for a term of 27

months. Further, in order to allow Cugini to stay in his local area instead of being sent to a distant federal institution, Judge Ryskamp recommended that the Prison Bureau place Cugini in a facility in South Florida, preferably under "maximum home confinement" or in a halfway house—hardly a serious statement by the federal government that Cugini's pattern of behavior was intolerable.

Cugini, perhaps heartened by the leniency shown to him by the court, tested the goodwill of the federal government once again. On September 21, 2012, he filed a pro se motion for the government for the return of the art seized from his home at the time of his arrest. "The government," he complained, "returned only some of the property that was seized from me whereas, I want the remaining items returned as well. Below is the list of the items the government has failed to return to me."[21] In an attachment to his motion, Cugini clarified that "only" 60 paintings had been returned to him. He signed his filing, "God Bless You, Luigi Cugini."[22] His list of paintings that he wanted returned was voluminous, and even included a few photographs of works by Henri, Bacon, and Boldini that included Cugini's handwritten notation "Important Artist." The court would hear none of it, with Judge Ryskamp ruling less than a month later that the "motion for return of seized property is denied as moot. The government has returned the property that the defendant is entitled to receive."[23] Judge Ryskamp agreed with the prosecution's assertion that the rest of the art had been used as instrumentalities of Cugini's criminal activity.

ON SEPTEMBER 9, 2013, Luigi Cugini filed a motion with the U.S. District Court for the Southern District of Florida seeking an early termination of his supervised release. Apparently forgetting his long involvement in the trafficking of fraudulent art, he cited Title 18 of the U.S. Code, Section 3553, which refers to the conduct of the

defendant and the "nature and circumstances of the offense and the history and characteristics of the defendant." He argued, "Petitioner behavior since release has generally been productive and positive . . . and he has not been in any incidents/violations of the law."[24] How long Cugini will go before he tries to sell another misattributed work of art is anyone's guess. But it's safe to say that the FBI will be watching closely.

SIX

THE CAPTOR

AS YOUNG POSTDOCTORAL STUDENTS IN EUROPE, HARRY AND RUTH BAK-
win were as devoted to their studies and to each other as their
colleagues were to the quaint restaurants and pubs of their neighbor-
hood—and it showed. The pair would go on to become accomplished
and well-published pediatricians, and thanks to the time they spent
together visiting galleries and museums viewing and learning about
art, they amassed one of the most respected collections of paintings
in the United States.

In 1929, the Drs. Bakwin traveled with their four children on
their annual trip to Europe and ultimately made their way to Swit-
zerland. The couple, still in the nascent stages of their lifelong love
of collecting, visited the Galerie Thannhauser in Lucerne, where
they made a significant purchase: Vincent van Gogh's *L'Arlésienne,
Madame Ginoux*.[1] The painting is an essential work in the Dutch
painter's oeuvre, completed as Van Gogh convalesced from one of
his many struggles with mental illness at the asylum in Saint-Remy,
near Arles, during a period considered to be the zenith of the artist's
creativity.[2] It was one of the six existing Van Gogh portraits of the

cafe-owning Ginoux that was privately held, with the others hanging in some of the world's most notable museums, including the Metropolitan Museum of Art in New York and the Musée d'Orsay in Paris. *L'Arlésienne, Madame Ginoux* was one of the more important pieces of the more than 100 paintings and sculptures collected throughout the Bakwins' lifetimes, in what would become one of America's best collections of Impressionist and Post-Impressionist art.

Throughout their lives, the Bakwins' children would each develop an affinity for certain pieces of their parents' collection, and Harry and Ruth saw to it that at the time of their respective deaths, each child would inherit a painting of their choice. For the couple's eldest son the decision was easy. In 1987, upon his beloved mother's passing, Edward Bakwin chose the Van Gogh from the collection that had come to include works by Picasso, Cézanne, Matisse, Gaugin, and many others. Less than 20 years later, however, Edward would make a decision that came with much more difficulty. He chose to sell the Van Gogh at an auction on May 2, 2006, through the famed auction house Christie's in New York City. Though the painting would fetch Edward more than $40 million, it wasn't money that motivated him, it was fear. "It was a very major decision of mine to sell it," he said. "The risk of damage of any kind or robbery just felt a little too high. Much as I would have loved to continue holding it, it seemed to me too important to have hanging in a modest apartment in Chicago."[3]

This fear was grounded in personal experience. Edward Bakwin had only to look to his own family to find good reason to worry that his painting could be targeted by thieves. In 1976, Edward's younger brother Michael made his own selection from his parents' collection. He, too, made what he felt was an easy choice, selecting Paul Cézanne's *Bouilloire et Fruits* (*Pitcher and Fruit*). Michael Bakwin was not alone in his appreciation of the Cubist masterpiece. No less an

expert on the medium than Pablo Picasso himself (whom the Bakwins met during their travels) called the painting one of the greatest pictures ever painted.[4] Michael proudly and lovingly displayed the painting in the dining room in his home in Stockbridge, Massachusetts. There it hung, the crowning piece of his collection of paintings that made for one of the greatest displays of art in all the Berkshires, a region rich in great art and scenic majesty. That's no small claim: the pastoral area lays claim to some of the nation's best college museums and was the home of the great sculptor Daniel Chester French (whose most notable work was the Lincoln Memorial) and the twentieth-century American master Norman Rockwell. Rockwell, whose museum is located in Stockbridge, moved to the region in 1953 and left an indelible mark on the Berkshires, just as the Berkshires left its own on his works. His famous images bear the region's unmistakable New England essence, and the people of Stockbridge and the surrounding area served as models for many of his works.

So to say that Cézanne's *Bouilloire et Fruits* was perhaps the most valuable painting in Stockbridge truly meant something. That distinction came with good reason, for it is one of the great examples of his play with dimension and planes that so influenced the Cubist movement. At any moment, it seems, the fruit on the table in Cézanne's painting might roll off. Yet it transfixes the viewer, just as the artist knew it would. "I will astonish Paris with an apple!" Cézanne famously foretold, and that he did. Though in his own lifetime he was denied the acceptance from the Salon in Paris—the official art exhibition of the Fine Arts Academy—that he deeply craved, his legacy is that of the leading forefather of Impressionism. The English literary master D. H. Lawrence called Cézanne "the most interesting figure in modern art, and the only really interesting figure." For Lawrence, it was Cézanne's constant struggle with the establishment that made him such an important figure, and he pointed to Cézanne's

portrayal of fruit—as in Michael Bakwin's painting—as the key to his victory. "Cézanne's apple is a great deal," he wrote, "more than Plato's Idea. Cézanne's apple rolled the stone from the mouth of the tomb."[5] Of his influence on the movement that he would inspire, the great Pablo Picasso called Cézanne "the father of us all."[6] And here in tiny Stockbridge, Massachusetts, this seminal work hung along with others in Michael Bakwin's multimillion-dollar collection, secured only by a rarely locked door.

IN MAY 1978, Michael Bakwin, his wife Doris, and her two children packed their car and traveled to Ossining, New York, for a Memorial Day visit to his parents' home. Though they were known to travel often and at a moment's notice, this particular trip was a welcome getaway for rest and relaxation before the busy summer months would bring tourists to the Avalock Inn, a small resort bought and operated by Michael Bakwin after a number of years working in the world of hotel and restaurant consulting.

When the Bakwins returned home at about 5:30 p.m. Monday night, they weren't looking for any signs of trouble. After all, Stockbridge was a place where people rarely bothered to lock their doors and where crime was something folks could read about if they chose to peruse the *Boston Herald American*, the tabloid in the big city to the east; but it was rarely found in the *Berkshire Eagle*. Michael and Doris noticed nothing unusual when they turned in for the night after the long drive home. There was no mess, nothing ransacked, nothing broken. There were no signs that anyone had forced their way into the home. The next day, the couple set about making their appointed rounds, with Doris returning home first that Tuesday afternoon. Opening a sliding door that led into the dining room, she found the walls bare. Seven of her husband's treasured paintings were gone, and the only evidence they had ever been there was a lonely,

empty frame on the floor that had held the famous Cézanne. This was long before the era of the cell phone, and Doris frantically tried to reach her husband. Unable to locate him, she phoned the local chief of police and reported the crime. Upon arrival at the scene, the officers also noted an absence of signs of forced entry. The Bakwins could not recall whether or not they had locked the house when they left. They did note, however, that the spare key they often left beneath a ceramic frog in the yard was not present.[7]

Michael Bakwin remembers that he "sort of went into shock" upon arriving home. Virtually incapacitated by what he saw, Doris took control of the scene, dealing with the Stockbridge police, who were eventually joined by the Massachusetts State Police and, later, the Federal Bureau of Investigation.[8] This show of force at the crime scene was fully warranted: the haul by the thieves from the Bakwin home amounted to the largest-scale home break-in in the history of the Commonwealth of Massachusetts. In addition to the Cézanne, six other works were taken: *Portrait of a Young Man* and *Girl in a Red Robe,* both by Chaim Soutine; *Flowers* by Maurice Vlaminck; *The Red House* by Maurice Utrillo; and *Boy in the Red Shirt* and *Head of a Woman* by Jean Jansem. Of the lot, only the two Soutines and the Vlaminck were insured by Bakwin, and for a meager $47,000 at that. "Unfortunately, insuring paintings is extremely expensive," he would later say, "and I was just a little bit too cheap to do so, and didn't think anything would happen to them."[9]

WHEN AN ART THEFT OCCURS, motives are frequently either missed or misconstrued. Often, investigators tell the media that the crime was surely the work of professional art thieves, especially when police learn that the pieces stolen are of extraordinarily high values. In fact, high-value paintings are rarely stolen by crooks that can be characterized as professional art thieves. The reason for this is simple: highly

valuable and recognizable masterpieces—like Cézanne's *Bouilloire et Fruits*—are exceptionally difficult to fence. As a result, thieves who pilfer such works eventually learn the folly of their ways and turn their nefarious inclinations toward targets that are easier to unload. Masterworks are most often stolen by shortsighted first-timers who are certain they can sell their ill-gotten gains, only to learn that there are no buyers willing to fork over hundreds of thousands of dollars—or more—for something they can never show anyone. History is bereft of the oft-imagined evil billionaire sitting in his private viewing room with a stolen piece of art meant never to be shown to another living person. Such is the fodder of Hollywood scripts, not true crime. In reality, it's almost impossible to find a buyer for highly valuable stolen art. And for thieves that's a hard thing to accept. After all, if you're holding a few million in stolen art (or at least that's what the newspapers are saying) and you are accustomed to getting ten cents on the dollar for your stolen goods, it's got to be difficult to walk away empty-handed with dreams of riches dancing in your mind.

So despite the strong interest in the crime from investigators at the local, state, and federal levels, the prospects of capturing the thief or thieves and returning Michael Bakwin's treasured paintings to him were anyone's guess. To be sure, Bakwin took his own steps to try to recover his art: he hired a lawyer and together they decided to post a reward of $25,000 for the return of the paintings in local newspapers; he contacted the International Foundation for Art Research in New York to provide them with records of the theft in case the paintings surfaced in a sale; he worked to spread the word of the theft by contacting auction houses and art galleries; and, later, he hired a private investigator to help recover his items. All of his efforts were to no avail.

Sometime after the theft, there was a glimmer of hope for a recovery. The Bakwins received three phone calls from an individual who spoke of recovering the Cézanne for a fee. While it's not uncommon for a person posting a large reward to be contacted by cranks and con men, the caller was able to provide bona fides, describing stickers from Europe on the reverse of the Cézanne that appeared to be accurate. However, there was a problem. "The trouble was that the people who stole the paintings didn't know what they had stolen. They got a little bit nervous," Michael Bakwin said.[10] Though the caller eventually produced nothing, a mention was made of an individual identified only as "David." This would prove important when a suspect in the crime emerged by that same first name.[11]

DAVID T. COLVIN WAS NO STRANGER to trouble, and he was in it again—deep. He had lost $1,500 in a card game to an associate named Arthur Samson, who, after waiting a year and a half for Colvin to pay up, had run out of patience. Late in the evening of February 12, 1979, Samson, accompanied by Brian Matchett, a local legend with martial arts expertise and a license to carry a firearm, traveled to Colvin's home in Pittsfield, Massachusetts, to collect his long-awaited winnings. The next morning, the pair met with Colvin in his home. Shortly after entering, an altercation ensued in which Matchett shot the hulking six foot four, 300-pound Colvin with the two .38 caliber hollow-point bullets that would ultimately kill him. According to the shooter, as Colvin lay bleeding he told him, "It doesn't matter, I want to die anyways."[12]

Some time after Colvin met his violent end, his attorney, Robert M. Mardirosian of Watertown, was in the attic of a property he owned across the street from his law offices. There he found a treasure worth millions: Michael Bakwin's paintings. Mardirosian must

have known what they were immediately. Shortly before his death, Colvin visited Mardirosian to discuss federal firearms charges he was facing, and during that meeting Colvin showed his lawyer the paintings he had taken. Mardirosian talked Colvin out of taking the art to Florida where he thought he could fence it, and the thief held on to the works. Rather than make the trek all the way back to Pittsfield, which was closer to Albany than it was to Boston, Colvin asked Mardirosian if he had a place he could crash for the night. Mardirosian offered him his attic next door. And it was there that Colvin left his bounty.

There's a pattern that seems to emerge when highly valuable, highly recognizable art is stolen: hot masterpieces are either recovered very quickly because of snitches, hard-working investigators, and lucky breaks, or they turn up after a generation or so has passed, after the scariest member of the thieving gang has passed on or lost his fearsomeness and all involved have finally come to the realization that despite their best efforts, they simply cannot monetize their stolen art. Left with no options, the art is eventually returned. Here, in the hands of attorney Robert Mardirosian, Michael Bakwin's paintings were at the crossroads of a quick recovery or being unseen for decades.

Mardirosian clearly understood the importance of what he had found. In fact, he was uniquely positioned to understand the paintings' value both in terms of money and culture. Like Cézanne, Mardirosian's avocation in the law could not suppress his love for art, and Impressionism in particular. In fact, in 1989 the attorney would eventually leave his law practice to become a full-time artist, using the name "Romard" to sign his works. "I understand color. I can make it sing for me . . . I'm not painting the subject, I'm painting the emotion that the subject evokes in me," he would say of his technique. He counted among his influences Picasso, Van Gogh, Miró, and, of course, Cézanne.[13]

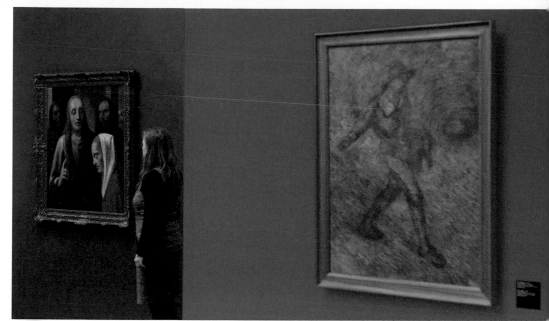

A woman looks at a painting by forger Han van Meegeren, which he sold as Jan Vermeer's painting Christ and the Adultress. *Also pictured is a forgery of Vincent van Gogh's painting* The Sower *by Leonhard Wackerforger at a 2014 exhibition of fakes at Moritzburg art museum in Germany.*

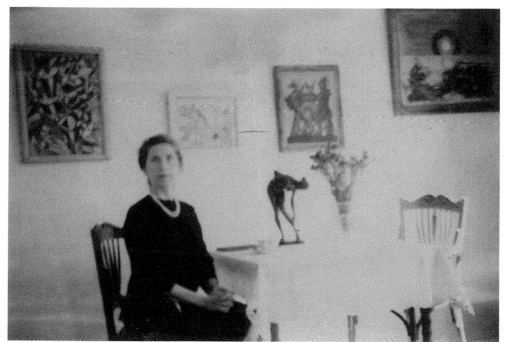

Wolfgang Beltracchi's wife Helene poses as her own grandmother in front of forged paintings. At left is an artwork supposedly by Ferdinand Leger, unidentified paintings in the middle, and at right, Tremblement de Terre *supposedly by Max Ernst. The couple staged this old family photograph as a back story for the forged paintings to prove their authenticity.*

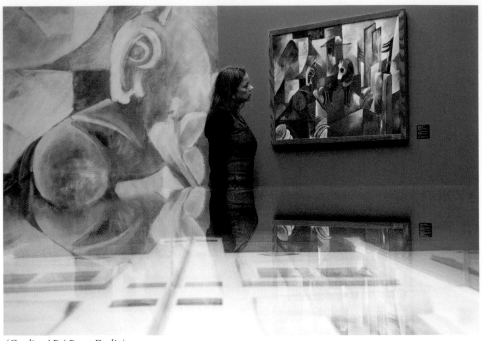

A woman studies the forgery Zwei rote Pferde in der Landschaf *(Two Red Horses in Landscape), which was created in the style of artist Heinrich Campendonk by forger Wolfgang Beltracchi.*

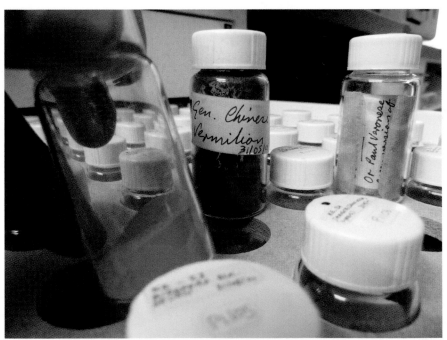

The pigment collection of Dr. Nicholas Eastaugh and Dr. Jilleen Nadolny of Art Analysis & Research. The collection is comprised of over 3,000 provenanced samples. Eastaugh's technical investigations of Beltracchi's work uncovered his fraud, and the pair has performed analyses of a number of the forger's other works.

German art forger Wolfgang Beltracchi.

Ann Freedman, gallerist and former president of the now defunct Knoedler & Company, September 2014.

An encaustic Stars and Stripes painting entitled Flag, *made between 1960–1966 by U.S. artist Jasper Johns.*

Lawrence Salander, center, leaves New York Supreme Court with his son Jonah, right, and his attorney Charles Ross in New York. Salander pleaded guilty to 29 counts of grand larceny and fraud and was sentenced to 6 to 18 years in prison.

Former New York foundry owner Brian Ramnarine leaves federal court in Manhattan after he was sentenced to 30 months in prison for trying to sell phony knockoffs of a sculpture of Jasper Johns' Flag painting. Ramnarine had done work for Johns in the past, including casting a sculpture of Johns' classic 1960 Flag painting.

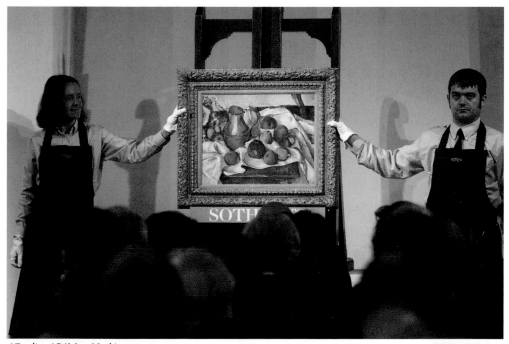

Michael Bakwin's Bouilloire et Fruits, *painted by French impressionist Paul Cézanne, sells at a 1999 Sotheby's auction in London for $29 million.*

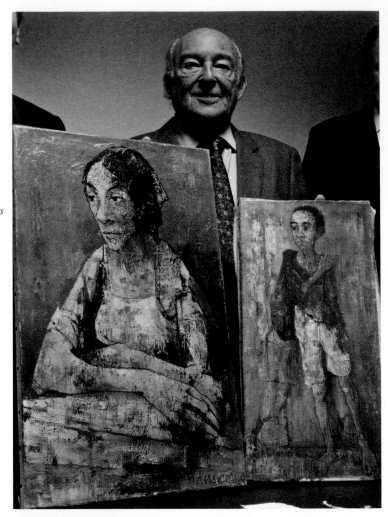

(Credit: AP / Charles Krupa)

Michael Bakwin holds up two paintings that were returned to him at the U.S. Attorney's office in Boston in 2010. The two oil paintings by Jean Jansem were stolen from Bakwin and were returned following the 2008 trial of Robert Mardirosian. Bakwin had not seen the paintings since the 1978 theft.

(Credit: U.S. Department of Justice)

A fake of Picasso's La Femme au Chapeau Bleu (The Woman in the Blue Hat), *unwittingly created by a trompe l'oeil artist for dealer Tatiana Khan. Khan told the artist it was needed to aid the police, then attempted to pass it off as an authentic Picasso.*

But despite his close familiarity with the sort of art he had found in his attic and exactly how it was procured, Mardirosian failed to return the paintings to their rightful owner in Stockbridge, betraying his responsibility as an attorney and officer of the court. Instead, he worked diligently to find a way to do the impossible: take well-known, high-priced, and stolen paintings and turn a profit with them. Thus, his was a unique sort of art scam: the art was legitimate, but his decades-long, illicit affair with it was anything but.

Clearly, this was an unethical and unconventional choice, but Mardirosian was no stranger to unorthodox ploys. In what was probably his most newsworthy criminal defense argument, he attempted to get a client—a gardener—cleared of a first-degree murder charge by arguing that the murderer was under the influence of the pesticides he had been mixing. It was the mixture that led the man to strangle his victim, Mardirosian argued in court. The jury saw past his claims and returned a guilty verdict.[14]

While that argument might have been outlandish, making a desperate argument in order to clear a client is nothing new for a defense attorney. Attempting to monetize a deceased criminal client's stolen goods, however, is. But off went Robert Mardirosian on a trek that would span more than a quarter century and two continents.

TWO DECADES WOULD PASS without Michael Bakwin hearing a word about his stolen treasures. With no new leads, no signs of life, no reason for hope, the idea that he'd ever again see his paintings, especially his precious Cézanne, had faded from his daily thoughts. Then, in 1999, things took a sudden and dramatic turn. On the other side of the Atlantic, Lloyds Insurance Company, the underwriter for the storied insurer Lloyds of London, rang the offices of the Art Loss Register with an inquiry about a number of paintings that were set to be shipped to London from Russia. Intrigued by the inquiry, the staff

went to work researching the paintings to determine whether or not they were stolen. This was the work Julian Radcliffe, the organization's founder, formed the ALR to do.

Radcliffe, himself a former Lloyds employee who had worked for Britain's security service MI5, started a firm called Control Risks in 1975 to provide guidance to governments, corporations, and families dealing with extortion attempts and negotiations related to kidnappings throughout the world. Then, in 1986, Radcliffe was asked to examine the feasibility of forming a separate company to deal with the problem of stolen art. There certainly exists a bustling market: the Federal Bureau of Investigation calls art theft "a looming criminal enterprise with estimated losses in the billions of dollars annually."[15] Radcliffe worked with the major auction houses, art dealers, and police from a number of countries and identified a need for a database of stolen art that could be used to vet art sales and auctions. To start such a database, Radcliffe turned to the International Foundation for Art Research in New York—the very same organization to whom Michael Bakwin had reported his stolen paintings in 1978. IFAR had already started a database of its own years earlier, but lacked the resources to grow the database and staff it to the point that it could serve the international market. Radcliffe cut a deal: IFAR would turn over its database to the ALR in return for a share holding of the new company. And thus a powerhouse in the fight against the illicit trade in stolen art was born. By 2008, the ALR would grow to 30 employees working with a database holding nearly 200,000 stolen works of art from around the world and conducting around 400,000 searches per year.[16]

Radcliffe's team quickly came back with its findings: the paintings submitted by Lloyds were indeed stolen, and they were taken from the home of Michael Bakwin in 1978. This wasn't the ALR's first encounter with Bakwin: in the early 1990s, a Cézanne similar

to the one stolen from Bakwin was put up for auction, and while performing its due diligence, the ALR contacted him to ensure that they had not come upon his *Bouilloire et Fruits*. But now, in 1999, it was certain that Bakwin's Cézanne and his other paintings were on the market.

Radcliffe asked his associates to put him in touch with the man seeking insurance on the paintings that were awaiting transport, and then notified the FBI and British authorities. Next, the ALR contacted Michael Bakwin to advise him of this much stronger lead. Seeing an opportunity to recover his beloved paintings, Bakwin entered into what Radcliffe described as a "standard recovery contract" and chose to pay the ALR on a contingency basis. The ALR didn't come cheap: the contingency plan called for Bakwin to pay the firm 15 percent of the first $75,000 of value of the art plus 10 percent of any value above that figure. Such an agreement would mean, for instance, that if the ALR returned, say, just $1 million worth of art to Bakwin, he would in turn owe the ALR $103,750. This, of course, far exceeded the $25,000 reward Bakwin had offered for a brief period shortly after the theft more than 20 years earlier. But he figured the gambit was worth it.

With a signed agreement in hand, the ALR went right to work. ALR contacted Scotland Yard, but because it didn't appear that a crime had occurred on British soil, they referred the ALR to the FBI. After being briefed on what the ALR had found to date, the bureau recommended that they try to learn more about the individual who sought to insure the stolen paintings through Lloyds. Lloyds obliged and provided the ALR with the individual's identity: Tony Westbrook. Soon enough, Radcliffe and a trusted deputy, Sarah Jackson, arranged to meet with Westbrook near the offices of Lloyds.

The trio sat in the London restaurant, discussing the art in question, where Westbrook revealed that he had been asked to sell the

paintings in question and thus sought to bring them to London from Russia to have them appraised. Westbrook provided Radcliffe and Jackson with an odd story as to how he became involved with the paintings—he had registered in a hotel listing himself as an "architect," which was somehow translated to mean "art expert," and based on this, he alleged, he was asked to help with the sale of highly valuable paintings.

Radcliffe informed Westbrook that the paintings were run through the ALR database and determined to be stolen. This led to a series of meetings and telephone conversations between the parties. Westbrook inquired about a reward or payment for the stolen art. "I explained that no payment or reward could be made unless we were told who was holding the pictures and how they got them," Radcliffe said, "and I explained my reasons for our position on that."[17] Radcliffe went on to inform Westbrook that the ALR, the insurance industry, and victims of crime are hesitant to pay what amounts to a ransom for stolen property lest they encourage such schemes. So, Radcliffe told Westbrook, a number of conditions would have to be met before any payments would be made to those currently holding the paintings. "The conditions included the fact that we must know the identity of the person to whom the payment was going to be made and have some understanding or assurance that they would not pass that payment on to any criminal. We also needed to know how the pictures had come into the possession of the person holding them. We needed to inform the police, and we needed to make certain that no payment was excessive and that the maximum intelligence for the police was obtained at the same time," said Radcliffe.[18]

Perhaps seeing the writing on the wall, Westbrook inquired about the possibility of payments to him for his help. Seizing the opportunity to get Westbrook on his side, Radcliffe agreed to some

payments dependent on his assistance. In other words, he co-opted Westbrook.

It proved to be a wise move. Westbrook opened up to the ALR with more insight into exactly who it was behind the operation. He reported that he was contacted only via telephone by an unknown person who was using him as a conduit for information. He could only confirm that the caller had a "mid-Atlantic accent" and called him in the evening, a fact that led the Londoner to believe his calls were coming from the United States because of the time difference. The only thing that Westbrook was sure of, though, was that the caller was insistent in his expectation that he receive "substantial payment" for any paintings he might turn over.[19]

Seeking to determine whether the anonymous party in the States was truly in possession of the Bakwin paintings, the ALR team requested proof of life. That's when the holding party did something that proved it beyond any doubt: he provided photos of all seven works. Ordinarily, this wouldn't be absolute proof, but unbeknownst to everyone but Bakwin, no photos of the stolen Utrillo existed. Not even the artist himself had photographed the painting. In fact, when Bakwin posted a notice of his stolen art back In 1978, he could produce only an image of a similar Utrillo painting. So when Westbrook produced the ALR with an image of Bakwin's Utrillo, it was obvious the photo was taken post-theft, and thus it became clear that the man with the mid-Atlantic accent was for real.

Following the proof of life, Radcliffe received a proposal from the shadowy figure through Westbrook. According to Radcliffe, the party holding Bakwin's art notified him that "if we brought the pictures in to a neutral location, a bank in Switzerland, and they were inspected by an expert and proved to be the pictures stolen from Mr. Bakwin, then they would release those pictures, provided we pay

$15 million."[20] So there it was: a price tag, and a rather exorbitant one at that.

Radcliffe immediately dismissed the proposal. He told West-brook that his side needed someone—preferably an attorney—with whom the ALR could negotiate face-to-face. In mid-1999, West-brook informed Radcliffe that a Swiss lawyer, Dr. Bernhard Vischer, would be entering the negotiations on behalf of the party holding the paintings, and within weeks the first of many meetings was held in Geneva at the offices of an attorney for the ALR. Vischer revealed to Radcliffe that the involvement of Russians, which had been cited during the initial overtures made through Westbrook, were false. He also let it be known that the party he represented—and refused to identify—expected payment for the return of the paintings. In response, Radcliffe spelled out again the ethical argument against paying what was essentially a ransom demand, since he had no way of knowing whether the party holding the paintings was one of the thieves or closely connected to them.

Bakwin's team continued to work feverishly to determine who had possession of his art. Radcliffe submitted a number of questions to Vischer toward that end, but the answers provided were of little value. Finally, Radcliffe told Vischer that he would have to produce a statement stating to whom any payment would go. For instance, Vischer's boss would have to attest to the fact that he was not the thief, nor a criminal, nor a member of the Bakwin family, and so on. This would provide Bakwin and the ALR with some assurance that they were not making unethical payments. Absent such a statement, Vischer would have to identify the individual who was controlling the stolen paintings. Finally, after further discussion, Vischer agreed to the latter demand.

With the promise of the statement from Vischer in hand, Rad-cliffe and his team came up with an idea that would nevertheless

keep Michael Bakwin's money out of the hands of this unscrupulous anonymous figure. Radcliffe successfully negotiated with Vischer a trade of sorts: in return for the Cézanne, ownership of the other six paintings would be signed over to Vischer's client. Upon hearing of the deal, Bakwin told Radcliffe, "I think that's extortion, but if we can get the painting back that way, I can't believe that we could not also get the other six paintings."[21]

The deal was to be consummated at the same Geneva offices of the ALR's lawyer where Radcliffe and Vischer first met. The date was set for October 25, 1999. Radcliffe and a pair of art experts from Sotheby's—Michel Strauss and Caroline Lang—arrived on time, eager to see if the proposal would go as planned and to inspect the Cézanne should it be delivered as agreed. Tensions were high as hours passed before Vischer finally arrived, looking "hot and bothered," according to Strauss.[22] The parties got right to work and reviewed the pertinent paperwork; seeing everything in order, Vischer made a brief phone call to an unknown party saying that he would be retrieving the painting to bring back to the offices.

Though Vischer instructed everyone to wait inside as he left the office to get the painting, Radcliffe followed at a distance and watched the goings-on. He witnessed Vischer proceed from the grounds of the office to a street corner where he waited beneath a tree. Suddenly, in a scene straight out of a John le Carré novel, a white car drove toward Vischer and stopped at the corner. An object wrapped in a black trash bag was passed through the car door. Once Vischer took possession, he headed back upstairs to the lawyer's office as the mysterious white car sped away from the scene.

Paul Cézanne could never have imagined such a scene, and he likely never dreamed his precious *Bouilloire et Fruits* would be subject to such cloak-and-dagger intrigue, never mind ending up in a trash bag. But there it was as the bagged package was unwrapped and the

painting inspected by experts in Impressionist paintings from Sotheby's, both of whom confirmed that the painting was authentic. "Nervously impatient," Strauss would later write, "I tore a small hole in the bin-bag with my right index finger, pushed aside the layers of soft padding and revealed about six square centimeters of paint. I was instantly in no doubt that this was the Cézanne in question, recognizing the patches of colour and the artist's distinctive brushwork. Impatiently, I finished unwrapping the package and brought to light the stunning still life, unframed and in fine condition."[23]

With that, Radcliffe agreed to sign a bill of sale on Bakwin's behalf that read, "For value received, the undersigned transfers and assigns to Erie International Trading Company Panama (the company) all of the undersigned's right, title and interest to the paintings described on schedule A." Schedule A was merely a one-page document on an Art Loss Register letterhead listing the seven paintings stolen from Bakwin's Stockbridge home in 1978, with a line scratched through the Cézanne and initialed by Vischer. A sealed envelope containing the identity of the anonymous individual behind both the Erie International Trading Company and the negotiations themselves was presented and, as agreed, given to the multinational law firm Herbert Smith for safekeeping.

Radcliffe instructed Strauss to transport the Cézanne to London immediately, and after insuring the piece for transit for nearly $20 million, the team left that evening on a London-bound flight with the painting still wrapped in the trash bag and on the aircraft floor at Strauss's feet.[24]

Soon thereafter, Michael Bakwin was reunited with his prized *Bouilloire et Fruits,* the painting that he had not only urged his parents to buy, but had described as the most beautiful thing in the world.[25] The reunion, however, was bittersweet. Faced with an enormous bill from the ALR, whose fee was based on the value of the

painting, and concerned about his ability to safeguard a painting of such historic and monetary value, Bakwin came to the sad realization that he would have to sell his beloved Cézanne at auction. He instructed Sotheby's to sell the painting as soon as convenient. The famed auction house was able to include it in its December 1999 sale, where it brought Bakwin more than $28 million. In an affidavit, Bakwin stated that he then paid the ALR approximately $2.6 million.[26]

THE RECOVERY OF THE CÉZANNE in 1999 was a major victory for Radcliffe. Indeed, it was the biggest and most important recovery of a stolen painting that the ALR had ever accomplished. But Radcliffe and Bakwin did not intend to rest on the laurels of the Cézanne return and went back to work to regain ownership of the six paintings signed over to whomever was behind Panama's Erie International Trading Company. In fact, on the very night of the Cézanne recovery, with the painting safely en route to London, Radcliffe joined Vischer for a drink and posited to him that the agreement he had signed earlier that same day might not stand up in court. He told Vischer, "They should never try to sell the pictures, they should come back to us, and . . . we should negotiate now to get those pictures returned" before law enforcement began putting pressure on Vischer and his principals at Erie International.[27] Within months, with Swiss authorities allegedly stirring over his involvement in the case, Vischer withdrew from further negotiations.

For the next six years, the ALR continued to pursue the remaining six Bakwin paintings. Negotiations with Tony Westbrook, who had resumed his role as intermediary with the unnamed holder of the paintings, continued but moved glacially. Meanwhile, the anonymous holder of the paintings approached a prominent Massachusetts businessman, Paul Palandjian, seeking his help in selling the

six remaining Bakwin paintings. Palandjian was told that though the paintings were once stolen, title for them had been subsequently cleared. In January 2005, Palandjian traveled to Geneva, Switzerland, and met with an affluent Swiss banker, Henri Klein, and took delivery of the paintings. With the help of Klein, Palandjian stored the paintings in a Swiss bank vault while he approached Sotheby's about selling the artwork. Sotheby's informed Palandjian that they were interested in selling four of the works—the two Soutines, the Vlaminck, and the Utrillo.[28]

Then, in the spring of 2005, Julian Radcliffe received a call from Sotheby's in London about four paintings they planned to include in an upcoming auction. This was hardly unusual: running checks through the ALR prior to sale was by then accepted as a key step in performing due diligence on an artwork's provenance. But Radcliffe's interest was piqued when he was asked if title was clear on four of the six stolen Bakwin paintings. For the second time, Michael Bakwin's paintings were at a critical crossroads. If Radcliffe told the Sotheby's representative that the pictures could not be legally sold, they'd likely disappear again for untold years. So he made a key decision: he told Sotheby's the paintings were clear for sale. A month later, with the paintings' whereabouts—London—now known, Radcliffe and Bakwin filed suit in a British court to stop the sale, arguing that the 1999 agreement to, in essence, trade ownership of six of the paintings for the return of the Cézanne was made under duress. The High Court of London agreed with Bakwin's argument and not only awarded ownership of all of the paintings to him but ordered that the identity of the man behind Erie International Trading Company be revealed. On January 23, 2006, Bakwin was given the elaborately sealed envelope that had previously been entrusted to the law firm Herbert Smith. Within, he finally learned the name of his tormenter: Robert Mardirosian, the attorney who had found the stolen paintings in his

attic decades earlier. There was another key component to the High Court's judgment: Mardirosian was ordered to pay Bakwin $3 million to recoup his costs.[29]

In response to the judgment, Mardirosian embarked on a curious public relations mission in the United States. He granted an extensive interview to the *Boston Globe* in which he made no qualms about what amounted to his criminal behavior. And he went to the airwaves to tell his side of the story on Boston's National Public Radio station, WBUR, in an interview with host Bob Oakes. It was the latter that proved most damaging to Mardirosian. Oakes asked Mardirosian, "You knew they [the paintings] were stolen; your client [Colvin] told you that." Mardirosian answered, "That's right." Mardirosian went on to state that he had held onto the paintings so he could get a reward or finder's fee and had moved them overseas years earlier for safekeeping.[30]

FBI SPECIAL AGENT GEOFF KELLY of the agency's Boston Field Office received a call from Julian Radcliffe some time after the British High Court had issued the injunction halting the sale of Bakwin's paintings. Radcliffe requested a meeting with Kelly to discuss the latest developments in the case, which the bureau had been monitoring for years. Agent Kelly is everything you'd expect from an FBI agent and more. A SWAT team operator assigned to the Violent Crimes Task Force who can sit at a piano and play Rachmaninoff, Kelly was particularly qualified to deal with the Mardirosian art-related matter. He had spent years investigating complex fraud cases with the economic crimes unit and was a member of the FBI's exclusive Art Crime Team. Perhaps most notably, Kelly was the FBI's lead special agent investigating the infamous 1990 heist at the Isabella Stewart Gardner Museum—by far the largest art theft in history. He was just the man to work in pursuit of stolen masterpieces.

Radcliffe laid out what he knew of the saga to the savvy street agent, and Kelly went to work investigating the matter. After reviewing evidence including a shipping invoice produced by Radcliffe listing the consignor of four of the paintings in question as Palandjian (who described himself as an "agent of an undisclosed owner"), and the document naming Mardirosian as the owner of Erie International, Kelly was confident he had enough to establish probable cause for the arrest of Mardirosian. Still, the agent recalls being shocked when he heard the Mardirosian radio interview in real time during his commute to work one morning: "I was listening to NPR, as is usual, and I almost drove off the road when I started to listen to Bob Oakes' interview with Mr. Mardirosian. As I was listening, my cell phone started to go off from a number of my colleagues who were listening to NPR as well." Kelly recalls that during the radio interview, Mardirosian helped make the FBI's case against him. "One of the issues I anticipated with regard to a prosecution was proving intent relating to the substantive charge of possessing stolen property," Kelly later recalled. "It was incredible that Mr. Mardirosian, a defense attorney, was speaking to a reporter on live radio acknowledging that he was aware that the artwork was stolen."[31]

Armed with his findings, Kelly made the short trip from his office in Boston's Government Center over to the John J. Moakley Courthouse for a meeting with assistant U.S. attorney Jonathan Mitchell, the federal prosecutor assigned to look into the Mardirosian matter.

Mitchell, a graduate of Harvard and Georgetown Law School who would go on to become the mayor of New Bedford, Massachusetts, had himself heard Mardirosian's interview with Oakes on WBUR and could hardly believe his ears. "Here was a criminal defense counsel who has told innumerable clients to keep their mouths shut," Mitchell said, "yet he went on the air and admitted knowing the paintings he held for decades were, in fact, stolen."[32] Like Kelly,

Mitchell believed that a crime had been committed and he sent the agent out to interview Mardirosian. When Kelly tried to interview him at his home in Cohasset, he was told that Mardirosian had obtained a lawyer, Jeanne Kempthorne, a one-time federal prosecutor who had served the District of Massachusetts alongside Mitchell years earlier.

Mitchell contacted his former colleague and arranged a meeting to discuss her client's plight. Mitchell and Kelly met with the defense counsel at the Moakley Courthouse, and the feds asked Kempthorne if her client was interested in disposing of the case mounting against him. Perhaps, Mitchell posited, a deal could be reached between the government and her client against whom there appeared to be an open-and-shut case. Kempthorne, however, surprised the feds by replying that there was no case to be had against her client. Aware that Mardirosian's home on the French Riviera made him a serious flight risk, Mitchell asked Kempthorne to have her client turn over his passport as the meeting came to a close. When about a week had passed with no word from Kempthorne about the passport, Mitchell told Kelly to arrest Mardirosian. That's when the other shoe dropped: Kelly found that, just two days after the meeting between the feds and his lawyer, Robert Mardirosian had departed the United States for France.[33]

Nine months passed before Mardirosian finally agreed to come back to the United States. While his return would later be depicted as a voluntary return at the request of the federal authorities from an innocent sojourn, it's arguable that Mardirosian came home because his passport and visa had expired and he risked running afoul of the French. On February 13, 2007, upon his arrival at Logan International Airport in Boston, Mardirosian was arrested by FBI agents waiting for him in the U.S. Customs and Border Protection inspections hall.

Less than a week before his return and arrest, FBI agents and Falmouth Police led by Special Agent Kelly went to Mardirosian's home in Falmouth with a warrant to search the premises. Finding no one within and hoping to avoid unnecessary damage to the home, Kelly contacted Mitchell before making a forcible entry. Mitchell reached out to defense attorneys, who contacted Mardirosian's 51-year-old son Marc. They called back Mitchell with a curious message: Marc was at Wood's Hole (about a ten-minute drive) and wouldn't be back for two hours, so the agents could go ahead and make a forcible entry. One would think that he'd have come straight home given the fact that federal agents with a search warrant were prepared to knock down the door to get inside, but the message from Mardirosian's son was that it was fine for them to do just that.

Rather than bust down the door, Kelly popped out a window adjacent to the door, which allowed the team entry. Once inside, they found good reason, one could speculate, for Mardirosian's son to wish to avoid driving home to unlock the premises. Agents discovered weapons, including two shotguns, a vial of cocaine, and three trash bags containing more than 50 pounds of marijuana—one of the biggest pot seizures in Falmouth history. Like his father, Marc Mardirosian remained at large until authorities were able to track him down.[34] But he was not convicted of any wrongdoing.

THE FEDERAL TRIAL OF ROBERT MARDIROSIAN began on August 12, 2008. Assistant U.S. attorney Ryan DiSantis provided the direct examination of Michael Bakwin, and the man who was victimized for the better part of three decades by Mardirosian served the prosecution well by coming across as a sympathetic figure. This was no small feat. Yes, Bakwin had been robbed and kept from his prized possessions, but at the same time he also testified that he had sold the Cézanne at auction and walked away with more than $28 million.

That's a figure that could easily alienate some jurors. DiSantis recalls that in order to show the jury that Bakwin, despite his wealth, was a person not so unlike themselves, he had him "describe his early work history at the outset of his direct examination, which included a five-year period in which he worked his way up in the hotel and restaurant business. His jobs during that time included work as a waiter, steward, and chief steward." In addition, DiSantis spent considerable time doing extensive preparation for the trial with his subject, a fact that left Bakwin more relaxed on the witness stand. "His personality also came through," DiSantis said, "which I believe allowed him to connect with the jurors."[35]

On the cross-examination of Bakwin, Mardirosian's defense attorney Kempthorne attempted to put the focus of the case on the victim, but it was for naught. Mitchell called Radcliffe to the stand, and, through the director of the Art Loss Register, Mitchell was able to keep the focus of the trial on Mardirosian and the intricate scam he clumsily constructed to try to squeeze money out of Bakwin. Mitchell skillfully led Radcliffe through a recounting of the underhanded behavior of Mardirosian and the subsequent epic negotiations that had begun back in 1999. The defense had worked hard to characterize Radcliffe as a greedy, unethical opportunist, and only Mitchell's deft handling of the witness kept them from succeeding.

The centerpiece of the case, as Mitchell saw it, was established when Mardirosian made his damning statements in his radio interview. WBUR readily handed over the recording to the prosecution without a subpoena, a key development in the case. "Subpoenaing a media outlet requires the approval of the United States Attorney General, which is rarely granted," Mitchell said, "but WBUR rightly provided it to us." Why a seasoned defense attorney would make such admissions on air is difficult to understand, but Mitchell has a theory. "At some level and at some point, he had deluded himself

with the belief that what he had done was just fine, that he broke no law, and that the entire transaction was lawful. He would have been better off throwing himself on the mercy of the court" than going to trial, the prosecutor believes.[36]

In the government's closing argument, DiSantis delivered a riveting narrative that had the jury on the edge of their seats. At 4:45 p.m. on August 18, 2008, the trial ended with the court in recess for the jury. At 5 p.m. that same day, the jury returned its unanimous verdict: guilty. DiSantis described his feeling when the verdict was read as "satisfying." He added, "Having a hand in righting a wrong that had persisted for over a generation was a very rewarding experience."[37]

Four months later, Mardirosian was back before the court for sentencing. Judge Mark Wolf sentenced the 74-year-old—who was by now claiming to be suffering from the beginning stages of dementia—to seven years in federal prison for his crime, a substantial penalty that surprised even Michael Bakwin. "He's my age," he told journalist Gretchen Voss. "He shouldn't be in jail. I feel awful. An old guy my age in jail? He should have to pay some other way."[38]

But pay he would. In 2011, a Massachusetts state court ordered Mardirosian to pay Bakwin $3.1 million in damages for the whole sordid affair. It was a final justice for Bakwin, who was finally able to recoup the costs of recovering his possessions. But a question remains in the case: Could Bakwin have circumvented all of the intrigue by going straight to the FBI with a plea for help when the paintings had first surfaced back in 1999? An FBI sting operation, after all, would have cost him nothing at all, and that might have been the best route from the very start for Bakwin. As Kelly said, "I cannot speak for Mr. Bakwin and why he chose to go through [Mardirosian's] extortionate deal for the Cézanne; however, I'm confident that if the FBI had been allowed to work the investigation to its logical conclusion when it was

first brought to our attention [when the Cézanne resurfaced], quite likely, all of the pieces would have been recovered and Mr. Mardirosian would have been identified much earlier as the subject behind the illegal deal."[39] Indeed, the case might have ended much sooner— and at a far lesser cost.

SEVEN

THE DOUBLE DEALER

IN THE HEART OF ROSLYN HEIGHTS, NEW YORK, BETWEEN A PSYCHIC READ-ing center and a sports rehabilitation complex sits a newly constructed pale-brick building belonging to the Chabad of Roslyn. The cube-like structure features a prominent Modernist rendering of a meno-rah extending above the building's roofline. The impressive menorah is functional, lit each year to celebrate Chanukah. It's also billed by the Chabad of Roslyn to be one of the tallest menorahs in the world (without exceeding the 30-foot height limit set forth by Jewish law). The Roslyn Chabad movement is the beneficiary of the Ely Sakhai Torah Center at that location, where the faithful may visit for a va-riety of services, ranging from lectures to Jewish services to adult education. The Torah Center is named for its benefactor, a Jewish émigré from Iran committed to his faith and heritage who was eager to make a mark among his people in his adopted homeland.

Ely Sakhai[1] moved to the United States in 1962 at the age of ten and would go on to donate millions of dollars to Jewish charities. Prone to loud attire and flashy jewelry, the pot-bellied antiques dealer with a thin mustache and dark, receding hair became well known

for his philanthropy in Long Island, where he made his home.[2] And in addition to his generosity in providing money to support his fellow Jews, in 2009 Sakhai helped to right a wrong committed by the Nazis during World War II.

In 1940, Adolf Hitler's forces invaded the previously neutral nation of Belgium. It took the Germans less than three weeks to force the Belgians to surrender, leading to more than four years of Nazi occupation. Finally, in 1944, Canadian and Allied forces liberated Belgium, but not before Nazis had looted art from many families, including one Belgian family that was forced to flee its Ohain apartment in order to seek refuge in the countryside. After the liberation they returned home to find that five oil paintings had been taken by the Nazis, the same fate as so much art throughout Europe. They were left with no other recourse but to file a claim for their missing paintings with the Belgian office for looted art, and the works were listed in the *Répertoire d'oeuvres d'art dont la Belgique a été spoliée durant la guerre 1939–1945*, a listing of Belgian war losses.[3] Among the paintings that were taken was a portrait of their young daughter with her pet rabbit, which they had commissioned to be painted by the famed Belgian artist Anto Carte.

Carte was a leading Belgian artist who rose to prominence after the First World War. The son of a carpenter, Carte was drawn to decorating at a young age and started evening painting classes before he even reached his teenage years at the Academy of Bergen. He then attended the Royal Academy of Brussels after winning a scholarship and studied under Jean Delville and Constant Montald. While studying theater decoration in Paris, he encountered the work of the great French and Italian painters at the Louvre; he then moved to Italy to paint frescoes. The influence of Italian painters extended to the work of his contemporary, the great Amadeo Modigliani, whose portraiture greatly influenced Carte's work.[4] Carte would come to

be considered among the best of what was called the Belgian "new primitive school," and today his paintings can fetch prices up to the hundreds of thousands of dollars.

Carte's rendering of the young daughter, titled *Jeune Fille a la Robe Bleue* (*Young Girl in the Blue Dress*) and painted in 1932, depicts the blond, pig-tailed girl holding a small group of flowers and seated on a bench aside her small pet rabbit, the Belgian countryside in the distance. Sadly, the painting was seemingly lost to the world and, perhaps more importantly, to the family—yet another victim of Nazi derangement. Decades passed without as much as a whisper about the location of the precious family heirloom.

In 1990, *Jeune Fille* was sold at Christie's auction in London to an American buyer. Unfortunately, it changed hands without the buyer or the auction house being made aware that the painting had emerged from the dark world of Nazi looted art. Years later, Julian Radcliffe's London-based Art Loss Register entered the painting into its database of lost and stolen works from the database of Belgian war losses. Then, in November 2008, there was a break: Christopher A. Marinello, then of the ALR and now the director of Art Recovery International, traced the location of the Carte painting to the Long Island gallery owned by Ely Sakhai and his son Andre. Marinello is among the world's leading experts in the recovery of lost and stolen art. An attorney by trade with decades of experience as both a litigator and recovery specialist, he had already negotiated the return of hundreds of millions of dollars worth of art by the time he took on the challenge of helping to recover Carte's *Jeune Fille*. Among these were many important pieces looted by the Nazis, including an El Greco, a Picasso hanging in a Washington, D.C. museum, a Monet being sold by one billionaire to another, and a major work by the British Impressionist Alfred Sisley.

In order to get *Jeune Fille* back into the hands of its rightful owners, Marinello reached out to the Department of Homeland Security's

Immigration and Customs Enforcement team at their New York Office of Investigations. ICE was created as part of the reorganization of law enforcement and security agencies after 9/11 and the subsequent creation of DHS. The agency then formed a dedicated unit of special agents under the umbrella of the Cultural Property, Art, and Antiquities program to coordinate investigations related to looted cultural heritage or stolen artwork. Agents assigned to this unit undergo special training to better understand the unique needs inherent to a criminal investigation involving art and cultural property. ICE even brings in the Smithsonian Institution's Museum Conservation Institute to provide on-site training in the handling, storage, and authentication of art, antiquities, and artifacts. This training program was developed thanks to the work of Senior Special Agent Bonnie Goldblatt, an investigator who had begun her career as a customs agent in 1983 and had spent years working art theft cases for the agency. Goldblatt had experience working investigations relating to the recovery and return of art stolen from museums and individuals during World War II. Based on this experience, she would become ICE's regional subject matter expert in the field of art and antiquities investigations, working closely with the State Department's Office of Holocaust Issues.

Goldblatt's work involving Nazi looted art began in 1995 when she attended a conference in New York at which the ownership rights of art stolen during World War II was debated. Soon, she would develop many of the participants into sources of her own for work in repatriation. Her first such recovery took place in 2003 and involved the *Sefer Yetzira,* a rare fourteenth-century kabbalistic manuscript that had been looted by the Nazis from Vienna's Jewish library. When the manuscript was found listed in the auction catalog of Kestenbaum and Company, Goldblatt jumped into action, and ultimately the auction house voluntarily turned the item over to the authorities.[5]

So when it came to working to recover the Carte painting, Goldblatt and Marinello were an ideal pair for the mission.

Though Marinello had traced *Jeune Fille* to Sakhai's Long Island gallery, there was a slight problem: the Belgian war losses registry that listed the painting did not, unfortunately, include a photo of Carte's creation. So he contacted the Belgians directly, and though they couldn't provide a photo of the painting, they did provide the art recovery specialist with a photo of the young blond girl who was depicted in the painting, seated with her rabbit. The similarity between the photo and the painting was undeniable. He provided the documentation to Goldblatt, who contacted Sakhai and informed him that the painting he had in his possession had been confiscated by the Nazis 65 years earlier and reported as an official war loss by its rightful owners. Sakhai forfeited the painting to its rightful owner—the very same girl whose portrait Carte had painted. Still frightened by the whole experience many decades later, however, the now elderly woman in the painting could not bring herself to come to the ceremony marking its return at the handover ceremony at the Jewish Museum of Belgium on December 1, 2009. Goldblatt told the *Jerusalem Post,* "The Holocaust left her with such a scar that she was scared if she came out with the painting it would be stolen again."[6]

The recovery of *Jeune Fille* was far more important for its historic significance than for a big-dollar value. The return of the painting, estimated at a relatively low $15,000, marked an important closing of a sad chapter in one innocent woman's life. But it would hardly be the last intersection between Nazi looted art and the careers of Marinello and Goldblatt. Rather, the two would continue to work steadfastly to repatriate art stolen during World War II. Marinello, through Art Recovery International, continues to work to recover looted art and is deeply involved with the huge cache of so-called "degenerate art," including a Matisse, found in the home of the reclusive Cornelius

Gerlitt in Munich. (For more on this "degenerate art," see Chapter 1.) As for Goldblatt, Marinello called her "unlike any civil servant I have ever encountered. . . . She is extremely dedicated and passionate about her work." And her passion was evident when she said, "Every time I return a Holocaust painting I just get teary-eyed. . . . I'd like to get it all back."[7]

Clearly, art affected the tough, seasoned federal agent in a way perhaps money laundering or drug interdiction might not, inspiring intense commitment and even heroic efforts. Surely, too, the willingness of the art dealer Sakhai to turn over the painting should be ranked as, at the least, magnanimous, if not heroic. After all, he was a victim in a sense too. He had purchased a fine work of art in good faith, believing that its provenance was solid and title clear; yet he parted with his expensive possession voluntarily so that it could be returned to a woman whose life was so adversely affected by the Nazis, just like so many of Sakhai's Jewish brethren during the Second World War.

BUT THERE WAS ANOTHER SIDE to Ely Sakhai, a separate portrait of a dealer who proved not so altruistic. Despite the injustice suffered by the Belgian family at the hands of the most evil anti-Semites in history, Sakhai wasn't going to walk away from his Anto Carte empty-handed, happy simply to have righted a historic wrong. Instead, Sakhai wanted something in return, ranting about how he, too, was Jewish and suffered as well. Plus, he wanted his purchase price for the painting.[8]

That Sakhai would be less than generous in his art dealings is of no surprise, as this restitution affair came on the heels of an elaborate and clever confidence game he created, taking forgery to a whole new level and scamming art collectors living far from his home in Old Westbury, New York.

Sakhai entered the art market first by working at his brother's antiques shop in Manhattan. Eventually, he would branch out on his own, opening a shop in which he sold furniture, antiques, and art. But the art Sakhai peddled was not in the league of the storied art galleries of New York, where prices could easily escalate into the tens of millions. Instead, he dabbled in relatively inexpensive items. He did, however, occasionally have an authentic Tiffany lamp for sale. Such lamps can be a rarity in antiques stores: many copies have flooded the market over the past few decades; some copies can be excellent, with the same level of exacting detail forgers put into paintings. Indeed, Tiffany lamps are considered true works of art and can fetch anywhere from a few thousand to over a million dollars. Sakhai made an intriguing observation about the authentic Tiffany lamp he had for sale in his shop—it was identical to a fake he had on a nearby shelf. He considered the two lamps and found them similar in every respect except for the presence of an authenticating label affixed to the base of the true Tiffany. Then he had a thought: if he could duplicate that label and adhere it to the base of much cheaper Tiffany copies, he could sell them as originals at a steep profit. And that he did, making hundreds of thousands of dollars off his crooked scheme.[9]

It would have been bad enough had he stopped there. But Ely Sakhai had grander plans. Flush with the earnings he made selling lamps, Sakhai decided to morph from a moderately successful antiques shop owner to a successful art dealer, opening a gallery he named Exclusive Art Ltd. He also began dating and eventually married an affluent Japanese woman with whom he made trips to Japan and learned the practices of art collectors there. Soon he had another brainstorm.

Sakhai had begun attending art auctions at Sotheby's and Christie's around 1990 looking to buy Impressionist and Post-Impressionist

works. Some took note of his unusual style of dress, but few noticed him for his purchases. That's because he focused his efforts on lesser-known, midrange value paintings by renowned artists. Among those popular nineteenth- and twentieth-century figures whose works he bought were Marc Chagall, Claude Monet, Pierre-Auguste Renoir, and the man who had so influenced Anto Carte, Amadeo Modigliani.

For an artist whose life was cut so tragically short—he died at only 36 years of age of tubercular meningitis—and therefore produced a somewhat limited body of work, Modigliani's work has been the subject of a great deal of fraud. The famous and prolific forgers Elmyr de Hory and, later, John Myatt, made numerous counterfeit paintings attributed to him, and the problem of tracking Modiglianis is complicated by the fact that he was destitute and often resorted to trading his paintings for food. Furthermore, his mistress, Jeanne Hebuterne, committed suicide just days after his death. Thus, little information about his works remains. Perhaps most startling was the 2012 arrest of Christian Gregori Parisot, the man who headed the Archives Legales Amadeo Modigliani and was once considered one of the world's most reliable authenticators of the artist's works. Parisot was nabbed by Italian police after a raid of an exhibition resulted in authorities finding 22 fakes. They would go on to seize 59 fakes from Parisot and his suspected accomplice, art dealer Matteo Vignapiano. In all, it is thought that Parisot had put more than 100 bogus Modiglianis on the art market. Incredibly, Parisot was arrested a few years earlier for fakes he offered for sale as drawings made by Modigliani's mistress, Hebuterne.[10] For that crime, Parisot was convicted and sentenced to two years in jail as well as ordered to pay a fine.[11]

ACQUIRING MIDPRICED MASTERWORKS by the likes of Modigliani was only the start of Sakhai's plan. Just as he cunningly converted cheap copies into authentic Tiffany lamps by affixing counterfeit

authentication labels to them, he would substitute copies of master paintings for originals in a heretofore untested scam. Now that he had obtained originals from reputable auction houses like Christie's and Sotheby's, he needed to find a way to produce exact duplicates of them. This would be much more difficult than finding a lamp that was similar to a true Tiffany, and would garner much closer inspection than that made by a casual shopper happening into his old antiques store. Now he needed artists with great skill and an equal amount of discretion to work for him.

In order to obtain talented labor at bargain prices, Sakhai turned to a group often exploited by con men: immigrants to the United States. Aware that Chinese artists receive a great amount of practice copying works as art students, he created a workforce of talented Chinese immigrants. As James Wynne, a highly regarded FBI special agent with vast expertise in the investigation of art crimes, said, "These individuals were professionally trained artists. They all received formal training in oil painting and part of that training involved copying masters."[12] Working for Sakhai was not the break these artists probably hoped for in their quest for a new life in the United States. Instead, he exploited their desperation for money by paying them paltry sums for their works. In a number of cases, Sakhai even sponsored Chinese artists to come to the United States with work visas, and then used their immigration status and economic situation as leverage over them.[13] And to keep a close eye on their work and their activities, he set them up in a studio located directly above his art gallery. It was virtually a case of indentured servitude meets high art.

Sakhai's plan was criminal genius in its simplicity. Because he was indeed the true owner of the paintings he bought, he held the actual certificates of authenticity. And because he bought them from reputable institutions, his ownership was a true part of each

painting's provenance. Therefore, he could provide a credible authen-
ticating document to potential buyers, giving them the confidence
that they were buying the original painting when, in fact, Sakhai was
selling them a copy.

Assistant United States attorney Jane Levine said, "Mr.
Sakhai . . . took a number of steps to make the forgeries look like
they were actually created in the time period when that artist lived."[14]
Committed to making sure his copies were beyond reproach, Sakhai
hunted down era-appropriate canvases on which his artists could re-
create his paintings, visiting antiques shops around the area to find
cheap old paintings. His purchases did not go unnoticed by antiques
dealers, leading them to grow suspicious of his intentions. One dealer
told *New York Magazine*, "Everybody who was selling them to him
would know what he was doing with them. He wouldn't care what
the painting was."[15] Clearly, he wasn't buying them for any particular
aesthetic appeal, nor was he making an investment. It was as if he
were purchasing supplies for some illicit enterprise.

Another advantage to Sakhai's scheme was that many of his cop-
ies were made from the actual masterwork, not from a printed image,
thus resulting in a more believable painting. According to Sharon
Flescher, the executive director of the International Foundation for
Art Research: "What was so clever in Sakhai's scheme was that he in
fact did own the authentic work. If the fakes were based simply on
photographs, you're always likely to trip yourself up."[16] The copies
had to be meticulous, including each and every mark, scar, and abra-
sion on the painting—and not just on the front of the canvas. He
ensured that even the backs of the copies matched the backs of the
authentic paintings, an important way to fool someone who has seen
the authentic painting or has some expert information about it. He
even had his team of artists re-create the frames holding the paint-
ings, paying careful attention to accuracy in terms of appearance and

age. As a final step, and in order to keep his copies from appearing to be freshly painted, Sakhai would have a coating applied to some of the forgeries in order to give the paintings a passable patina.

While he was no artist himself, Sakhai's eye for a good scam gave him the requisite attention to detail to pull off the multimillion-dollar scheme. Once he was satisfied that his replica would pass muster, he set his sights on what he believed would be the perfect place for his dupes: his wife's homeland. On trips to Japan, Sakhai noted at the time a surge in interest in Impressionist paintings, and it was no coincidence that Sakhai had bought a number of them. So, in the Land of the Rising Sun he had a market hungry for his art. Further, selling his wares in Japan presented him with a certain level of assurance that if his counterfeit paintings were found out, no fuss would be raised because of the cultural tendency to avoid public embarrassment at all costs. And finally, he would be doing his business quite far from New York, giving him the luxury of distance from his victims. As Special Agent Wynne put it, "I think the Japanese market was a convenient and safe place for him to place these paintings, in fact it was the other side of the world."[17]

WHILE SAKHAI'S SCHEME IS THOUGHT to have involved hundreds of paintings, some of the most significant involve four Chagalls (*La Nappe Mauve; Vase de Fleurs avec Coq et Lune; Les Maries au Bouquet de Fleurs; and Le Roi David Dans Le Paysage Vert*), Renoir's *Jeune Femme S'Essuyant,* Gauguin's *Vase de Fleurs (Lilas),* Monet's *Le Mont Kolsas,* and *Palaste* by Paul Klee. Of course, there was a Modigliani, *La Blonde Aux Boucles D'Orielle.* But most surprisingly, there was a Rembrandt—*The Apostle James.*

While Rembrandt's paintings have very often throughout history been the subject of thievery, in the modern world of art scams, forged and faked Rembrandts are quite rare. Indeed, such illicit activity is

rare when it comes to any classical painting by an Old Master. As the stories of this book illustrate, artists such as Chagall, Dalí, Picasso, Miró, and their contemporaries are far more likely to be used in a widespread, ongoing scam than the likes of Rubens, Botticelli, or Valazquez. That's not to say that people looking to get rich quick don't ever attempt to present a never-before-seen Da Vinci of questionable provenance; rather, when con men set their sights on running an ongoing scam while attempting to maintain an air of legitimacy, they often turn to the Impressionists or Abstract Expressionists. The reason is practical rather than aesthetic: it's easier to paint like an Impressionist or Abstract Expressionist than like Raphael or Vermeer, because it's a very difficult thing to render, say, the human form or a landscape using different tones and values of paint to create that form. It is far easier to dab different colors of paint on a canvas than to apply it in a smooth, seamless sort of way. Thus, Sakhai's introduction of Rembrandt's *The Apostle James* into his mix of imposter paintings is surprising and somewhat unique, at least since the exposure of Han van Meegeren as a fraud after the Second World War. (For more on van Meegeren, see the Introduction.)

The reasons are many why Sakhai's use of a Rembrandt was risky. First, only about a dozen or so Rembrandts come up for sale every decade. As a result, offering up a Rembrandt for sale in Japan, the United States, or indeed anywhere in the world is newsworthy, and attention to a deal is anathema to a con man's playbook. Second, Rembrandt's paintings are extremely well known and studied, right down to every last brushstroke. The Rembrandt Research Project, a group that has been putting every work attributed to the great master under the microscope—and more—for more than 40 years works to ascertain whether a painting is, is not, or might be a Rembrandt. They can rather quickly and easily expose a fake, and that's not the sort of nemesis the con man wants. That august group consists of

the world's best experts in the subject of Rembrandt, and that makes trying to traffic in counterfeits of his paintings especially risky if not downright fatuous. The Rembrandt Research Project—or any skilled paintings conservator or conservation scientist—could quickly determine if a Rembrandt was a fake or forgery by conducting a scientific analysis of the chemical composition and structure of the paint used in the work. Rembrandt's paints have been analyzed in great detail, and the materials he used are well known, yet not easily replicated. While Sakhai was committed to giving his artists period-appropriate frames and canvases, he did not attempt to re-create Rembrandt's paints. Furthermore, the *craquelure,* or cracking pattern, of the centuries-old paint is impossible to copy for any artist, and the appearance and paths of the fissures in the paint serves a purpose for authenticators in a way not dissimilar to how a human fingerprint helps crime investigators identify people.

Contrast this with the number and frequency with which more contemporary artists have seen their works counterfeited. The works of Jackson Pollock—or those attributed to him—have consistently been the subject of attempts to scam buyers out of millions of dollars. Art such as that produced by Pollock is more difficult to quickly dismiss as a fake or forgery. For one, the materials he used are far more readily available on the market, usually manufactured rather than created in his workshop, as was the case with the Old Masters. Additionally, aged only over decades as opposed to centuries, there is less chance that his works would show a craquelure, as is the case with many classical works such as those by Rembrandt. And of course, it is much easier to replicate a seemingly random series of splatters than the hand skills of a master painter whose brush-stroke technique has mesmerized art historians and connoisseurs for hundreds of years. Said one successful recent forger, a self-taught amateur artist: "I love Monet. The Impressionists are quite easy to do."[18] One

would be hard-pressed to find a forger who would say the same about Rembrandt.

Take for instance the controversy surrounding the so-called Matter paintings. In 2005, filmmaker Alex Matter, whose parents knew Jackson Pollock, unveiled 32 works he claimed were painted by the famous Abstract Expressionist. Though Matter could show that his paintings were authenticated by a Pollock art historian, contrarian views on the authenticity were raised just as suddenly as the works appeared. And in another case, a truck driver by the name of Teri Horton bought a painting for five dollars at a flea market that she believes to be a lost Pollock work. To this day, the debate still rages unresolved regarding whether any of these paintings are Pollocks or cheap knockoffs.

None of this is to say that Rembrandts are easy to identify. The aforementioned Rembrandt Research Project has labeled a number of works attributed to him as only possibly done by the master himself, with the group unable to come to a consensus. Since many famous Old Masters taught talented students, paintings exist that were executed by understudies and followers that are quite similar in terms of age, technique, materials, and subject matter. Confusing the matter further is the fact that it was not altogether unusual for the master to put just the finishing touches on a picture painted in *almost* its entirety by an apprentice.

STILL, AND WITHOUT QUESTION, attempting to pass off a counterfeit Rembrandt was an incredibly brazen move on Sakhai's part. But brazen he was, and he did have a certain advantage in his scheme: the legitimate ownership of the authentic painting that he had his artists copy. The authenticity of his Rembrandt, *The Apostle James,* was not questioned. Nor was the fact that it was purchased by Ely Sakhai from a reputable source. So when he would offer what he purported

to be the painting for sale, it didn't raise questions about authenticity, if only because those interested in the painting perhaps failed to imagine the nefarious scheme of the seller. Thanks in large measure to his travels in the Far East with his wife, Sakhai made it his mission to establish a steady clientele in Tokyo and Taiwan too. And in June 1997, he sold his Rembrandt to the Japanese businessman and art collector Yoichi Takeuchi.

Takeuchi had been a customer of Sakhai's since 1992, when he started buying art from him in a complicated deal involving a third party who would later allegedly renege on their part in the purchase of the artwork, leaving Takeuchi with paintings he didn't want. When Takeuchi accused Sakhai of a "fraudulent plot" against him, Sakhai replied that he, too, was the victim and had filed suit against the third party. Of course, he had not. The summons he showed Takeuchi was bogus.[19] With a loan balance still due to Takeuchi, Sakhai made him an offer: he'd sell him *The Apostle James* for forgiveness of the loan plus $350,000. Takeuchi believed that the painting was authentic, and he would go on to say that he was influenced in his decision to purchase the painting at a dinner in New York with a person who claimed to be a branch manager for Citibank. The Citibank representative, said Takeuchi, certified that the Rembrandt was exhibited in the Metropolitan Museum. So the businessman accepted Sakhai's offer and made the deal for the Rembrandt.[20]

It stands as a testament to an art lover's desire to believe that he has made a great find and executed a great deal that Takeuchi purchased *The Apostle James* from Sakhai. In 1992, near the beginning of their business relationship, Takeuchi was furious with Sakhai over another major purchase. Writing in November of that year, he said, "You have delivered about 500 paintings to us with the condition you provide a provenance and certificate for each painting. . . . We feel we cannot do business in trust with you anymore. . . . This case

will become a court case in Japan soon. But we feel very sorry that our trust and friendship will end this way. We also point out that you have to provide provenances and certificates regardless of the situation. If you break your promises, you will be prosecuted as an international criminal."[21] Given this inauspicious start to the relationship, it is surprising that Takeuchi would continue to conduct business with a person he so described. Nevertheless, he would go on to make the Rembrandt purchase.

Shortly after the transaction was made, Takeuchi turned to two experts to examine his prized Rembrandt for the sake of appraising its value. The pair inspected *The Apostle James* and came to a clear conclusion: the painting was not what it was promised to be. Takeuchi contacted Sakhai to inform him of the news, but the con man remained steadfast: the experts were mistaken, he told his client. As he had done in 1992, Takeuchi wrote to Sakhai accusing him of selling a "forged Rembrandt piece" to him, threatening to contact the authorities and to file a lawsuit against the dealer. "As it was exactly like before," Takeuchi wrote, "I was tricked again by your performance. . . . Prof. Tanaka has looked closely to examine the painting, and he concluded this painting is totally different from the one . . . Citibank certified." Takeuchi added that he had "gotten the report of examination by IR [infrared] and X-ray from the world famous restoration authority, Prof. Kuroe. The result . . . also conflicts from what you said."[22]

Perhaps banking on the possibility that Takeuchi was bluffing and would not want to suffer the stigma of being played for a fool, Sakhai did not back down. Instead, he continued to deny that the painting was a fake. As Takeuchi would later describe, Sakhai "remained unruffled."[23] Remarkably, Sakhai played his dupe perfectly. Swayed by Sakhai's stubborn denial of both Takeuchi's accusations and the experts' findings, and the fact that other well-known

Japanese buyers had done business with the dealer, he backed down and held on to the Rembrandt. Takeuchi was also buttressed by the fact that Tanaka told him the painting was nonetheless worth about $4.75 million—a curiously high figure for a copy. After all, in 1997, Tanaka wrote to Sakhai, stating that the painting he had sold to Takeuchi was not the authentic *The Apostle James* and that "the differences between the two" were "easily" detected.[24] So despite being exposed by experts and confronted by a powerful buyer, Sakhai was able to walk away from his sale of a copy unscathed. Tanaka's unusually high valuation of the painting, perhaps a gesture intended to save his client any further embarrassment, also spared Sakhai an earlier comeuppance. But he was far from done, duping an untold number of buyers in Asia and elsewhere. Federal prosecutor Jane Levine would later write that "Sakhai interjected hundreds of forgeries into the international art market."[25]

CALL IT KARMA OR SERENDIPITY, but Sakhai would be undone by circumstances as simple as his scheme was complex. Not content to simply make enormous profits on the fakes he sold to unsuspecting buyers, Sakhai's greed led him to sell the original authentic works too. When a few years had passed after he sold his fraudulent works, Sakhai would move to sell the real painting. Because he had used the original certificate of authenticity to sell the copies, he would need to have a new certificate issued. Armed with the real painting and clear title and provenance to support him, obtaining authenticating documents was relatively easy.

One of the originals he decided to sell was Paul Gauguin's *Vase de Fleurs* (*Lilas*). In order to do so he approached Sotheby's in New York, which promptly listed the painting in their catalog for their spring auction in May 2000. Sotheby's main competitor, Christie's, also had a Gauguin for sale in their spring auction catalog: an identical *Vase de*

Fleurs (Lilas). It wasn't long before the two auction houses communicated with each other and agreed to submit the paintings to an expert to determine whose was the fake. For authentication they turned to Sylvie Crussard of the Wildenstein Institute in Paris.

Crussard is the coauthor of *Gauguin: A Savage in the Making: Catalogue Raisonne of the Paintings (1873–1888)* and one of the world's leading experts on the works of the great French Post-Impressionist. The painting created by Sakhai's Chinese copyist was considered by the expert to be "so similar in the detail of brush strokes that one would not notice any differences from photographs if one did not suspect the existence of two versions," and said it would be "impossible to tell which version should be catalogued" from photographs.[26] However, Crussard knew that Gauguin would never have copied one of his paintings without making changes, and when the two actual works were put side by side, "all doubts were quickly removed." Crussard examined not only the brush strokes, but the sides and reverses of the paintings and easily found that despite Sakhai's best attempts to artificially age the copy, they were vastly different. "One looked old and the other new," she said. "And no one hesitated" in identifying the authentic painting from the fake.[27] The Christie's version was pulled from its catalog and Sotheby's sold Sakhai's original at auction. Unlike the better-known works by Gauguin, which can sell for tens of millions of dollars, *Vase de Fleurs* brought Sakhai more than $300,000.

FBI agent James Wynne worked to find the provenance of the fake, which had been sold to a Japanese collector before making its way to Gallery Muse in Tokyo.[28] Based on his decades-long experience in investigating art crimes, he was able to determine that the ownership of both the fake and the authentic paintings intersected at one person: Ely Sakhai. Later, more such cases would become known to the bureau. One buyer who purchased a work by the Swiss painter

Paul Klee later found that the identical painting was being offered by Sotheby's. Alarmed, the collector alerted investigators, who tracked those paintings back to Sakhai as well. Soon, thanks to the dogged efforts of Agent Wynne, feds were able to track a dozen such incidents involving Sakhai, beginning 14 years earlier when he bought Marc Chagall's *La Nappe Mauve* at Christie's in London for about $300,000. He fraudulently sold a copy of the painting three years later for nearly a half-million dollars; five years after that, he sold the authentic work for over $30,000 more than he paid for it.[29]

Wynne's work on the case was nothing short of painstaking. In addition to the intense provenance research he completed, he also set about doing stakeouts of Sakhai's establishment to find who was painting the copies. Said prosecutor Jane Levine, "Jim Wynne was able to identify, locate, and speak to many of the artists that had actually created the forgeries."[30] Once he had interrogated the Chinese artists, Wynne was able to convince them to provide evidence of Sakhai's scheme. The artists gave Wynne photographs documenting the copies they had made. Said Wynne, "To me this was the most significant event in the history of the case, because we now had Mr. Sakhai commissioning, ordering, orchestrating the entire scheme."[31]

ON MARCH 9, 2004, Ely Sakhai was arrested in his gallery in New York on federal mail and wire fraud charges by James Wynne and a number of his fellow FBI agents. Three months later, a Southern District of New York grand jury indicted Sakhai on those charges as well as the related conspiracy. A September 2004 statement to stockholders of another of Sakhai's business ventures, Australian-Canadian Oil Royalties, declared that Sakhai had been indicted but that he, as the company's president and director, "vigorously" denied the charges.[32] That vigorous denial didn't last long. As happens with so many art fraud con men, Sakhai realized the government's case against him

was rock solid and pleaded guilty on November 29, 2004, to the conspiracy and mail fraud charges. He also agreed to an enormous restitution agreement that would require him to repay $12.5 million to his victims in addition to the forfeiture of 11 paintings.

At his sentencing, Judge Loretta A. Preska sentenced Sakhai to 41 months in a federal penitentiary. Yoichi Takeuchi attempted to sue Sakhai in a New York federal court for damages related to the sale of the phony Rembrandt painting, but he was unsuccessful due to the statute of limitations on his case. He is not alone in his loss. As Sakhai's prosecutor Jane Levine has written, despite a six-year intensive investigation into Sakhai's wide-ranging fraud, "we do not know and may never know the full scope of the crime and the damage caused." She added that the damage done by Sakhai "will reverberate in the art world for many years to come," because Sakhai's copyists made hundreds of copies for him that are still out there in the hands of unsuspecting dupes, all wanting to believe they have the real thing.[33]

EIGHT

THE BAIT AND SWITCH

THE LATE PUBLISHER MALCOLM FORBES WAS ONE OF THE GREAT COLLEC-
tors in American history. His was an eclectic taste: he amassed toy
soldiers, autographs, and, most famously, Fabergé eggs, for which he
had a fascination that began in his youth. He also collected historic
documents, purchasing the expense account that Paul Revere submit-
ted after alerting the townspeople of the coming of the "Regulars," as
well as a note handwritten by Abraham Lincoln. While Forbes was
also a collector of art and favored military depictions while eschew-
ing abstract art, perhaps the art he loved most was the art of collect-
ing. "If anyone should seek my advice about collecting," he said, "I'd
quickly point out the old truth—buy only what you like. Measure a
work by the joy and satisfaction it will bring."[1]

After Forbes's death, most of his collection was sold over time,
and little today remains of what he so passionately collected. Even his
treasured Fabergé eggs would eventually be auctioned off, along with
his paintings. While his art collection was certainly valuable, it did
not rival that of other families known for their wealth. "My interest
is not that of an academic collector," Forbes said. "I didn't grow up

exposed to old masters. My father didn't found the Mellon museum." Instead, his artistic tastes veered toward trompe l'oeil, or "trick the eye" works—artistry so meticulously detailed that it made the two-dimensional appear three-dimensional.[2]

Forbes, then, would likely have appreciated the work of the Los Angeles–area artist Maria Apelo Cruz, a trompe l'oeil artist whose ability to create classic reproductions has garnered her elite clients from LA and Beverly Hills who are looking to restore intricate works of art on items ranging from antique furniture to large murals. *Elements of Living* magazine reported in 2005 that Cruz, classically trained as a painter, kept herself busy by copying the styles of long-dead painters. "I love to recreate what I find most beautiful. Luckily for me enough people have a need for my particular skill."[3]

One such person was Tatiana Khan, the owner of the Los Angeles art gallery Chateau Allegré. The then 65-year-old Khan had spent over four decades in the business of buying and selling art and approached the talented artist with a commission. She showed Cruz a photograph of a pastel drawing by Pablo Picasso and offered her $1,000 to make an exact replica of the work. The drawing was needed for a noble cause, explained Khan, whose appearance was that of a much older woman. A client of hers had owned the original, she said, until it was stolen from the client's home along with some jewelry. In order to catch the thief, the police needed an exact copy to use as a prop, so Khan was willing to provide the artist the exact dimensions of the original. Understanding that she'd be helping the authorities to recover a work by a true master, Cruz accepted the job and went to work duplicating the work.[4]

As a first step, Cruz took the photo Khan provided her to a copy store in Van Nuys and enlarged the image in the photo to the size prescribed by the art dealer (30.5 × 23 cm). Then, back in her Sherman Oaks studio, she merely traced the image in the photo onto

paper and used pastels to add the appropriate color. The original work consisted of varying shades of blue with touches of yellow, gray, and rouge, and it took Cruz only two weeks to copy. When she was done, Cruz had a dilemma: as an ethical artist, her practice upon completion of a copy of such a work would be to sign it with her own name followed by "after" and the artist's name, in this case "after Picasso." But since it was her belief that the piece was to be used as a prop in a ruse conducted by the police, she contacted Khan and sought her guidance. Cruz was told to sign Picasso's name only, and she did as she was instructed.

There was no reason that Cruz should not trust Khan. The two had a preexisting positive relationship, and Khan had her admirers in the community. A professional associate spoke of her practice of putting concern for her clients over any desire for a "quick sale." Members of her family spoke of her big-hearted nature, calling her "the family angel" who provided an unemployed sister living out of state with large sums of money for her cancer treatment. Even former Nevada attorney general George Chanos attested to her character, describing Khan's actions as a businesswoman as "evidencing a caring and compassionate soul, someone who cared more about doing the right thing than making a sale."[5]

Perhaps it was this reputation that led buyers to Tatiana Khan. One buyer from Beverly Hills had been purchasing "collectibles and other decorative items" from Khan for years. Most of these items were those that Khan told the buyer she was selling from Malcolm Forbes's collection. This was nothing new, according to Khan, who said that most of the items she had for sale were obtained from a London dealer involved in moving Forbes's collection. Another customer bought four items from Khan for about $4,000, all of which were let go at a great deal in order to clear space in Chateau Allegré for the entire Forbes collection, which Khan said she had purchased.

Clearly, Khan's connection to the collectibles from Malcolm Forbes's estate was a key selling point for her business.

It was this sort of cachet that led Jack K. to bring his business associate, Vic S., to Khan's gallery on La Cienega Boulevard in Los Angeles in July 2006.[6] Vic, who had been making investments with Jack for around a decade, was in the market for Impressionist paintings, and since some of his investments with Jack had included art purchases through Chateau Allegré, he met with Khan in person to discuss the sort of items he was seeking. Khan told the investors she might be able to accommodate their needs since she was in possession of artwork from the Forbes estates for sale. Because of a conflict within their family, Khan explained, the Forbeses were desirous of handling the sale of their works privately. As a result, the works from the Forbes Collection were available below market value. As proof of her connection to the Forbes family, Khan opened a book in her shop and showed Vic the signature of Malcolm Forbes inside. It was a strong sales pitch by an experienced dealer.

Aware that there was money to be made selling Impressionist works to the pair, Khan began to seek some high-value pieces and contacted Frederick Hudson of Frederick Hudson Fine Art in New York City. Hudson is a reputable art broker capable of connecting buyers and sellers of art, and Khan was seeking to be connected to people looking to sell Impressionist works that she could then sell to Jack and Vic. Hudson went to work reaching out to his contacts to get photos of art that met the needs of the two investors. He sent what he had to Khan.

Included in the pile of photos that Hudson delivered to Khan was a painting by the esteemed Jewish Modernist Marc Chagall titled *Le Bouquet Sur le Toit,* an untitled work by the Dutch American master Willem de Kooning, and a drawing by Picasso called *La Femme au Chapeau Bleu* (*The Woman in the Blue Hat*). Of the three, Hudson

was only able to provide certificates of authenticity for the Chagall and de Kooning. She took special notice of these as good prospects for her client-investors, and asked Hudson to seek the certificate of authenticity for the Picasso.

The asking price from the private European owner of *La Femme au Chapeau Bleu* was $1.35 million, but the absence of provenance was a sticking point for Khan. Hudson contacted his counterpart who represented the Picasso's owner but was unable to obtain an authenticating document. Though Khan said she had a buyer lined up for the Picasso, she and Hudson spoke no further about the drawing. Khan came up with a solution of her own: she visited her trompe l'oeil artist, Maria Apelo Cruz, with her story about the theft and the need for the pastel drawing for a police operation.

WEEKS LATER, KHAN CALLED Hudson with "something to tell him that he wouldn't believe."[7] Incredibly, she said that during a visit to a client's home she saw the exact Picasso pastel about which she had previously inquired, and she intended to get it to show to him. Soon thereafter, Khan again called Hudson, this time inviting him to come to Chateau Allegré to see the Picasso. When he arrived, he saw that Khan had not only miraculously acquired the pastel, but she also was able to get the provenance she needed. She explained that on a trip to Palm Springs she was able to obtain *La Femme au Chapeau Bleu*, along with its certificate of authenticity, which the former owner had kept in her safe deposit box after inheriting an art collection from her father. In addition, Khan told Hudson that she obtained the work in a trade, giving the Palm Springs woman a large-scale European sculpture that had been in her garden.

Something about the pastel apparently didn't seem exactly right to Hudson. The experienced art broker, unaware of Khan's scheme, advised her to contact Sotheby's to discuss the Picasso because of the

similarity between the work she had and the one that the auction house had previously sold for $900,000. Thinking that this could not be one and the same as the image he had sent her in a photograph, Hudson posited to Khan that perhaps Picasso made two versions of the work. If this was the case, her work could draw attention in the art world—and that attention could conceivably increase its value. Curiously, Khan was not only uninterested in pursuing such information, she told Hudson "not to say anything about it and to leave the matter alone."

While Khan's Picasso only raised questions in the mind of Frederick Hudson, Jack and Vic were impressed with the pastel, which they believed had been created by the storied artist in 1902. They entered into an agreement to purchase it from Khan in 2006 for $2 million. Just a few days later, Khan provided the investors with an appraisal listing the value of *La Femme au Chapeau Bleu* at $5 million. Vic saw an opportunity to profit from investments in art through Khan's access to the Forbes Collection, and he set out to form a collective of investors with whom he could gather up valuable Forbes pieces at bargain prices. As part of this venture, Vic gave Khan deposits on the untitled de Kooning and a Renoir from Chateau Allegré, but those deals later fell through.

IN 2007, NEARLY EIGHT MONTHS after buying the phony Picasso, Vic decided that it was time to sell it and realize some profit from his investment. He called Jack and informed him of his decision to sell the piece. Jack brought the pastel to Khan's gallery, where it sat for 17 months unsold. From time to time, the art dealer would contact the owners to say that she had received offers on the purported Picasso, but these were merely creations of her imagination, devised in order to keep the investors at bay.

Soon the pressure on the owners to sell the pastel intensified. The financial crisis of 2007–08 forced Vic's hand, and he met with a financial adviser to discuss his investment portfolio. As a first step, the financial adviser told Vic to compile a complete inventory of his assets and their itemized values. Apparently not content with a June 2008 appraisal produced by Khan placing the value of the pastel at $5 million, he brought his version of *La Femme au Chapeau Bleu* to the Silverman Gallery in Beverly Hills. After examining the piece, the Silvermans were concerned about its authenticity and referred Vic to Dr. Enrique Mallen, a professor of Spanish and art history at Sam Houston State University.[8] Mallen is a respected expert on the subject of Pablo Picasso and is the general editor of the On-line Picasso Project. The site boasts more than 24,000 artworks in its digital catalogue raisonné and bills itself as "the most comprehensive, authoritative resource on the life and works of Pablo Picasso."[9] Mallen examined what he described as "substantial photographic and textual evidence"[10] to compare the Khan Picasso with the pastel that in 1990 had been sold at auction by Sotheby's in New York. "I immediately knew where to look for comparison since the original artwork is a known pastel, which some identify as a portrait of Jane Avril," Mallen recalled. "After comparing the two artworks closely, it did not take long to see the similarities and discrepancies."[11] Connoisseurship was undoing the scheme. Mallen's conclusions were nothing short of damning: not only wasn't the Khan pastel the same work auctioned by Sotheby's, it was "not by the hand of Pablo Picasso." The professor had also found troubling the fact that the signatures on the two works were "to all intents and purposes, identical," explaining that Picasso's signatures during the time the original piece was produced "varied considerably."[12] Thus, the Khan pastel could not even have been a separate version created by the master, since the

signatures would not have been identical. Instead, their similarity pointed toward a copy.[13] Further, as Mallen later stated, "Picasso has never copied himself. He was even quoted as saying that the worst thing an artist can ever do is copy himself."[14]

Picasso himself once said that "it is not enough to know an artist's works. One must also know when he did them, why, how, in what circumstances . . . I attempt to leave as complete a documentation as possible for posterity."[15] Clearly, in this instance, his signing technique at the turn of the twentieth century left documentation that protected his legacy. He once refused to sign one of his paintings for a woman, telling her, "If I sign it now, I'll be putting my 1943 signature on a canvas painted in 1922. No, I cannot sign it, madam, I'm sorry."[16]

Despite this apparent attention to detailing authenticity, however, Picasso's works have been the subject of rampant art crimes. According to Claudia Andreiu, the legal counsel for the Picasso Administration—the organization responsible for handling permissions and rights for the artist's works—"Authenticity is a huge issue and is more and more complex, especially with all the fakes and forgeries and all the undocumented works coming into the market in the last few years."[17] This cache of questionable works can often be difficult for experts to authenticate. One of the complicating factors is the absence of an exhaustive catalogue raisonné, due in part to the fact that the artist was so remarkably prolific. While the On-line Picasso Project's catalogue size is impressive, it accounts for less than half of his more than 50,000 works.

Moreover, in 2012 the Art Loss Register announced that according to its stolen art database, Picasso's works have been stolen more than those of any other artist. The ALR reported that there are 1,147 stolen Picassos, outpacing the second-most-stolen artist—American painter Nick Lawrence—by more than 2 to 1.[18]

Picasso's link to art crime is not only as victim. In 1911, when arguably the most famous painting in the world, Leonardo Da Vinci's *Mona Lisa,* was stolen from the Louvre, a young Pablo Picasso was considered a prime suspect, along with his associate, the poet Guillaume Apollinaire. As it turned out, Picasso's connection to a roguish character named Honoré Joseph Géry Pieret—who himself had pilfered some objects from the Louvre—was the cause for the suspicion cast upon him and he was, of course, eventually removed from the list of suspects.[19]

STOLEN PAINTINGS WERE ON THE MIND of Canadian journalist Joshua Knelman when he was tagging along with legendary LAPD art crime detective Don Hrycyk and his partner as Knelman did research for his book *Hot Art: Chasing Thieves and Detectives through the Secret World of Stolen Art.* Coincidentally, the author and Hrycyk encountered Tatiana Khan in her home in Los Angeles. Knelman described the scene:

> The detectives walked around to the rear of the house. They found a door in the fence and slipped into the back garden, which was full of statues and plants packed tightly together. A narrow path led to a back door. They knocked. A Hispanic caregiver answered and invited them inside. The back hallway opened into a yawning room, two floors high. The room was packed full of antiques and paintings. It was chaotic; it looked like the piled-up remains of what once was a thriving antiques business. An old woman sat in a chair near a row of television screens filled with images from cameras. . . . Before they left, both Hrycyk and [his partner] had noticed what looked like a Picasso perched carelessly on a cluttered sofa. They inquired about it, and the woman told them it was a genuine Picasso worth a huge sum of

money. Hrycyk surreptitiously took a photo of the painting with his cell.[20]

That Hrycyk would have a sixth sense about the work is not unusual. For more than 20 years, he has investigated art theft and forgeries for the Los Angeles police and is arguably the best investigator ever to work art crime cases. While most cops would probably have believed they had stumbled upon some sort of eccentric—or deluded—Miss Havisham character, Hrycyk knew something was amiss with the work. But it wasn't until another law enforcement officer with a strong background in investigating fraud was on the case that Khan's scheme would fall apart.

BECAUSE OF DR. MALLEN'S FINDINGS declaring the Picasso pastel *La Femme au Chapeau Bleu* sold by Tatiana Khan a fake, the matter was referred to the Federal Bureau of Investigation and placed in the able hands of Special Agent Linda English. English had spent nearly 20 years with the FBI when she was assigned the case. With an expertise in fraud and financial crimes investigations, she was well equipped to look into a forgery scam involving millions of dollars in investments. Earlier, she had been the lead agent whose dogged investigative work cracked a major financial fraud scam involving a real estate investor who concocted an elaborate Ponzi scheme through which she convinced 600 people to invest $18 million in foreclosed properties. She also brought down an even larger Ponzi scheme—second only to that of Bernie Madoff—when her work led to the arrest of Reed Slatkin, one of the cofounders of EarthLink. Slatkin had left his ministry in the Church of Scientology to prey upon investors, including some members of his former flock and Hollywood celebrities, ultimately bringing in nearly $600 million from his dupes. English's work on

these cases was noteworthy enough to warrant two segments on the CNBC television show *American Greed*.

English went to work scouring Khan's financial records, and she contacted former customers who told of their experiences buying from Chateau Allegré under the impression that they were buying items from the Forbes Collection. She examined wire transfers to confirm payments from Vic and Jack for the pastel, and then twice met with Tatiana Khan herself at her home and gallery in Los Angeles.

The investigator found Khan to be "sickly," with an oxygen machine and severe scoliosis, and her gallery "packed full with antiques and furniture." English—who had interviewed countless scam artists in her career—was quickly onto Khan's scheme, though she did think Khan "was a good liar," as she recalled, "and used her frailties to her benefit."[21] Also aware that Khan had used the Forbes Collection provenance to establish her bona fides when selling Vic and Jack the fake Picasso, English asked Khan how she came to acquire the piece. The art dealer told the FBI agent an entirely different story than the one she used to make the sale to the pair of investors. This time, Khan stated that she obtained the pastel from a woman named Rusica Sakic Porter around 2005. According to Khan, Porter was an aesthetician she had met when one of her gallery employees visited Porter for a facial across the street from Chateau Allegré. As is the case in many provenance scams, Khan used war to explain the artwork's dicey history, saying that Porter's family purchased the work before the Bosnian War. Khan told English that Porter borrowed $40,000 from her and gave her the Picasso as collateral for the loan.

Khan developed the story even further, telling the FBI agent that she had a document she obtained from Porter. She retrieved it and handed it to the investigator, and explained that she had cut

the top of the page off because it had the price paid by Porter's family—$300,000—on it. In order to get a current market value for the work, Khan claimed she contacted Christie's and Sotheby's and received values ranging from $2 million to $5 million. Nevertheless, she sold it to Jack and Vic at the low end of that range in order to move it quickly.

Khan's story became more elaborate still. She told English that after she sold the Picasso, she told Porter that she would determine how much money she owed to her from the sale. Because she was soon departing for a trip to Bosnia, Porter told Khan to pay her bills for her while she was away and upon her return they would make arrangements to settle their finances. However, about a year after her return from Bosnia, Porter died, according to Khan.

English discussed with Khan her claims about selling items from the Forbes Collection. Khan admitted that she was being sued by two former clients about falsely representing that the items she had sold them came from the Forbes Collection. In a departure from what she had told others, Khan told English that she had merely sold a cabinet and some books with Forbes's stamp in them.

Now Khan had provided two completely disparate provenances for the pastel, neither of which was based in the truth. But the truth was known by English, who described the dealer as "the consummate con."[22] On October 8, 2009, English interviewed Frederick Hudson, the art broker who had originally supplied the photo of the available—and authentic—Picasso *La Femme au Chapeau Bleu*. During his meeting with the FBI agent, Hudson was forthcoming about his interactions with Khan related to the Picasso, from the moment he sent her the images of available art to her seemingly serendipitous stumble upon the pastel at the home of a woman in Palm Springs. While meeting with Hudson, English reviewed provenance information held by Hudson for the works he was dealing. She noticed that

the record Khan produced, which had allegedly belonged to the Porter family from prewar Bosnia, matched Hudson's records perfectly but for Hudson's letterhead graphic at the top—the portion that was ostensibly cut off by Khan to remove the original price. English clearly had damning evidence in the case: an apparently forged record of ownership and the third provenance story that Khan had used. This, combined with the findings made by Mallen of the On-line Picasso Project, made it clear that Khan knowingly was shopping a fraudulent piece of art. English now had all she needed to make her case against Khan. But one question remained: Where did it come from?

Special Agent English didn't have to wait long to find the answer to that question. The very next day after she interviewed him in person, Frederick Hudson telephoned her with a piece of information that he recalled in the hours since their meeting. Once, he recounted, when he was at Chateau Allegré, he was introduced to an art restorer named "Maria," a trompe l'oeil artist who had regularly worked with Khan. Hudson told the investigator he was shown a book of her work and that he found Maria's work was "remarkable."[23]

English tracked down Maria Apelo Cruz based on Hudson's information, and because her years of investigating complex fraud schemes had taught her the value of meticulously examining all of the data before her. After she had gone through the larger entries in Khan's financial records and ledgers, she moved to the smaller expenditures and followed up with the individuals with whom Khan had dealt. She came across a $1,000 payment to Cruz and paid her a visit. After discussing some furniture that Cruz had restored for Khan, English had a question for the artist: "Have you ever seen the painting *The Woman in the Blue Hat?*" Cruz's response took the seasoned agent aback: "I painted that."[24]

English said she was in "complete shock" when she learned that Cruz had been the artist of the phony Picasso, especially because of

the paltry sum she had been paid for creating a work that sold for well over a million dollars. While the FBI agent had been involved in cases involving many millions of dollars, this was her first art case, and the nuances of the art world—both legitimate and illicit—were new to her. Now she was studying up on details like provenance and the authentication of paintings. So while an agent from the bureau's Art Crime Team might not be surprised to hear that an unwitting forger was paid only $1,000 for a painting, it was news to English. And that's not to say that the fake wasn't well done: English would later recall that the prosecutor on the case, an art aficionado herself, considered Cruz's copy to be "beautiful."[25]

The artist, who English found to be "very credible,"[26] went on to tell of Khan's visit and commission to reproduce the pastel in order to help the police trick a thief. And then Cruz described a later visit from Khan in which the dealer predicted the FBI agent's visit on the topic of the pastel. Cruz informed English that Khan instructed her to lie to the FBI—a federal crime—by stating that she hadn't copied any art for her. Instead, Khan said, Cruz should simply say that she had restored art for her. She then went a step further and told Cruz to falsify her invoice for the work by indicating that the $1,000 fee was for retouching work on a primitive painting. Cruz told Khan that the request made her feel uncomfortable and refused to take the invoice back in order to make changes. Concerned about what she was hearing, and unwilling to run afoul of the law, Cruz asked where her copy was and Khan was cryptic, saying that she had given it to a friend.

In order to cover all of her bases, English continued to hunt down possible leads she found in Khan's financial records. Though the majority of the items Khan sold were antiques and furniture, she had bought and sold enough paintings to lead the investigator to create a spreadsheet listing them and their provenance in order to ensure that this affair was not part of a larger scheme.[27] After English

had tracked each of them down and completed her work examining Khan's finances, it was time for the bureau to move on Tatiana Khan.

KHAN'S ATTEMPT TO GET CRUZ to falsify the invoice and mislead the FBI constituted witness tampering, and the false provenance story she gave to English during the interview constituted providing false statements to the FBI. Further, the electronic financial transactions she conducted with Vic and Jack constituted wire fraud. So, on the morning of January 8, 2010, federal agents visited the home of Tatiana Khan and presented her with a summons directing her to appear in federal court for an initial appearance nearly three weeks later. During a search of her home, investigators came upon a de Kooning painting that she purchased with the ill-gotten gains from the counterfeit Picasso. As a result, the feds seized the $720,000 painting from the home.[28]

The charges against Khan brought with them a maximum sentence of 45 years in federal prison. Now approaching 70 and in ill health, Khan and her attorneys decided to accept responsibility for her crime in what would have been a slam-dunk case for prosecutors. It was a wise move: federal probation officers responsible for compiling a pre-sentence recommendation to the judge cited her extremely poor health as a reason for a downward departure in the sentencing guidelines for her crimes. Sparing the government a trial would also spare Khan a long sentence.

Khan's attorneys, James Spertus and Amanda Touchton, described her extensive cardiac and respiratory problems as not only cause for a sentence of probation, but as the reason for her crime. "Ms. Khan will not survive any sentence of imprisonment. Ms. Khan committed the crimes of conviction while suffering from extreme financial pressures that resulted from overwhelmingly large medical bills. Ms. Khan has no medical insurance, she turned 70 this year,

and she [is] under a crushing debt from staggeringly high medical bills."[29] Federal prosecutors did not put up much of a fight to put Khan away for a substantial amount of time, and she was sentenced to five years' probation. There was, however, an additional component of the sentence: $2 million in restitution. Toward that end, Khan agreed that the de Kooning painting, which had been seized by federal agents under asset forfeiture rules, should be turned over to Vic, who would inform the court of her cooperation with regard to restitution.[30]

Less than a year after sentencing, Khan filed for Chapter 7 bankruptcy. It was an unceremonious end for an art dealer who once moved paintings valued in the hundreds of thousands. In her Bankruptcy Schedule B, Khan listed her antiques inventory as being valued at more than $6 million. The U.S. Trustee assigned to the case, Jason Rund, aware of her conviction and fearing that her information might be unreliable, decided to investigate this appraisal further. He contacted two reputable appraisers who informed him of the actual value of the inventory: $750,000. With her business gone, it would prove to be the last exaggerated appraisal Tatiana Khan would ever make.

NINE

THE PRINTMAKER

THE FAMED ART CRITIC ROBERT HUGHES ONCE DECLARED MODERNIST painter Marc Chagall to be "the quintessential Jewish artist of the twentieth century."[1] Born Moishe Shagal in Russia in 1887, Chagall's Jewish heritage is evident in many of his creations. He produced a large number of works inspired by the Bible, and while he didn't shy away from Christianity—his *White Crucifixion* was said to be a favorite of Pope Francis—the emphasis of his religious oeuvre was certainly the Jewish experience.[2] He describes the intersection between his religion and art in his autobiography, *My Life:* "In short, this is painting. Every Saturday Uncle Neuch put on a talis, any talis, and read the Bible aloud. He played the violin like a cobbler. Grandfather listened to him dreamily. Rembrandt alone could have fathomed the thoughts of the old grandfather, butcher, tradesman and cantor, while his son played the violin . . ."[3]

While perhaps best known for his paintings, Chagall worked in a wide array of mediums, including sculptures, tapestries, and ceramics. His skill with stained glass was such that his windows adorn synagogues, a number of cathedrals, and the United Nations building

in New York, where he created a window titled *Peace* dedicated to the memory of the late UN secretary-general Dag Hammarskjöld. After 1966, Chagall did very little painting and instead concentrated on making stained glass. He also turned to the creation of engravings on copper, but despite these efforts, this period of his career would become best known for his lithographs, a skill for which he is widely admired. Chagall learned the art of lithography at the atelier of Fernand Mourlot, a printmaker who was the key force behind the rebirth of lithographs after World War II. Charles Sorlier, who had been one of his teachers at Mourlot's studio, would soon describe Chagall as "an absolute master of the technique," and the artist spent years practicing his craft.[4]

At about this time, Chagall produced *The Story of Exodus,* a book consisting of 24 vividly colored lithographs measuring about 19.5 × 14.5 inches. Two hundred eighty-five signed portfolios were produced, with 250 of them numbered and printed on *Velin d'Arches.* Copies of *The Story of Exodus* are today quite valuable, with one realizing a price of $40,000 at a Christie's auction in October 2011.[5] Chagall's publisher was Leon Amiel, a successful New York publisher with strong ties to the Modernist art community. Though he published dozens of books on art covering artists like Paul Klee, Joan Miró, and Wassily Kandinsky, as well as works on Judaism and the Holy Land, his involvement with Chagall's *The Story of Exodus* was more than just that of a businessman selling a product. Like Chagall, Amiel was dedicated to his Jewish roots and published a wide array of works on Judaica, from tomes on Hebrew manuscripts to books on Jewish cuisine. The two collaborated on an illustrated Haggadah—a prayer book for the Passover service, and according to Amiel, it was during this work that he inspired Chagall to create his Exodus series of paintings.[6]

Leon Amiel's connection to legendary Modernists is impressive. In addition to his close relationship with Chagall (he would later write a book titled *Homage to Chagall*), the New Jersey–based publisher with a mansion in Long Island was friends with a number of other well-known artists. Picasso created a work in red, green, yellow, and purple pencil titled *Visage de faune (Pour Leon Amiel)* in 1957. Similarly, Salvador Dalí produced his own *Pour Leon Amiel,* a work in black and blue and including the Surrealist's trademark melting clock. Amiel was also a friend of the innovative and influential Joan Miró and published many volumes on the artist.

Amiel, a heavyset man with large plastic-framed glasses and an even larger smile, has been described as "a major force in the art world," hobnobbing with a veritable who's who of artists from his period and rising to the upper echelon in the world of fine art publishing.[7] By the mid-1980s, it was estimated that he was worth upward of $40 million. And a great deal of the fortune he was amassing was earned through the sale of the art prints he was producing at his publishing enterprise in Secaucus, New Jersey. Perhaps the key to his success was the modern and efficient printing presses he imported in the 1970s that utilized photography and color separation. These machines allowed him to produce thousands of lithographs per hour, while the traditional method of using lithographic stone produced just 30 in the same time.[8]

THE CREATION OF LITHOGRAPHS and serigraphs can be divided into three categories. First, lithographic and serigraphic prints are most valuable when they are produced as part of an original limited edition print. This category of prints must be created under the artist's supervision in order to meet the standard of ethics of the art industry. These prints are then signed and numbered by the artist as proof of

their acceptance of the edition, and the artist sometimes reserves a small percentage of them for his own use or for use by a publisher. Referred to as "artist's proofs," these are identified by the designations H.C. (*hors de commerce,* or "not for sale"), or E.A. (*épreuve d'artiste,* or "artist's proof") or A.P. (also meaning "artist's proof"), usually in place of the edition number. Second, "afters" are copies of an original work made by others with the artist's permission. These copies have only nominal value in the decorative art market. And third, there are unauthorized reproductions of an artist's works, or works made to resemble what an artist might have created, made without the consent or involvement of the artist. If these works carry the artist's signature, they are considered forgeries.[9]

WHILE THINGS WERE GOING WELL for Leon Amiel's business, associates of his in the world of print dealing, Carol Convertine and her husband Martin Fleischman, had reason to worry. In 1986, their business, Carol Convertine Galleries, was raided by New York state authorities investigating them for using misleading sales tactics to peddle counterfeit art to investors via a telephone marketing scheme. Although Convertine Galleries boasted a Madison Avenue address that situated it near Museum Row, all of the Convertine sales were made by telephone through scripted salespeople who could reap 25 percent commissions for each sale. The script used by the print pushers made the claim to potential investors that art historically appreciated in value at a rate better than stocks, oil, diamonds, or rare stamps.[10] The climate was ripe for convincing potential buyers that they could expect their investments to appreciate dramatically and quickly. Before Convertine and Fleischman would be brought to trial, Van Gogh's *Sunflowers* would sell for $39.9 million—a then record auction price for a single painting. The prior high-water mark for a painting at auction was nearly $30 million less.[11] This market, combined with

the ever-present desire for investors to believe they have found the opportunity of a lifetime, ensured that the Convertine operation didn't disappoint its principals, grossing $1.2 million from the sale of about 2,000 poster-quality prints that they had bought for as little as $30 and sold for up to $3,000 by falsely portraying them as original lithographs by Dalí, Chagall, and Picasso. However, the scam also ultimately brought prison sentences for Convertine and Fleischman, who were charged with securities fraud because they sold the prints as investments.[12]

The Convertine prosecution was unique in that it amounted to the nation's first felony convictions against what was described as a "telephone boiler-room gallery."[13] At the heart of the case was an exploding trade in questionable fine art prints, and it would soon lead to investigations that would rock the art world.

LEON AMIEL'S NAME WOULD surface as a result of the Convertine case when he acknowledged that "some of" the fake lithographs had come from him. Speaking to the *New York Times*, Amiel explained that the Dalí lithographs he had provided were not fakes at all; rather, they were "lithographic interpretations" of Dalí's original works.[14]

Provenance for Dalí's works has been the subject of great scrutiny, and the ways in which his prints have become among the most faked in the world are as bizarre and difficult to believe as some of the surreal pieces he created. For instance, in the late 1970s, Dalí was paid $400,000 by a publisher named Lyle Stewart to produce illustrations for a series to be called *Tarot Cards*. When Dalí gave Stewart his completed illustrations, the publisher was unimpressed with the works and decided not to produce *Tarot Cards* and demanded a refund. When Dalí refused to give back the $400,000, Stewart filed a lawsuit. In an unusual resolution to the case, the judge ordered Dalí to sign 17,000 blank sheets of paper on which *Tarot Cards* would

have been printed so that Stewart could sell the package and recover his losses. Dalí, following the judge's orders, signed all 17,000 sheets under the watchful eye of an attorney.[15] There were now thousands of sheets of printing paper bearing the signature of the artist without also including his artwork. Anything could have been printed on it.

Incredibly, the situation got even worse. Stewart sold the blank sheets to Peter J. "Captain" Moore, a former assistant to Dalí whose relationship with the artist had soured. Moore sold the cache of signed blank sheets to three publishers in Paris. Then, according to A. Reynolds Morse, the founder of the Salvador Dalí Museum in St. Petersburg, Florida, Moore realized "if he could sell 17,000 sheets, he could sell 40,000." Soon, Moore began forging a large but untold number of signed blank sheets and selling them for $40 apiece to French publishers. The scam was finally discovered by French customs officials who nabbed a truck carrying 40,000 signed blanks. "Since that time, we have no idea how many [Dalí] sheets were forged, but it's in the millions," Morse said.[16]

Though it's still unknown how many Dalí frauds are in circulation, it's certain that the pieces pushed by Amiel through the ill-fated Carol Convertine Galleries were among them. Amiel further explained his dubious defense that the pieces were "lithographic interpretations" by saying, "I don't know how these people sell to the public. What they claim and how they sell it is something I don't get involved with."[17] In other words, his operating philosophy was that he merely produced prints; how dealers described them was up to them. And this credo would be an inspiration for generations of Amiels to come.

Though realizing outstanding profits from his business, the late 1980s would soon become a devastating period for the family of the publishing magnate. First, federal agents—apparently unimpressed by the statements Leon gave to the *New York Times* and spurred by

numerous accounts to the Federal Trade Commission about what appeared to be an art print fraud ring—turned their attention to his operation. And second, Leon Amiel was diagnosed with liver cancer that would take his life in October 1988.

Saddened but undeterred by the death of their powerful patriarch, the Amiel family forged ahead. First, Leon's brother Sam took over the business, but he was soon fired by Leon's widow, Hilda, when she discovered he had been stealing paintings.[18] Hilda then assumed the helm of the business herself with her daughters Kathryn and Joanne, and even her granddaughter Sarina, helping her run the business. The women met with Marc Kniebihler, Leon's trusted chromist—the person who had actually created the fraudulent artwork since 1983.[19] The Amiel women made it clear to him that they wanted to continue Leon's business. Kniebihler told the women that he would be willing to continue his work with them, but no longer wanted to be paid with the prints that were created at the Amiel workshop. Instead, the chromist said he "wanted to be paid with prints preferably made by the artist and signed by the artist." He told his new bosses that if they ran a "clean business" that, in time, they could be legitimately profitable. However, the Amiel women would have none of that.

Like Kniebihler, other associates wanted to discuss how work would proceed under the new Amiel leadership. One such person was art dealer Philip Coffaro, who had been dealing with Leon as far back as 1979. Though Coffaro initially believed he was obtaining legitimate art from Amiel, it took just a couple of years for him to realize that the works he was purchasing were, in his words, "no good." The prints were too plentiful, and the color and paper just not right. But it wasn't just connoisseurship that told Coffaro that the prints were frauds. He had witnessed Leon boldly sign and number "limited edition" works in other artists' names at his Secaucus facility.

Leon even taught Coffaro how to place fraudulent edition numbers on prints in a manner by which he could avoid detection. Nevertheless, Coffaro was pleased with the profits he was turning and continued to deal with Amiel. But now Leon was gone, and Coffaro wanted to talk to the women to discuss what he felt was a "downgrading" in the quality of the prints they produced.

Hilda assured Coffaro that the prints would be better and that they had already "taken care of most of that in Secaucus, and the material was looked at and everything that looked bad was thrown out." She even promised letters of authenticity for future prints he bought from them. But Coffaro found that Hilda didn't make good on her assurances, and he remained dissatisfied with the quality of the prints he was receiving. According to Coffaro, the signatures that the Amiels were putting on their prints were problematic and appeared "child like." Since the days when Leon was running the operation, the practice was to leave the prints unsigned until the last moment in case law enforcement officers visited the facility, at which time they could simply say they were selling posters as opposed to authentic, authorized fine art prints. Coffaro eventually confronted Hilda and Kathryn about the poor quality of signatures he was receiving. Coffaro recalled that Kathryn explained, "Look, I know [they] are terrible, my mother had my uncle signing them, but Sarina will be coming home soon and they will be better." Sarina was away at college in Boston and was the best signature-forger on the team. Her return would improve matters.

In around 1990, Hilda and Kathryn approached the chromist Kniebihler again to discuss some financial problems they were experiencing. What they needed, they told Kniebihler, was an inventory of the facility in Island Park to determine the value of the pieces they had on hand. He agreed, telling the Amiels that any fake prints he discovered would be considered worthless and not part of the inventory. Soon, Kniebihler found that the Amiels had sold a set of

Miró reproductions that he had made—portraying them as original, pencil-signed prints—to Flemming Hall, a major customer of theirs. His inventory also showed that all of the prints the Amiels were creating in Secaucus were fake. Kniebihler gave the Amiel women an ultimatum: they could either clean up their act right away or "forget the whole thing."[20] He also told them that Coffaro was a "crook."[21] The women responded by denying Kniebihler further access to the inventory at the Island Park facility.[22]

THE UNITED STATES POSTAL INSPECTION SERVICE (USPIS) dates back to Benjamin Franklin, who created the position of surveyor—a title changed to special agent in 1801—to help him regulate and audit the postal system. Today, postal inspectors work to protect the integrity of the nation's mail service by investigating those who, among other things, use it to defraud the public. Given the use of the mail to receive and distribute counterfeit fine art prints, the agency was a natural to join into the investigation of the Amiel family operation. USPIS utilized two undercover postal inspectors—Waiman Leung and Raymond Hang—to get to the bottom of the Amiel scheme.

Leung approached the Amiels, posing as an art dealer from Asia interested in purchasing genuine pieces of art, preferably by Dalí, Miró, Chagall, and Picasso—precisely the artists in which the Amiels specialized. After just one meeting, the undercover agent purchased 22 prints attributed by the Amiels to this group of artists and bearing signatures in pencil. When Leung inquired about authenticity, Kathryn Amiel informed him that she had no documentation for some of the artworks nor information about their provenance outside of what was in her father's documents. Instead, she insisted that the sale was on an "as is" basis.

Postal Inspector Leung and his undercover partner, Raymond Hang, continued pressing Kathryn for some documentation proving

provenance. Kathryn and Sarina finally relented and rewrote, on company letterhead, information from Leon's documents and mailed it to the undercover investigators. Armed with the forged prints and the phony documentation, the feds executed a search warrant at the Island Park facility in July 1991. Postal inspectors uncovered and seized stacks of prints, the first few signed and the rest unsigned, which was consistent with the practice of the late patriarch. In all, federal agents found and confiscated 50,000 prints supposedly by Dalí; 20,000 Mirós; 2,200 Picassos; and 650 Chagalls. They also took print reproduction equipment and seized over $1.3 million in cash, $1.5 million in properties, and three cars.[23]

During the search investigators found a copy of a fax that had been sent to the European distributor Flemming Hall by Sarina. On the top, Sarina wrote, "I was rummaging through a drawer and came across this quote! I hope you enjoy it as much as we did!" It matched copies of the same quote that had been posted on the wall of the Island Park facility under the heading "words to live by." It was the statement that Leon Amiel had made to the *New York Times* years earlier when the Carol Convertine Galleries had been closed: "I don't know how these people sell to the public, what they claim and how they sell it is something I don't get involved with."

THE AMIELS WERE ARRESTED for charges related to conspiracy to commit mail fraud, and federal trade officials estimated that customers may have been conned out of more than $11 million.[24] The U.S. Justice Department filed the charges against the Amiels while the Federal Trade Commission froze their assets. Criminal charges were also announced in Denmark and Sweden against the Amiels' European distributor Flemming Hall. The investigation, dubbed Operation Bogart for "bogus art," led to what the FTC described as an "industry-wide investigation of art dealers," and included the issuance of

subpoenas for a number of galleries, auctioneers, and distributors in several major cities.[25]

In January 1993, before the Amiels' trial could begin, Hilda succumbed to cancer. Before she died, she left a deposition in which she denied any wrongdoing. Her daughter Kathryn's defense lawyer told the press she didn't know what Leon's business practices were. "I'm not denying the stuff is bad," attorney Adrian DiLuzio said. "I don't know whether he was getting duped himself or he was doing the duping." But as for his wife, daughters, and granddaughter, "They were naive in the extreme."[26] However, the witnesses against the Amiel women painted a different picture. The chromist Marc Kniebihler, not a defendant, told his story, as did Philip Coffaro, who had been named as a defendant alongside the Amiels in an FTC civil complaint.

Another art dealer, former New York City police officer Thomas Wallace—who the Amiels alleged was deeply involved in organized crime—testified against the family. Like his father-in-law Coffaro, Wallace had met with the Amiel women to discuss operations in the post-Leon era and had been in the practice of purchasing pieces he knew to be counterfeit from their operation. The Amiels told him they would continue to sell him prints, but according to Joanne, they would not provide certificates of authenticity and would sell only on an "as is" basis. Wallace also assisted the Amiels in an inventory of their facility, and he testified that he saw large quantities of prints, some signed and some not. Again, each stack consisted of just one or two pencil-signed copies at the top with the rest unsigned, just as Leon had preferred. Wallace also purchased 20 pieces from the Amiels. When two were found to be unsigned, he returned them to Sarina, apparently the team's best forger, who took care of it for him.

Yet another art dealer was called to the stand to testify to the Amiels' illicit operation. Lawrence Groeger had begun purchasing

prints from Leon in 1988 and knew they were fraudulent based on the number available. During his meeting with the women in early 1989, he informed them that he was having a problem with galleries in California. "[A]lot of the galleries were aware of the fact that there were multiple copies of Miró prints available for sale." This, he said, "created a lot of suspicion regarding the authenticity of the prints." Though the Amiels told Groeger that they would protect him in the California market, his largest customer, the Upstairs Gallery, was raided by the Los Angeles Police Department later that year, with many of the prints that were seized having come through him from the Amiels. Groeger met again with the Amiels seeking documentation for the works, and though Joanne promised to help, it never came. Soon thereafter, Groeger himself was raided by police who confiscated 60 pieces of inventory and a set of prints that he had intended to return to the Amiels. All of it was found to be counterfeit.

The evidence presented at trial was overwhelming, and all of the Amiel women were found guilty by the jury. Kathryn, Joanne, and Sarina Amiel were given sentences of 78, 46, and 33 months in prison, respectively. And Operation Bogart continued with gusto, having placed Leon Amiel at the center of the large-scale international scheme that authorities believed resulted in more than $500 million in counterfeit art sales.

OPERATION BOGART NETTED ANOTHER crooked dealer in 1993, putting Chicago art dealer Donald Austin behind the defendant's table in federal court. At his high point, Austin, a former barber, had opened nearly 30 art galleries in Chicago, Michigan, and California. By the 1980s, his chain was bringing in about $34 million per year in sales of art priced from the hundreds to a few thousand dollars.[27] But during a raid of Austin's headquarters by the FTC in 1988, they found questionable works attributed to Dalí, Picasso, Chagall, and

Miró—the hallmarks of the Amiels' involvement. Austin had once allegedly said, "One day we'll all be sitting in jail because of Leon Amiel."[28] And he was correct: he was convicted of fraud charges and sentenced to 102 months in a federal prison.

Austin's involvement with prints obtained through Amiel was described in court from the witness stand by an art wholesaler from Northbrook, Illinois, named Michael Zabrin. Zabrin's involvement in art fraud first emerged in 1989, not as a con man, but as a victim, when the Los Angeles County district attorney's office charged self-described art "emulator" Tony Tetro with 45 felony counts for fabricating and distributing watercolors and lithographs. In addition to Miró and Chagall, Tetro—described at the time as "one of the largest art forgers on the West Coast"—forged 29 watercolors by Hiro Yamagata. Tetro and his accomplice, art dealer Mark Sawicki, defrauded four gallery owners including Zabrin.[29]

But Zabrin was anything but a victim when it came to peddling counterfeit art. A college graduate from a middle-class background, he turned an affinity for collecting prints into a lucrative career selling and consigning them. Eager to ensure a constant flow of art, he found a reliable source in none other than Philip Coffaro, the Long Island art dealer who had become a pipeline for Leon Amiel's operation. Short and curly haired with a bushy mustache, Zabrin was eager to meet the legendary publisher, and when he discovered that a close friend was a distant relative of Amiel's, an audience was granted. Soon, Zabrin had access to the Amiel mother lode of counterfeit art. He was no innocent dupe. He later recounted that when he would choose prints that bore no signature for purchase, Amiel's daughter "taught me to leave the room." Upon his return, the prints would all bear the autographs of the artists.[30]

Postal Inspector Jack Ellis would later recall that Zabrin "seemed like the cog" in the Amiel operation. Together with another postal

inspector, James Tendick, and David Spiegel of the FTC, Ellis formed a plan to squeeze Zabrin for information. Using an art dealer as a cooperating witness and an undercover postal inspector as her assistant, the feds purchased two Miró prints for which Zabrin provided signed certificates of authenticity. The prints were fakes. When the undercover officer later visited Zabrin's home, she took notice of a large number of Miró, Picasso, and Andy Warhol prints. In October 1990, federal agents raided Zabrin's business and seized his records. Then came the squeeze: the feds told Zabrin that he could face 20 years in prison for his crimes or he could cooperate with the authorities in hope of being granted some leniency. He quickly opted for the latter.[31]

Zabrin immediately became a key figure in the successful prosecution of the Amiels. Postal inspectors were able to gather damning evidence against Philip Coffaro thanks to Zabrin's work and then turned him into a government witness against the Amiel women as well as Groeger, Austin, and Ted Robertson of California, who had been identified as an active member of the counterfeit Dalí ring by Jack Ellis's predecessor, Postal Inspector Robert DeMuro. Robertson was not only dealing Dalís; he had broadened his counterfeiting horizons to include Erté, Picasso, Miró, and Chagall. To demonstrate his bona fides, Robertson even gave one prospective buyer a copy of a videotape showing him at Erté's birthday party. Unaware of the raids that had been carried out and of Coffaro's status as a government cooperator, Robertson approached Coffaro's business with a number of fake Picasso prints and Erté gouaches. He was ultimately arrested in his apartment in France in March 1992.[32] He pleaded guilty to two counts of fraud in federal court in New York.

For his efforts assisting the federal investigation into the enormous counterfeit lithograph ring, prosecutors recommended that the court be lenient toward Zabrin and the judge complied, sentencing

him to just one year and a day in prison, which the con man served at a low-security prison camp just hours from his home in Illinois. Except for the separation from his wife and two young daughters, his time in prison didn't provide the sort of punishment that was perhaps necessary to scare him straight. Zabrin told *Chicago* magazine, "I had no idea what to expect, but after I got acclimated and realized I could get along with everybody, it actually turned out to be fun. It was like a camp for bad boys."[33]

AFTER HIS RELEASE FROM FEDERAL PRISON, Zabrin returned to what he knew best: selling fine art prints. His time away was brief enough— only ten months at the camp and a short stint at a halfway house—to ensure that some of his connections were still active. Zabrin would soon form a new network, bringing on a business associate who could handle internet sales for him, a venture that would bring him hundreds of thousands of dollars. And though his prior pipeline of counterfeit prints were now serving long prison sentences, Zabrin found new sources to funnel fraudulent fine art to him. These included Jerome Bengis and an Italian national named Elio Bonfiglioli, whose counterfeit prints were considered to be of high quality. There was also James Kennedy, a man described as "a virtual caricature of the dealer con artist" who was fond of partying, alcohol, and drugs.[34]

There was one other individual who provided prints to Zabrin, and the name was all too familiar: Leon Amiel Jr. Despite his name, he was actually Leon's grandson, and he had access to a cache of his grandfather's prints that had not been seized by federal agents years earlier in the raids that resulted in the arrest of his grandmother, mother, aunts, and sister. Leon Jr. was eager to follow in the footsteps of his famous namesake and jumped feetfirst into the world of trafficking in counterfeit prints, using the online auction site eBay and other means to sell his illicit goods.[35] Meanwhile, his coconspirator

Kennedy would forge the signatures of artists such as Alexander Calder, Chagall, Miró, and Picasso on the prints he received from Leon Jr. Eventually, however, eBay caught on to the scheme used by Leon Jr., which included a system of placing bids for his own items in order to artificially inflate their prices. The massive auction site suspended Leon Jr.'s account and his activities, as well as those of Zabrin, Kennedy, and others who came to the attention—once again—of federal investigators.

Zabrin didn't confine his criminal activities to just art scams. In 2001, Zabrin was arrested and convicted for shoplifting a handbag off a display rack at Neiman Marcus. Four years later he would also be arrested for shoplifting a crystal figurine from Saks Fifth Avenue. But it wasn't until May 6, 2006, when postal inspectors and FBI agents executed a search warrant at Zabrin's home, that he was again facing serious prison time. This time, agents discovered a number of counterfeit prints and records regarding the sale of other pieces via art galleries and the internet. In one instance, investigators discovered that a customer returned a piece that was found to be counterfeit and was issued a refund by Zabrin, who in turn resold the same piece as authentic. The investigators also determined that Zabrin was receiving the bad prints from Bonfiglioli, Bengis, Kennedy, and Amiel's grandson.

Zabrin knew the routine and quickly agreed to again enter into what was perhaps his second-best role after con man—government informant. Zabrin wore a wire and made a number of recordings for the feds that helped them to bring criminal fraud charges, still apparently pending, against the other members of the ring. According to assistant U.S. attorneys Nancy DePodesta and Stephen Heinze, "[Zabrin], unlike many criminal defendants, readily admitted the scope of his criminal conduct and was forthcoming when asked questions regarding other subjects and aspects of the investigation."[36]

However, all was not well with Zabrin's performance: federal investigators discovered that Zabrin's addiction to pulling off scams was so strong that he had perpetrated a new one even while being handled as a federal informant.

Agents running the investigation orchestrated calls from Zabrin to a particular target. In an astonishingly risky and bold scheme, Zabrin made additional calls to the target unbeknownst to his federal agent handlers. In these unauthorized calls, Zabrin negotiated two separate purchases for a total of eight Chagall lithographs that would be financed by his business partner. However, Zabrin told his partner that he had only purchased six, with the intent to sell the remaining two for his own profit behind his partner's back.

Federal agents and prosecutors were irate, as they realized that this sort of unscrupulous behavior seriously jeopardized Zabrin's usefulness as a cooperator and eventual witness at trial. Zabrin's ploy proved self-destructive. This time, prosecutors made no pleas to the sentencing judge for leniency. Instead, the assistant U.S. attorneys assigned to the case were harsh in their recommendation to federal judge Robert Dow. Dismissing the defense attorney's excuses of mental illness for his behavior, they described Zabrin as "a very cunning individual who is able to effectively lie and manipulate others for personal gain." Zabrin, they argued, "poses a serious risk of recidivism"; they added that his crimes "constitute a thoroughly planned-out scheme to defraud hundreds of people over a period of several years."[37]

Despite his cooperation and assistance, Judge Dow agreed with prosecutors and dealt with Zabrin severely, sentencing him to nine years in federal prison. Meanwhile, the grandson of the man who reigned over this enormous counterfeit lithograph scam like a mafia don also pleaded guilty in federal court for his role in feeding fraudulent fine art to unsuspecting buyers. On June 15, 2011, U.S. District

Court judge Joan Gottschall heard Leon Amiel Jr. ask for mercy, choking up as he told her "my children are my life." Judge Gottschall, who could have sent Leon Jr. away for nine years in prison, was sympathetic to his request and sentenced him to only two. She cited his commitment to his family, his mental problems, and a family history of emotional and physical abuse in her ruling. "He (was) being raised by criminals," she said.[38]

TEN

THE TELESCAM

FORGED AND FAKED PAINTINGS ARE COMPLETELY DIFFERENT THINGS FROM their stolen counterparts. Stolen paintings are hidden away, banished from human contact, and stashed in attics, basements, storage units, and drug hides. But phony paintings live a different life. They hang on walls in homes, galleries, and even museums. They are like amateur boxers, jutting out their glass jaws and daring the observer to punch. However, the scam that moves the painting from knowing forger to unsuspecting buyer is ideally and most commonly pulled off in private, in a one-on-one meeting between the con artist and the buyer, who wants to believe they've found something special at a price that is even more special. And that's what makes the scam pulled off by Kristine Eubanks so audacious.

Eubanks, assisted by her husband Gerald Sullivan, was the brains behind an enterprise called Fine Art Treasures Gallery, which broadcasted a televised art auction for six hours every Friday and Saturday night on Dish Network and DirecTV. As her website advertised, her "auction show offers the best in fine art, original paintings, museum quality prints, bronze statues and other great art that will accent your

home or office or make a beautiful gift."[1] Eubanks, a Chicago native, had an unusually diverse professional background for a founder of a television art auction. She followed her dreams of working in Hollywood, and eventually moved to California where she served as executive vice president and partner at Elixer Entertainment, a film production company out of Los Angeles. After a successful stint at Elixer, Eubanks embarked on a career in marketing with Iwerks Entertainment in Burbank, a firm that developed special-format movie theaters. A driven, competitive businesswoman, she also studied fine art photography, an endeavor that served as a primer on the high-value prints and lithographs. And in the early 2000s, she discovered a burgeoning new form of art print called a giclée, which would open up new possibilities for her.

On her website for the television show, Eubanks provided a list of useful art-related terms for the novice art buyer. Posting the definitions made sense: part of the business model of Fine Art Treasures Gallery was clearly the marketing of high-end art to middle-class consumers who otherwise would not have access to the works of famous artists and who might be making their first foray into the purchase of art. Everything from "Artist Proof" to "Watercolor" was defined. The definition she supplied for *giclée,* however, was equal parts explanation and sales pitch. It read: "A giclée is a fine art print produced from state-of-the-art digital print-making and intuitive artistic treatment on archival watercolor paper or canvas that lasts for at least 75 years. Because of its archival quality, giclée fine art prints, [*sic*] are increasingly sought after by major galleries, museums, and private collections to help preserve fine art for generations to come."[2]

Interestingly, the folk rock musician Graham Nash was at the forefront of the creation of giclée prints. Nash, an accomplished digital photographer, was credited with the first use of inkjet printing in a fine art application, when in 1991 he made samples of his work using

the giclée process on a high-tech—and very expensive—IRIS 3047 commercial graphics printer. In fact, Nash coined the term *digigraph* for this new form, but it didn't stick. It was an associate of his in the field of high-quality print production, Jack Duganne, who assigned the term *giclée* to the process in order to give the product a bit more panache when an artist for whom he had made some of the prints asked him what she should call them. "I was looking for a French or Italian word, because so many art techniques have foreign names," he said. Adopting the French word for a jet nozzle—*gicleur*—because of the way the inkjet printer sprays color onto the paper, he opted for the word *giclée,* meaning something that was sprayed.[3]

The rapid and continuous improvement in the quality of commercially available high-end printers, combined with the fact that they are becoming more and more affordable, has led to an increase in the production of giclée works by popular artists. Today, giclée prints can be of such great quality that they appear in museums, both as digital copies of works being stored for preservation and as original works in exhibitions. Even noteworthy artists such as Frank Stella, Robert Rauschenberg, and David Hockney have been known to create giclée works.

Kristine Eubanks saw the potential that giclée held from an entrepreneurial perspective, and she placed an advertisement in the trade publication *Art Business News,* offering high-quality printing on canvas under the company name Finer Image. Martha O'Brien, whose husband John was an up-and-coming, well-regarded California artist, happened upon the ad. John O'Brien painted works best described as Contemporary Romantic Realism, creating images influenced by the Impressionists but in a style uniquely his own. His paintings included Parisian settings, landscapes, Irish life, Art Deco, and street scenes. He had studied his craft abroad and at the Art Students League of New York, alumni of which include

Frederic Remington, Norman Rockwell, Roy Lichtenstein, Georgia O'Keeffe, and Jackson Pollock, just to name a very few.[4] With giclées still relatively unknown to many artists, O'Brien was initially apprehensive. "He didn't like the idea of his work being cheapened," Martha, a ballet teacher, recalled. But Finer Image provided him with a sample giclée and O'Brien was floored.[5] "He couldn't believe the color jumped out so brilliantly," Martha said. The O'Briens began ordering custom printing for John's artwork by sending Eubanks's company high-resolution images of the work via photographic slides, and sometimes even sent originals for Finer Image to sell to a client. Then Eubanks made them a great offer: if O'Brien entered into an exclusive printing arrangement with Finer Image, they would realize a substantial income using their mass-marketing abilities— Eubanks's forte. O'Brien's works would get more exposure, be sold on a greater scale, and be of very high quality, all without sacrificing control because he'd be signing every piece. He was all in.[6]

The O'Briens were excited over the promise that the Eubanks plan held. The giclée-making dealer told John and Martha that they could make six figures with their art, and things were looking up. The money from Eubanks arrived steadily as John continued to send paintings to her print shop. It was an important break in the life of the young artist, his wife, and their two young daughters. With visions of Thomas Kincaid–like success in their minds, the O'Briens were ready for John's talent to take him to the next level of fame for American artists. "Okay, here's our ticket into that circle," Martha said. The deal with Eubanks was sure to "get his name out there big time and get full page ads at *Art Business News* and attract the collector who would pay $50,000 for one of John's paintings."[7]

Just as with all innocent victims, the O'Briens found that the Eubanks plan wasn't all that they had hoped. John soon found that the television auction show wasn't the only venue through which his

works were being sold as authentic signed works. A friend of O'Brien's informed him that he had seen one of the artist's signed works on eBay, the online auction site. The O'Briens had already decided that perhaps the site would be a good place for them to sell John's works to make some additional income. But when they went onto eBay to post some pieces for sale, they were shocked to find that the site had already been flooded with John's works for auction. Worse yet, many of the artworks were knockoffs—pieces he never actually signed.

This was O'Brien's worst fear come true. Indeed, any artist would be dismayed to lose control of their works in such a fashion, for this was a twofold problem: not only were there lesser-quality prints that he would not have—and never had—signed now on the market, but they were in such number as to drive the value of his art down. And soon, even more bad news poured in: the O'Briens learned that his works were being sold on Princess Cruises.[8]

ART AUCTIONS AT SEA aboard cruise ships are a big business. The biggest player in the game is Park West Gallery, a Michigan-based company that describes its "Park West at Sea" branch as a group of "onboard art galleries" on more than 70 luxury cruise ships around the world, including ships in the Carnival, Celebrity, Holland America, Norwegian, Regent Seven Seas, and Royal Caribbean lines.[9] The business is incredibly lucrative—the *New York Times* reported that Park West Gallery was bringing in $300 million in revenue annually as of 2008.[10] Though Park West was embroiled in a series of civil lawsuits filed against the firm by parties alleging the sale of fakes and forgeries—including suits involving works by, of course, Salvador Dalí—Park West's chief executive, Albert Scaglione, has stated publicly that "in Park West's 40-year history, we have never sold a nonauthentic work of art."[11] Indeed, neither Scaglione nor Park West has ever been the subject of criminal charges.

Princess Cruise Lines, which has never used Park West Gallery,[12] has itself been mixed up with fraud allegations. Two retired women—Terrie Kifer and Joyce Sexton, both of Delaware—saw ads for an art auction aboard the Princess cruise ship they had boarded. Taken by the art available at steep discounts, the pair spent $86,000 on art. Princess noticed their purchases and invited them back for another cruise and membership in their Art Connoisseurs Program free of charge, an attractive offer for two women with dreams of opening their own art gallery. The pair was wined and dined by Princess aboard a ten-day cruise in the Mediterranean and even met some of the artists whose works might draw their interest. The sales pitch worked: Kifer and Sexton spent an additional $250,000 on art onboard the ship, purchasing works by Picasso, Chagall, Miró, and Erté. A year later, the women flew to Copenhagen to board another complimentary cruise, again with an art auction onboard. This time they met the Soviet-émigré artist Martiros Manoukian, a Surrealist painter whose painting, *Tranquil Remorse,* caught the attention of the women. Bidding against another passenger, the pair won the Manoukian for $71,640. On a later cruise, Sexton and Kifer saw *Tranquil Remorse* again available for sale. Shocked, they approached the artist and the ship's representative, only to be told that the piece was not exactly the same as the one they purchased. Worse yet, this time *Tranquil Remorse* sold for $20,000 less than they paid. Though Princess offered to buy their painting back, the pair filed suit against the cruise line and the artist in state court in Florida.[13] The parties reached a confidential settlement with Princess admitting no wrongdoing.[14]

Kristine Eubanks was a source for Princess Cruises, and not only were John O'Brien's works being sold onboard their ships, but another artist, Charlene Mitchell, would find that her prints were for sale at sea without her knowledge. Eubanks's pitch to Mitchell was

not unlike the one she made to O'Brien: you provide the paintings, I'll copy and sell them. Mitchell, who had already achieved some modicum of success with her paintings on her own, was shocked one day when a person contacted her looking to commission a portrait of his fiancée. The caller told Mitchell that he had come to know her work from a piece he bought aboard a Princess cruise. Mitchell was taken aback: to her knowledge, none of her works were being sold in auctions on cruises. Worse yet, the pieces were fakes and, like O'Brien's, never authorized or signed by Mitchell. It turned out that thousands of Princess passengers had bought unauthorized prints sold in bulk to the cruise line by Kristine Eubanks.[15] Indeed, their works had flooded the market, with a deleterious effect on their value.

To make matters even worse, though the televised auctions were initially profitable (Mitchell says that she made up to $10,000 some weeks[16]), soon neither Mitchell nor O'Brien was seeing any money from Eubanks, despite the sales on the televised auctions, eBay, and on the cruises. In 2002, the O'Briens didn't see a penny, but Eubanks did.[17] "It was such easy money [for Eubanks]. It was just like counterfeiting money," Martha O'Brien would say of Eubanks's giclée business. "I mean you've got a printer. You type in 100 and push the button *print* and you've got 100 images."[18] John O'Brien was furious over his loss of control and the nonpayment for his work. And when Charlene Mitchell began questioning the lack of compensation for her work, Eubanks's personality changed from that of a pleasant marketing professional to that of an adversary.

OF COURSE, IT WASN'T JUST ARTISTS who were victimized by Kristine Eubanks and Fine Art Treasures Gallery. The unauthorized works were sold to unknowing dupes who wanted badly to believe that they had come across a special deal, and Eubanks found plenty of them. By 2007 it was estimated that the operation had brought in

more than $20 million from over 10,000 victims across the country.[19] The vast majority of them were unaware they had fallen victim to a scam. But one who caught on to Eubanks's scheme was Myron Temchin.

As Temchin recalls,[20] he and his wife, Mary, were flipping the channels on the television in a hotel in San Rafael, California, one evening in 2005 when they came across the Fine Art Treasures Gallery auction. When Picasso-signed lithographs came on the screen, they were intrigued. The auction show stated that the prints were originals, signed by Picasso himself, and valued at between $50,000 and $58,000. Further, each came with a certificate of authenticity from the Manchester Gallery, David Smith Authentication Service. The deals were too good to pass up, and the Temchins bid on two Picasso lithographs, *The Bullfight* and *Trois Femmes,* winning them both for a total of just over $4,000.

The Temchins were neither art novices nor the typical suckers born every minute. Myron specifically questioned the telephone representative for Fine Art Treasures Gallery and asked if the pieces were original lithographs bearing original signatures. Informed that they were indeed completely original, Myron provided his credit card information and completed the sale. This was no greedy attempt to make a killing on a couple of art pieces. Instead, the Temchins saw the purchases as a gift to their family. "I think we were excited to think that we could have a lithograph from Picasso and then it would be something we could pass down through the family," Myron said.[21] In about a week, the first of their treasures arrived in a carton at the Temchin home via FedEx. Upon opening the box and examining her new Picasso, *Trois Femmes,* Mary instantly identified a problem. To her it was clear that this was not a lithograph, but instead was much more similar to a color photocopy and did not bear an original signature by Picasso. She called her husband and told him that the piece

was not what it was purported to be. The certificate of authenticity was inauthentic as well; it was a "cheap black and white Xerox copy on colored paper."[22] Not even the signature on that appeared to be real.

The next day, the second Picasso purchase, *The Bullfight,* arrived in the same manner. Again, it appeared to the couple to be a photocopy without an original signature. The pair, concerned that they might have been conned, researched the authentication service and found that though there was a famous David Smith who collected art, he had no connection at all to art authentication for Fine Art Treasures Gallery. They then went to the auctioneer's website at www.fineartreasures.net and found that it advertised "fine art, original paintings, museum quality prints." At that moment, the Temchins realized that they "had been swindled."[23] What they had were museum-quality prints, not original signed lithographs. After some research, they found that what they had was most likely "some kind of copy of one side of a print in a book."

The Temchins were not about to be anyone's fools. They researched the auction show and made attempts to contact Eubanks, even driving to one of her addresses only to find that it was a mailbox store. It was perhaps a good thing that Myron couldn't manage to find a way to confront her. Eubanks was earning a reputation for being an extremely feisty and difficult person with whom to deal. According to a federal investigator, some employees found her intimidating and others claimed to be afraid of her. LAPD art cop Don Hrycyk stated that "in one case she grabbed one person and threw them out of the business, and in another instance the man turned around and she kicked him in the rear. All of this sort of fit into what we were hearing, that she was very aggressive."[24]

Temchin decided to turn his investigation over to the professionals. He contacted Special Agent Christopher Calarco of the Federal Bureau of Investigation. Calarco was ideally suited to take on

the Eubanks scam. He had been with the FBI's Art Crime Team since its inception in 2004 and served as the team's coordinator for the Western region. Though he also supervised a violent crime and gang squad in the Los Angeles Division of the FBI, he was not just a door-crashing tough cop—he had also previously served as a prosecutor at the state and federal levels.[25] His interest had been piqued by the Fine Art Treasures Gallery case in late 2004 when he received several calls about the program. Despite his experience and training in art crime, this was the first time he had heard of a television program selling art. He also learned that the show potentially reached 25 million households through DirecTV and Dish Network. "When I started getting an idea of the potential scope of the fraud, and how many victims and how much loss there could be, the case took on a sense of urgency," Calarco recalled.[26] He obtained permission from the cooperative Temchin to have the purported Picassos examined to establish whether or not they were authentic. They were not. This, however, was not enough to make an arrest. Investigators still had to prove that Eubanks was knowingly trafficking in illicit art and had to learn with whom she might be working.

Calarco found that Eubanks was not alone in the business. In 2002, she brought aboard James Mobley, an experienced auctioneer who assisted her in her plot and also served as an on-air auctioneer. And there was her husband, Gerald Sullivan, who worked on the behind-the-scenes operations. But, according to one federal prosecutor, Eubanks "wore the pants in the family. She really controlled the business and she really was the one who was in charge of every aspect of it, and he, Mr. Sullivan, ran the details, ran the accounts, handled the transactions."[27]

AS INVESTIGATORS DUG DEEPER into the operation at Fine Art Treasures Gallery, it began to emerge that although the Eubanks trio was

raking in the money, their execution of the fraud wasn't especially tight. For one, she committed some of her crimes right in front of employees who were not in on the scam. Justin Lundberg, a shipping department employee at Fine Art Treasures, said that on several occasions as he was preparing to ship prints, he came across certificates of authenticity that were unsigned. Upon being notified of the omission, Eubanks would come to the shipping department and personally sign multiple copies of the certificates, which attested that the works were authentic and part of a limited edition. In addition, he saw Eubanks sign artists' signatures, saying she "paid royalties that made it legal." Another employee, William Woodard, stated that he saw Eubanks sign Picasso's name in front of him.[28] In another instance, Eubanks made a ham-handed effort at disguising her Fine Art Network by listing Thom Keith and his daughter Jennifer as officers and/or directors of her company when, in fact, the pair's only connection to the corporation was purchasing television media time for Eubanks.[29]

Perhaps it was a combination of the scammers' greed and the sheer volume of prints that Fine Art Treasures Gallery was moving, but they were sloppy in other ways in their crime too. Hrycyk recounted that seemingly minimal effort was put into the creation of the fraudulent certificates of authenticity: "In some cases the person signing [the certificate] didn't exist. . . . In some situations we saw that there was a certificate where you could see that the certificate paper was created on a certain day that's actually listed . . . but then the signature and the date that was attesting to the authenticity was a date that was two years prior to when the actual paper was created." The sloppiness, Hrycyk said, "just showed how reckless a lot of their actions were."[30] Here, investigators found that in many cases, Eubanks and her cohorts were making the certificates themselves, an error that would prove costly. The certificates are key pieces of evidence

when investigating an art crime in California. Section 1742(a) of the state's civil code requires dealers selling or consigning art to furnish a certificate of authenticity at the request of the purchaser or consignee. Falsifying the certificate, therefore, means breaking the law, pure and simple, so reputable dealers would know the importance of providing authentication. Added Hrycyk, "For somebody that's in the business, obviously it was a joke."[31]

Even the way that many of the auctions were conducted was rigged. For instance, Fine Art Treasures would claim false bids were made to fraudulently inflate retail and purchase prices for their prints, a practice known as shill bidding. They would even employ false ringing telephones to make viewers believe that a bona fide auction was taking place on television. They would broadcast that the art they had for sale was acquired from "estate liquidations all over the world." In fact, they were knowingly selling fake and forged artwork that was purchased from crooked suppliers. And of course, they were manufacturing some of the art themselves in their print shop.[32]

So many complaints were levied against the dealers that the Better Business Bureau ultimately gave them an F rating. For those who were not novice art collectors, the scam was a tremendous embarrassment. Tom and Mary Ann Cogliano bought six pieces—including a Dalí—from the televised auctions, spending more than $50,000. When they later donated the Dalí to a charity fund-raiser, they learned it was a fake. "It made me look foolish," Tom said, "especially with these folks who are my friends—and here I am with a fake piece of art."[33] And as the complaints flowed in, investigators widened the scope of the case, looking into the finances of Kristine Eubanks. They found in her bank accounts nearly $4 million, and, when they examined her tax return filings closely, also found that false documents had been filed in support of the fraud. It was time for a warrant. As the assistant U.S. attorney assigned to the case,

David Willingham, said, "When the personal investment accounts were located and there were significant assets that were directly traceable to the crimes themselves, then it was just a matter of putting that on paper and getting a judge to sign off on the warrant."[34]

IN SEPTEMBER 2006, investigators led by Agent Calarco raided Fine Art Treasures and arrested Eubanks. The belligerent Eubanks was immediately put into jail upon her arrest because she was on probation: the consummate con artist had previously pleaded no contest to using the credit cards of a deceased business partner, racking up $144,000 in bills. The judge in that case stipulated that if her record did not remain spotless, she would be put directly into jail. Clearly, it did not.

When her cohorts Sullivan and Mobley were arrested, they cooperated against their micromanaging taskmaster. All three understood that Calarco had developed an airtight case against them and chose to plead guilty. Eubanks was sentenced to seven years on charges including conspiracy to commit mail fraud, wire fraud, interstate transportation of stolen property, and tax evasion. At sentencing, federal district court judge Gary A. Feess called her fraud scheme "audacious in scope" and "blatantly illegal." Her husband, Sullivan, was sentenced to four years, and Mobley to five. The government also seized Eubanks's assets, including the $3.8 million in her bank accounts and much of the artwork that Fine Art Treasures Gallery had in its inventory.[35]

The troubles for Eubanks did not end there, however, and the inevitable civil suits followed, with good reason. Charlene Mitchell filed suit against not only Eubanks but Princess Cruises as well, alleging that the tourism giant had committed copyright infringement, fraud, breach of fiduciary duties, conversion, and unjust enrichment. When an attorney for Princess told the *New York Times*

that Mitchell benefited from the exposure her counterfeited works received onboard their ships, her attorney retorted, "Princess is so twisted it thinks that mass distribution of unauthorized, forged copies of artists' works on their ships helps artists." For her part, Mitchell said she found a better place through which to distribute her work: Park West Gallery.[36]

JOHN O'BRIEN, THE ARTIST WHOSE DREAMS were dashed by the unscrupulous actions of Eubanks, had a sadder fate than did Mitchell. In 2004, he lost his battle with melanoma, leaving behind Martha and two young daughters. As a result of the way the value of his works was diluted, his wife filed a federal civil suit against a host of individuals for damages related to the unauthorized copying and sale of her late husband's art. In her court filing, a familiar name emerged in another scam against John. According to Martha O'Brien, around the same time that they entered into the agreement with Kristine Eubanks, the couple was contacted by Michael Zabrin, the prolific dealer in illicit counterfeit prints (see chapter 9 on Zabrin's crimes). Zabrin told the O'Briens that he was interested in selling John's original artworks and purchasing wholesale, signed giclées. The artist made some deals with Zabrin Fine Arts, offering Zabrin wholesale rates for works the dealer would sell at retail prices. But Zabrin's only payments to the O'Briens were by check, and the crooked dealer stopped payment on both of them. And despite the price agreements with them, the O'Briens found that on Zabrin's website—Fine Art Masters—John's paintings and giclées were listed for sale at far below the price agreements, and without any authorization or compensation to the artist.

When the O'Briens eventually lost the sale of a giclée to a buyer who purchased a much cheaper one from Zabrin, the couple confronted him. Zabrin acknowledged that he bought his giclée from

John's publisher—Eubanks's company Finer Image—knowingly accepting the difference between the "authentic" works and the 90 "cheap knock-off" works he bought and resold from Finer Image. Incredibly, not only was Zabrin unfazed by the fact that the O'Briens had found him out, he offered to sell them the forged giclées for $100 apiece. Now, with her husband deceased, Martha O'Brien continues to work tirelessly to fix the harm that the likes of Eubanks, Sullivan, Mobley, and Zabrin have done. But it is a long and likely unwinnable battle she wages.

Unfortunately for the O'Briens, they came into contact simultaneously with two legendary fraudsters, neither with a sense of ethics or an ounce of care for the impact their actions would have—not only on duped customers, but also on the artist who created their product and their future generations to come. The artist's progeny would never realize the full earnings that his works should have gained had their integrity not been so badly damaged. Sadly, there is more of their ilk out there. As the man who successfully prosecuted the Eubanks case, David Willingham, said, "We cut the head off the snake. Just putting Kristine Eubanks in jail couldn't really stop the type of conduct that was going on, but what It could do was drastically reduce the market for where those suppliers of fake art could sell their wares."[37] But whether that market was truly affected in the long term remains to be seen.

ELEVEN

THE INTERNET

THE INFORMATION SUPERHIGHWAY IS A ROAD WITH AN ENDLESS NUMBER of off-ramps to shopping centers throughout the world. With nearly the entire planet as a potential customer, the spending power of the vast online community is enormous. E-commerce generates nearly a quarter-trillion dollars in sales for retailers in the United States alone, where it is projected by the market research firm Forrester to reach a staggering $370 billion by 2017.[1] There are nearly 3 billion internet users worldwide,[2] and these figures are not lost on those looking to make money, least of all the devious con men of the world.

One hardly sees a week pass without finding a bogus solicitation in his e-mail account. Whether it be a Nigerian scam involving money left behind by a heretofore unknown and now deceased distant relative, a nefarious attempt to trick a dupe into giving up a credit card number, or a get-rich-quick business proposal, online scam attempts have become an accepted part of the internet user's daily life. Little can be done to completely avoid crossing paths with an internet crook except remaining vigilant and adhering to the warning "let the buyer beware."

The ability to shop online is undeniably changing the way we live. For instance, bookstores are closing all over the country, unable to compete with the internet retail giant Amazon.com. The same is true for record stores, almost single-handedly undone worldwide by the invention of the MP3 and the emergence of Apple's iTunes. And Blockbuster exists as only a memory of the old days, with video store rentals having been replaced by the likes of Amazon Prime, Netflix, and others.

Still, it's not necessarily a negative development. Online shopping allows the consumer access to items it once could only dream of finding, never mind at lightning-quick speeds. Whether it's the newest hot gadget or a one-of-a-kind collectible, you can probably find it for sale online. And one website offers consumers that sort of access and variety on a wider scale than any other: eBay.

eBay, founded in the mid-1990s by Pierre Omidyar, is an online auction site that describes itself as "the world's online marketplace." It's a claim that is hard to refute, with the site boasting nearly 150 million buyers in 2014 shopping from 700 million global listings.[3] Shoppers can search for everything from an Aardvark microphone pro-amp to a Zyzz singlet and a mind-boggling array of items in between. The genius of eBay is in the fact that the company itself doesn't sell anything on its site other than a platform; all of the items for sale are offered as such by private parties who set prices, deliver the products, and conduct most financial transactions on their own (the latter part done through a payment service called PayPal, which, by no coincidence, was acquired by eBay). Items sold on eBay vary in prices from mere pennies to exorbitance, for, say, a Ferrari F12berlinetta ($599,900 or best offer).[4]

If you are an art lover, a simple eBay search can lead you to amazing finds. Take for instance the D. C. Grose painting *Trading on the Plains* (circa 1873–75). The painting is described as being in "perfect

condition after its restoration and canvas lining by Italian techni-
cians in religious art." It can be had for just $4,299,999.[5] Or perhaps
the Dutch Masters are your passion, in which case *The Evangelist
Matthew,* an oil painting "attributed to Rembrandt van Rijn," is for
sale for $1.5 million. The painting's eBay page provides its prov-
enance ("from the collection of the late Yvonne Schotte, daughter
of the Belgian magnate Hippolyte Schotte from castle Aalst") and
even includes an opinion on the authorship from the renowned Rem-
brandt scholar Gary Schwartz ("The painting does not seem to have
the quality that would convince art historians and collectors that it
was made by Rembrandt. . . . I would, therefore, be inclined to call
the painting a copy after a lost work by Rembrandt").[6] It's hard to
argue with Schwartz, whose reputation is beyond reproach, not only
because of his extensive expertise in all things Rembrandt, but also
because of the quality of the image that is posted on the page. But an
important question is, Did *the* Gary Schwartz really lend his opinion
on this painting? It's likely he did—there's no evidence that he did
not, and he debunks the painting's authenticity—but that's just it:
any seller can describe the item they have posted for sale just about
any way they want.

In order to take a closer look at the painting, eBay's technology
allows for the prospective buyer to magnify all 11 images of it for a
better view, and using the tool makes it seem obvious that though the
painting is certainly well done, it is not of the caliber of Rembrandt's
work. The zoom tool is essential to the buyer's inspection, but it ex-
poses one of the key limitations the art buyer faces on eBay: one
shops in a two-dimensional world. Even with the magnification, one
is not able to tell if the brush strokes are real or, for that matter, if the
painting is really available. It can't be looked at in different light at
different angles, can't have its craquelure inspected, can't be taken in
with all of the key three-dimensional visuals necessary to evaluate a

work. And of course, the buyer can't take full measure of the seller in this online marketplace, other than to look at his ratings from previous buyers. Such is part of the challenge of shopping for art on eBay.

The quality of the works for sale on the site—judging by the images—range from apparent masterworks to paintings by unknown artists who have set astronomical prices for their works based on an attempt to give themselves instant credibility, a dream to get rich quick, or a seriously mistaken view of their own talent. Yet despite the risks, a great amount of art is listed for sale on eBay. A search for the word "painting" in the category "art" on the site yielded nearly 460,000 results.[7] There's seemingly something for every art lover's taste, from Photorealism to Abstract Expressionism, on eBay. And any time art, money, and a large number of wide-eyed novice shoppers are combined, con men aren't too far away.

IN 2014, THE LONDON-BASED NEWSPAPER the *Telegraph* conducted an investigation into two men, Geoffrey Spilman and David Henty, both amateur artists and each separately selling fake paintings on eBay. The men shared a favorite subject of their frauds: the painter L. S. Lowry. Lowry was perhaps an obvious choice—both of the forgers are middle-class British men, as was Lowry, whose works were inspired by everyday life in his hometown and surrounding area, as well as the "down and outs" who inhabited it. Moreover, and perhaps more pragmatically, Lowry's materials were not highly complex, which enabled the forgers the ability to create very reasonable facsimiles of his work. Lowry wrote, "I am a simple man, and I use simple materials: ivory, black, vermilion (red), Prussian blue, yellow ochre, flake white and no medium (e.g., linseed oil). That's all I've ever used in my paintings."[8] Of course, these same simple materials were easily accessible to Spilman and Henty.

Spilman, the middle-aged son of a vicar, lives in a flat in War-wickshire. His scheme involved the use of the well-worn provenance claim that the paintings he was selling belonged to a deceased rela-tive—in his case, his father—and were found while he was rummag-ing through his home. He'd also sometimes resort to the "I found them at an art fair" story and claim that because he lacked paperwork on the painting, he could not guarantee provenance. Though it's not certain that he created all of the paintings he sold by himself, what is clear is that when he did, he would forge the signatures of the artists on the finished works. In addition to Lowrys, Spilman sold works by 25 other artists on eBay, including fellow Briton Ashley Jackson, a watercolorist whose daughter was tipped off by a client that paint-ings alleged to be by her father were listed on eBay. Because he had described some of the fraudulently signed works as "genuine and original," Spilman was arrested and issued a warning by police. eBay acted quickly and shut his seller account down, but Spilman, who employed multiple eBay accounts to sell and artificially inflate bids, established new eBay shops through which he sold his paintings.[9]

Rather than discontinue his scam, Spilman sought ways around the police. He contacted David Henty, a failed artist living in Brigh-ton who was also producing counterfeit paintings attributed to Lowry and others. Henty, who was previously convicted for his role in a passport forging scam, was also identified by the *Telegraph* as a forger selling art he himself had created via multiple eBay shops. Like many other forgers, Henty would shop for older, worn canvases to give his works an air of legitimacy. Confronted by the newspa-per about his scheme, he at first denied it, but then took a sense of pride in his work, deriding the counterfeits produced by the likes of Spilman. "If you know Lowrys they [other forgers] use the wrong colours," he said. "He only used five colours his whole life. I have to

have an interest in an artist to copy him. I would call myself a copyist not a forger."[10]

Henty is entitled to call himself whatever he wishes, but it doesn't change the damage that he and others like him do when they flood the market with knockoffs of other artists' works. In addition to putting the value of the paintings at risk—Spilman and Henty sold their works for as little as a few hundred pounds, while Jackson's watercolors typically fetch six figures, and Lowry's much more—the fakes damage the artists' overall reputations. As long as there are Spilmans out there bearing counterfeit signatures of the true artist, the fakes are likely to be grouped with the authentic works. Said Jackson, "It is unjust that someone can play on my credibility by creating poor imitations in my name. To be honest, some of the fakes they were offering were really awful and it was embarrassing to think they were purportedly done in my name. . . . They are like my children and I like to see them grow and develop."[11]

PAINTINGS ARE NOT THE ONLY objets d'art to be posted and sold on eBay by a con man with a bold scheme. In the summer of 2011, James Coombes was a man on a very specific philanthropic mission: he had decided that he wanted to acquire and then donate a piece of art by the renowned glass sculptor Dale Chihuly to Gonzaga University's Jundt Art Museum.[12] Coombes spent months searching for the right piece before he settled on a Chihuly glass bowl he found on eBay, described as "Dale Chihuly Studio Seaform art glass signed early original bowl/vase."[13] On New Year's Day 2012, the auction for the piece ended with Coombes as the highest bidder at a sale price of $1,591. Though he received the piece with no provenance, Coombes was pleased with what he had won, noting the Chihuly signature on the bowl, and maintained contact with the seller, Michael Little.

He soon learned that Little had more Chihulys for sale and the pair agreed to meet.

Chihuly's works are highly sought after and quite valuable. They are not usually sold out of an old SUV, but Coombes was not deterred when Little showed up with the Chihuly glassworks in his older model Ford Explorer. In fact, Coombes bought ten more pieces from Little—this time including drawings—for $6,500. So impressed was Coombes with the works he was buying from Little that on the very next day, he bought another 22 Chihulys for an additional $4,500. Clearly, the low prices and rather unconventional sales venue were not enough to make Coombes think that maybe he was being had.

Instead, after a couple of months had passed, Coombes decided he wanted the rest of Little's "Venetian Series" collection. So he traveled to Little's home in Renton, Washington (also Chihuly's home state), put down $10,000 cash with a promise to pay an additional $10,000, and bought the remaining pieces from the whole lot. When Coombes later received from Little 17 certificates of purchase signed by Chihuly, they indicated that the pieces had been sold through a Seattle gallery.

Though apparently very trusting of Little, Coombes wanted to be sure the art donation he was making to Gonzaga's museum was legitimate. So he sought out a specialist to authenticate his buys, Katherine Elliott of Elliott Arts West. Given the unique nature of Chihuly's work, there are very few people qualified to authenticate his artwork. Elliott is one such person: in addition to being an art dealer and appraiser specializing in Chihuly and other glass sculptures, Elliott actually had worked with the artist in his studio and had a hand in some of his early works. Little contacted Elliott via e-mail, and in their communications Little stated that many of the pieces presented for authentication came directly from Chihuly and

his collaborator Parks Anderson, as "lots of surplus or overstock or unwanted/mistake/mishap pieces which was either given or sold to Belltown Art."[14]

It didn't take Elliott long to determine that the work sold to Coombes by Little was a forgery. Elliott pointed to the pieces' proportions, the "indelicate and clunky" flowers, the "too large" spots of gold, and "sloppy" red jimmies as being problematic. As for the signature on the piece, that too was forged. She wrote, "It's done with the wrong tool, it's in the wrong place, and the date would not be correct if it was Chihuly's work."[15] For a second opinion, Elliott turned to another Chihuly collaborator, glassblower and artist Martin Blank. Blank concurred with her findings, saying he could "guarantee" that the pieces in question were not authentic. Finally, Elliott offered her opinion as to the origin of the piece. "I do not believe the seller of this piece can also be the maker," she stated. "I would guess [it] was made somewhere in the Pacific Northwest, probably as a knock-off." Then, perhaps casting criminal suspicion on Little himself, Elliott wrote, "The real culprit is the person who signed and dated it as if it was Chihuly's work, which it is not." One other thing was certain: Coombes's donation to Gonzaga, at least this time, was not to be.

Unfortunately, Coombes was not Little's only victim. Elliott was approached by additional customers of Little's who had bought forgeries. And as the scam continued and he conned additional victims, word made its way to James Vana, a trademark attorney representing Dale Chihuly. Vana, understanding that his client was a victim of a forger, contacted the Office of the U.S. Attorney for the Western District of Washington to report the counterfeits. Soon, Special Agent Michael Larson of the Immigration and Customs Enforcement's Homeland Security Investigations (HSI) branch was on the case.

Larson uncovered the breadth of Little's scheme, finding that the con man had used at least two different provenance stories. In one, he claimed that he had the art because a relative bought it with winnings from the lottery; in another, he stated that it was from a friend who was dying of cancer and was connected to the artist himself. When all was said and done, the HSI agent found that Little had victimized at least two dozen people before finally being arrested. When the scam was first discovered by Chihuly's studio and eBay was notified, the company immediately pulled Little's postings. Amazingly, Little went on with his frauds for an additional 18 months after being outed by Chihuly and eBay. As one of his victims would later say, "Michael Little is a masterful liar, cheat, and thief. I am so ashamed that I am not sure I can tell everyone what has happened."[16]

Based on the airtight investigation put together by Larson and the federal prosecutor assigned the case, Matthew Diggs, as well as the diligent expertise of Katherine Elliott, Little was convicted of wire fraud for his use of eBay as his venue for advertising and selling fake artwork. A federal judge sentenced him to five months in prison and a restitution of $75,389. But the short-term damage had been done to Chihuly. As U.S. attorney Jenny A. Durkan stated, "Fraud schemes like this one target all artists and damage confidence in the marketplace."[17]

SOON AFTER LITTLE WAS CONVICTED, another man accused of committing fraud while selling art on eBay was facing federal criminal charges. In an affidavit filed in federal court in the Southern District of New York, FBI agent Meredith Savona accused an East Hampton man of concocting a five-phase scheme to defraud art buyers. Jovian "John" Re, a former woodworker and an amateur artist, was described as an Abstract Expressionist painter who "sold more than 60 purported paintings by Jackson Pollock to art collectors for

approximately $1,889,390 that [he] falsely represented were created by the famous Abstract Expressionist American artist."[18]

Re is an interesting figure, portrayed on various websites as a man of many interests and unique skills ranging from art expertise to submarines.[19] Like Henty, Re had a previous conviction for counterfeiting. In his earlier case, he pleaded guilty in 1995 to criminal possession of a home printing press on which fake $20 bills were made, a crime for which he was sentenced to two to seven years in prison.[20] Internet postings about Re depict a true enigma. One WordPress blog, written by a person who identified herself as "Nicole Hadley," rebuts an unidentified "slanderous attack on Mr. John Re of East Hampton, NY who would otherwise be noted as a world expert in several modern and contemporary artists." The testimonial goes on to tell of a 1998 meeting "Hadley" and her husband "Jeff" had with Re at the Museum of Modern Art, at which, upon considering a painting of a woman, Re stated "this painting is a forgery." According to the writer, the trio was then approached by a curator who informed them that the painting in question "was in fact a reproduction." The blog entry closes with mention that Re is also a "search and rescue diver" and thanks him for his service. Interestingly, the "character rebuttal" on behalf of Re is the one and only posting on "Nicole Hadley's" blog. Furthermore, the writer, who describes herself as a collector of fine art, titled the post "John Re Art Connaisseur [sic]."[21] Of course, as with so many things on the internet, it's difficult to discern which—if any—of these postings are authentic.

Savona, whose prior assignment in the bureau included 12 years on the Organized Crime Squad, is a highly trained fraud and art crime expert serving on the FBI's Art Crime Team. Her affidavit spelled out Re's alleged crime as beginning with offering for sale the so-called Pollocks. Next, she described Re as using the tried-and-true story that the paintings had been found in the basement of a

family that had been given the works directly by the artist himself. This, said the investigator, "was a lie that Re told his victims to give the paintings a plausible provenance, or chain of ownership, and to induce Re's victims to buy the paintings."[22] Savona's investigation revealed that, according to the alleged victims, Re said that he had been helping Barbara Schulte clean out her basement after the death of her husband, George, a fellow woodworker, when he came across the paintings.[23]

Next, the affidavit states, Re told each of his buyers that they were the sole owners of the entire collection of Pollocks found in the basement. In one instance, Savona wrote, Re threatened a buyer with the prospect of changing the stated provenance, thus rendering the paintings of no value. Finally, like his contemporaries Spilman and Henty, Re allegedly engaged in shill bidding to artificially and fraudulently inflate the prices of the purported Pollocks he offered for sale on eBay.

One of Re's customers, identified only as "Customer-2" by Savona, became suspicious of the authenticity of the paintings purchased from Re and decided to seek an opinion from the International Foundation for Art Research, the well-respected New York–based organization with expertise in such work. Re became concerned with this decision and wrote to his customer, "I tries [sic] to make it clear not to [sic] long ago that using IFAR was NOT a good idea. I told you from horror stories I know to be true regarding IFAR . . . What the hell were you thinking, or were you letting someone do your thinking for you,"[24] according to an e-mail quoted in the affidavit and attributed to Re. In relation to the IFAR testing, Re allegedly wrote, "I know so far you said they gave you some indication that the pieces are doing well."[25]

In fact, the paintings were not doing well. IFAR's exhaustive work on the 45 paintings presented to them was damning. They

wrote to Customer-2 that they had conducted "a thorough investigation which included in person examination of all 45 paintings by specialists and conservators, extensive provenance and art historical research, and physical examination, and selective forensic testing of the materials."[26] The results: none of the 45 works were painted by Jackson Pollock. In addition to all of the examination and testing, IFAR found no evidence that George Schulte had a relationship with Jackson Pollock that would explain him having the paintings. Moreover, neither Schulte's family nor his friends recall George claiming to have Pollocks or seeing them in the home. Worse, experts discovered "the use [of] old papers scumbled over with dark pigments to intentionally distress them." This was "strongly suggestive of an attempt to deceive."[27]

The FBI investigator wrote of another troubling instance, this time related to another alleged customer of Re's. Savona reported that when this customer showed one of the purported Pollocks to a New York art dealer, some dirt was noticed on the painting. The dealer wet his finger with saliva to wipe it away (a common method of spot cleaning art) and found that paint came off of the artwork. This occurred in 2013, 57 years after the death of Pollock, by which time the paint would certainly have dried.[28]

Faced with the prospect of being exposed by one of his customers, the FBI states, Re resorted to threatening his clients. In one communication, he referenced a mafia crime family, telling a collector, "[I] would never threaten anybody unless I'm gonna follow through. I grew up in Brooklyn, ok? My mother's from the Bonanno family, which means Gambino. When I tell you to do something, you don't . . . be quiet. You don't question me. You don't talk over me. You don't disrespect me. You just do it . . . And if you got to call me back and ask one more time, your mother's going to start wondering why you stopped visiting her."[29]

Re reportedly used associates to inflate bids on his Schulte Pollocks placed on eBay. In one case, the FBI found that he had e-mailed an individual requesting that he place a bid of $26,000 on a painting in an attempt to give legitimate shoppers the impression that there was serious interest in the work. He then asked another individual to make three separate shill bids on the painting.[30]

In May 2014, Agent Savona visited John Re and questioned him about the paintings he had offered for sale. According to the agent, Re described himself as an art expert and, at first, denied offering paintings for auction on eBay as "authentic." But the agent came prepared and presented Re with copies of his eBay postings that did indeed make claims that his Pollocks were "authentic" and "real." Faced with the evidence, Re, the affidavit states, admitted he sold the paintings as authentic but "he did not think he had done anything wrong."[31] Ultimately, Re pleaded guilty to one count of wire fraud in federal court in 2014.

THOUGH THE FBI SAYS Re's total sales brought in nearly $2 million, the most expensive work he sold was alleged to have gone to Customer-2 at the price of only $60,000[32]—a figure substantially below the market value for a true painting by Pollock, whose works have sold for tens of millions of dollars. $60,000, however, for a painting that is essentially barely worth the price of the canvas is a nice profit. And it is clear evidence that there is no shortage of buyers who will ignore red flags like an inexplicably low price tag because they so badly want to believe they have found a hidden gem. But it's nowhere near the highest price taken in by a scammer via eBay.

IF THERE IS ONE THING that must be sacrosanct in an online auction, it is trust. Whether a buyer is bidding on a lock of Abraham Lincoln's hair, a ball signed by Derek Jeter, or a painting by Richard

Diebenkorn, the bidder is making a leap of faith each time they enter a dollar figure and click on the "Place Bid" button. After all, as eBay warns, "Bidding is meant to be fun, but remember that each bid you place enters you into a binding contract. . . . If you win an item, you're obligated to purchase it."[33] That's not to say that the seller can do as he pleases. eBay makes it clear on its site that "Sellers can't deny or reject any knowledge of or responsibility for the authenticity or legality their items." eBay does not allow sellers to list items if they are not sure they're authentic, or to use disclaimers like "I believe this is painted by Degas, but I can't be sure," "I cannot guarantee the authenticity of this item so please bid accordingly," or "The autograph looks real to me."[34]

When a young California attorney named Kenneth Walton offered for auction a painting purportedly by Diebenkorn, he was absolutely certain that the autograph didn't look real. No, Walton was not an expert in the work of the Bay Area Abstract Expressionist. In fact, he wasn't an expert in art at all. But he could be sure that the signature was not authentic because Walton was the person who signed it.

Walton and an associate, a con man named Ken Fetterman with whom he had served in the military, together with a third individual, Scott Beach, sought out cheap paintings to sell online on eBay utilizing all the dirty tricks they could come up with. They created 47 phony accounts and placed $300,000 worth of shill bids on hundreds of paintings they sold by attributing them to famous artists who had not painted them. They posted their worthless art under the names of such accomplished artists as Giacometti, Edward Hopper, and others. In all, Walton and his accomplices brought in $450,000 from more than 500 auctions.[35] But it was the Diebenkorn that made the biggest splash.

After finding a cheap painting that resembled Diebenkorn's style, he painted the initials "RD" and the number "52" (ostensibly

to indicate the year it was created) at the bottom right corner of the work. Rather than posting it as an authentic Diebenkorn, Walton tried to be clever. In the description of the painting on eBay, he wrote, "I got this big abstract art painting at a garage sale in Berkeley . . . back in my bachelor days. Then I got married, and my wife has never let me keep it in the house. She says it looks like it was done by a nutcase."[36] Walton was playing the clueless rube who didn't realize the treasure upon which he had stumbled, setting up his mark to jump on the "too good to be true" story. In furtherance of the backstory, Walton also posted a few other items to make his character seem more innocent and genuine, including an unopened roll of twine, a basketball, and a pewter frame.[37] To an online shopper, it seemed like the eBay seller, named "golfpoorly," was probably cleaning out his garage and decided to post some odds and ends in an online auction to make a few bucks. In fact, not only didn't Walton have a Diebenkorn, he hadn't a wife or a house, either. The innocent hayseed that Walton was portraying started the bidding for the painting at just 25 cents.[38]

Soon, the bids began to roll in, aided by dozens of shill bids that he and his cohorts arranged. The price for the painting ballooned to $135,805, with a man in the Netherlands the high bidder, which drew attention from the media, including the *New York Times*. In a May 2000 article on the Diebenkorn auction, Judith Dobrzynski wrote, "The six-figure sale is not only one of the highest prices paid online for art, it is also a powerful testimony to the ability of the Internet to ignite a sales frenzy, even for expensive items that may or may not be what people think they are."[39] Dobrzynski was right in her suspicion about the painting, of course. But the assertion about the sales frenzy was slightly off, if only because of the devious minds of Walton and his associates, for the price shot up at least in part due to the shill bids that they placed. Without it, other buyers might not

have taken note of the sale, or perhaps would have associated low bids with low quality. Indeed, as the price rose due to fake bids, legitimate bids rose with them.

The attention that the sale of the Walton Diebenkorn garnered led eBay to examine the affair more closely. When they found that Walton had bid on his own offering, they voided the sale and found that he was using at least five different account names while his associates used an additional eight. eBay suspended all of the accounts, as well as two more brought to their attention by the *Times*. According to Special Agent Donald Vilfer of the FBI's Sacramento office, the matter caught the bureau's attention when Dobrzynski wrote a follow-up story reporting that Walton and others had engaged in cross-bidding on items and arranged for the posting of strong customer ratings on the site.[40] Soon, Walton, Fetterman, and Beach were in the crosshairs of the FBI for internet fraud.

By March 2001, the trio was indicted by a federal grand jury for their fraud on eBay. Though the British newspaper the *Guardian* described Walton as a "bored lawyer,"[41] he clearly paid attention in law school, quickly identifying his dim prospects in court and agreeing to cooperate with the government, as did Beach. Fetterman, ever the scammer, fled arrest and went on to assume false identities, including that of the famous Pearl Jam guitarist Stone Gossard, before ultimately being arrested.[42] Both Beach and Fetterman were convicted of their crimes in federal court.

The scam and his 30-month sentence behind him, Walton wrote a book chronicling his crimes titled *Fake: Forgery, Lies and eBay*. He also reflects upon his frauds somewhat wistfully, telling the *Guardian*, "I miss the thrill of the hunt and then seeing how much you can get for something when you put it up." He also displays a keen understanding of what motivated his dupes, something he described as

an "optimistic self-delusion" in which "people really want to believe they have found something good."[43]

THE TIMEFRAME OF WALTON'S SCAM coincided with an incidence of internet crime that had risen to a level warranting closer scrutiny and a stronger response from federal law enforcement. With cyber crime exploding exponentially as a worldwide problem, the FBI decided it had to take action and in May 2000 established a partnership with the National White Collar Crime Center to form the Internet Crime Complaint Center (IC3). By its fourteenth anniversary, the IC3 had received 3 million complaints of internet crime. According to the group, the total dollar loss claimed from these complaints exceeds $2 billion.[44] Clearly, internet fraud poses a great threat to consumers and the world's economy. And where there exists a venue to scam a consumer, one can be sure that there's a con artist looking to get rich quick using art as their merchandise. After all, the internet has been the vehicle used by many to make unimaginable riches almost overnight. From social media websites to YouTube personalities to online retailers like eBay, internet fortunes seem to be amassed even during economic downturns. All it takes is one person with a URL, a computer, an internet connection, and a dream. Or, as in the case of the scam artists, a devious scheme. There is no shortage of these sorts attempting to exploit trusting buyers on the internet, and with eBay the largest of the lot, it's only natural that their services would be targeted. And they are quite often. As Lizzie Crocker wrote for the *Daily Beast*, "Since its inception, experts say, eBay has become a den of art forgery, an unregulated market where ignorant art enthusiasts are easy prey for forgers and scam artists."[45] But that's not to say that the problem isn't being addressed. eBay's Ryan Moore, lead manager for business communication, reports that "bad activity is

currently at an all-time low on eBay's marketplace—down 50% over the last seven years (2007–2014). In addition, only a tiny fraction of all transactions on our platform—far less than 1%—experience any kind of bad activity."[46]

Clearly, eBay works hard to counter fraud on its site, including scams related to art crime. One step they have taken in recent years is to enlist an expert in the field of art fraud to consult on an initiative to monitor art sales on the website. And the company told Crocker that it "aggressively detects and removes members who engage in any type of fraudulent behavior" and also provides shoppers with a link through which they can easily report an item that they suspect to be a fraudulent listing, at which point eBay undertakes a detailed review to remove any bad listing.[47]

Moore espoused the company's philosophy when it comes to fraud protection. "For eBay, nothing is more important than the trust of our customers. We utilize a combination of sophisticated detection tools, enforcement and strong relationships with brand owners, re- tailers and law enforcement agencies to effectively combat fraudulent activity and present our customers with a safe, trusted shopping ex- perience." He added that buyers on eBay do have recourse if they are victims of fraud, stating, "In cases where an item is not as described or something goes wrong, eBay's Money Back Guarantee ensures buyers get the item they ordered or they get their money back. Bot- tom line, when you buy and sell on eBay, we have your back."[48]

In addition, eBay established a Global Asset Protection Team to "promote the safe use of its platforms and to collaborate with lo- cal, national and international law enforcement in apprehending and prosecuting criminals." The team works to provide pertinent records to authorities investigating crimes committed using the site.[49] Fi- nally, eBay has utilized software to identify fraudulent activity on its site. The company provides information on its site about its efforts

to combat fraud, using its own online Help pages to explain avenues available to buyers, sellers, and law enforcement to help combat suspected fraud. It's an important mission, and recent history indicates that though fraud on eBay might be down, the site, like any gallery or auction house, remains an irresistible target for con men hoping to make a killing.

EPILOGUE

IN THE FALL OF 2014, IN ST. PETERSBURG, RUSSIA, AN ART EXPERT WAS held under house arrest, accused of complicity in a fraud involving a painting that she had misattributed in 2009 to Russian avant-garde artist Boris Grigoryev. The painting sold for $250,000 and, two years later, was determined to be a fake. The expert denied any wrongdoing, and her arrest set the Russian museum community into a frenzy, angry and fearful that a colleague could be imprisoned for being tricked by a clever forger.[1]

As that controversy raged in Russia, police in Vienna announced that they were seeking victims of a Serbian gang that had sold an un-known number of counterfeit Picassos, accompanied by bogus certif-icates of authenticity, in Austria. Though the gang had already been identified and arrested, authorities were desperate to find and inform victims that they had been had, some for as much as €300,000.[2]

As the Viennese authorities wrestled with the problem of the Picassos, a legal battle raged in Australia over the seizure of paintings taken from the home of Mohamed Aman Siddique when police en-tered his home with a warrant in an art forgery case involving three allegedly fake Brett Whitely works that had been sold for millions of dollars by art dealer Peter Gant. Police took additional works by other artists from the home for forensic investigation, leading to legal

arguments over police powers of search and seizure.[3] Gant staunchly maintains his innocence. The case is still pending.

At the same time these arguments were taking place in Australia, auctioneers in Great Britain announced they would be offering for sale hundreds of sketches and paintings by the late forger Eric Hebborn, one of the few who took on the challenge of duping dealers and buyers with works in the style of Renaissance masters. The works were estimated to fetch prices ranging from £100 to £500 each.[4]

Just a couple of weeks prior, in New Zealand, it was announced that forgeries by Elmyr de Hory of Claude Monet paintings had surfaced at an auction in Auckland, offered for sale by a descendant of the forger living in that area.[5] And over in Germany, police were busy officially charging two men with crimes related to an international art forgery ring it had uncovered 15 months prior. Investigators believe the ring of con men obtained their forgeries from studios based in Russia and Israel before being brought to Germany.[6]

Meanwhile, back in the United States, a documentary film titled *Art and Craft* was gaining attention for its depiction of the eccentric forger Mark Landis, who donated his fakes to dozens of museums without accepting any payment in return; thus he was never prosecuted. His works, featured in a touring exhibition curated by art fraud expert Colette Loll, are as fascinating as he is interesting—and bizarre.

One thing is for sure: fraud involving art is thriving. It captures the interest of casual observers interested in crime or art; it blinds buyers hoping for that one great find; and it captures the imagination of the unscrupulous con man who continues to see the possibilities that bad art holds for bringing in good money.

ACKNOWLEDGMENTS

THE LAST WORDS MY FATHER EVER SPOKE TO ME BEFORE HE DIED WERE those of encouragement for my work on this book. I hope that he would have been proud of it.

First and foremost, this book could not have been completed without the dedicated work of countless state and federal prosecutors, federal agents, postal inspectors, and police officers who investigated and prosecuted the crimes of the con men whose schemes, as well as the travails of the victims, are described within. The crimes that seem to lead to "open-and-shut" cases in fact required untold hours of investigation, interviews, surveillance, and—of course—paperwork in order to crack these complex crimes. More than anything else, this is a book about their work. I'm deeply indebted to all of them for their efforts.

I wish to thank my daughters, Gabby and Alessandra, who listened to me drone on and on about the writing process, various art crimes, and my work at the Isabella Stewart Gardner Museum. It must be a chore for them since both Gabby and Alessandra are far better writers and deeper thinkers than I.

I'm grateful to my literary agent, Sharlene Martin at Martin Literary Management, for her support, guidance, and faith. I'm also thankful for the support I received from my editor, Karen Wolny, and the entire team at Palgrave Macmillan.

At the Federal Bureau of Investigation, continued thanks go to Special Agent Geoffrey Kelly, Special Agent Greg Comcowich, public affairs specialist Katherine Gulotta, Special Agent Linda English (Ret.), Betsy Glick of the FBI's HQ Office of Public Affairs, and Laura Eimiller, FBI press relations for the Los Angeles Field Office.

At the Office of the U.S. Attorney for the District of Massachusetts, my gratitude goes to U.S. attorney Carmen Ortiz, public affairs officer Christina Sterling, and assistant U.S. attorney Ryan DiSantis.

Two local police officers in particular are making a major impact on art crime of all sorts in the American cities where it is the biggest problem, and I'm appreciative to them for their efforts. They are detectives Don Hrycyk of the Los Angeles Police Department and Mark Fishstein of the New York Police Department.

Thank you to former federal prosecutor and current mayor of New Bedford Jonathan Mitchell for his time, assistance, and his work.

From the United States Department of Homeland Security, thanks are in order for Special Agent Thomas Benz.

I owe a particular debt of gratitude to Dr. Nicholas Eastaugh and Dr. Jilleen Nadolny of Art Access & Research in London for their willingness to help me as well as for their expertise, perspectives, and remarkable work.

At the Isabella Stewart Gardner Museum, thank you to David Mathews, Shana McKenna, Amanda Venezia, and especially Gianfranco Pocobene, whose expertise was particularly valuable from concept to completion of this book. The breadth of Gianfranco's knowledge is staggering.

Dr. Enrique Mallen, professor, director and editor of the Online Picasso Project at Sam Houston State University; Christopher A. Marinello at Art Recovery International (www.artrecovery.com); and Ryan Moore at eBay kindly provided me with invaluable assistance.

The resources of artnet (www.artnet.com) were very valuable to me in my research.

Thanks are also due to Dr. Lois Cuddy for teaching me to be a writer.

Howie and Kathy Carr's encouragement was the catalyst for moving forward with this book. I'm indebted to them both for this and for all the opportunities to which they have exposed me.

Shau Yi Lee sent me countless useful stories on forgery from afar. Art fraud expert Collette Loll provided me with great ideas and direction. Read more about her work at www.artfraudinsights.com. Meghan Weeks lent me her perspectives on creating art. See her great paintings at megcweeks.com. Ashley Ragg assisted me with some last-second updates on the Knoedler case.

My proofreaders were indispensible, especially the brilliant Natalie Wolcott Williams, who lent me her expertise in the art world as well as the unabridged dictionary that is her brain.

I'm also thankful to Brian T. Kelly, Rob Fisher, Jamie Lawton, Elsa Puglielli, Peter Crowley, Michael Blanding, and Stephen Almagno for their support.

As I completed this book and I followed the events of the day, I cannot help but thank the men and women of the United States military, who put their lives on the line overseas so people like me can sit safely back home and work on books and such.

Most notably, I must thank my sister, Lori A. Giorgi, whose love, support, advice, and example mean everything to me. And finally, thanks are in order to the great matador Derek Fisher for all of his support and encouragement.

NOTES

INTRODUCTION

1. The story of Captain John Swords's scam using Gilbert Stuart's painting of George Washington was unearthed in E. P. Richardson, "China Trade Portraits of Washington after Stuart," *Pennsylvania Magazine of History and Biography,* January 1970, 95–100. This retelling relies on the original court documents provided in Richardson's article.
2. "The History of Fraud-Art," *Guardian,* n.d., retrieved September 28, 2014, http://www.theguardian.com/btbroadbandsecurity/story/0,1736129,00.html.
3. Jonathan Lopez, *The Man Who Made Vermeers* (Orlando: Harcourt, 2008), 183.
4. This modern-day U.S. dollar amount comes from a World War II guilders-to-reichsmarks conversion rate of 1:1.5, and a World War II dollars-to-reichsmarks conversion rate of 1:2.5, multiplied by an inflation ratio from 1944 to present-day U.S. dollars of 1:13.39. However, it does not take into account the exponential increase in valuations of the paintings of Johannes Vermeer, who is today the most coveted seventeenth-century Dutch painter.
5. Lopez, *The Man Who Made Vermeers.*
6. Andrew Levy, "The Most Devious Person I've Dealt With: Judge Hits Out at Con Man Who Tricked Widow Out of £700,000," *Daily Mail,* March 13, 2012, retrieved October 2, 2014, http://www.dailymail.co.uk/news/article-2114441/John-Drewe-trial-Judge-hits-con man-tricked-widow-700k.html.
7. Megan M. Fontella, "Foreword," *Collections: A Journal for Museum and Archives Professionals* 10, no. 3 (Summer 2014): 247.
8. "The Gentle Art of Forgery," *60 Minutes* (CBS), n.d., retrieved October 3, 2014, https://www.youtube.com/watch?v=e1nOweWPjFU.
9. Ibid.
10. Lopez, *The Man Who Made Vermeers,* 232.
11. www.tonytetro.com, retrieved October 4, 2014.
12. Anita F. Moskowitz, "Masterpiece or Master Fraud?" *Florentine,* December 9, 2013, retrieved October 4, 2014, http://www.theflorentine.net/articles/article-view.asp?issuetocId=8713.
13. Barry Cole and Geraldine Norman, "Obituary: Eric Hebborn," *Independent,* January 13, 1996, retrieved October 4, 2014, http://www.independent.co.uk/news/people/obituary-eric-hebborn-1323749.html.

14. LinkedIn profile, "Michael O'Kelly, Owner at Michael O'Kelly Books," retrieved October 4, 2014, https://www.linkedin.com/pub/michael-o-kelly/32/bb1/926.

15. Publicity page for *Caveat Emptor: The Secret Life of an American Art Forger* (Google eBook), retrieved October 4, 2014, http://books.google.com/books/about/Caveat_Emptor.html?id=8V8RmFasm5oC.

16. Justin Jones, "Expert Art Forger Is Exposed in Documentary," *Daily Beast,* April 18, 2014, retrieved October 4, 2014, http://www.thedailybeast.com/articles/2014/04/18/expert-art-forger-is-exposed-in-documentary.html.

17. Clifford Irving, *Fake! The Story of Elmyr de Hory, the Greatest Art Forger of Our Time* (New York: McGraw-Hill, 1969).

18. Kurt Bayer, "Fake Forgeries Pulled from Auction," *New Zealand Herald,* October 7, 2014, retrieved October 9, 2014, http://m.nzherald.co.nz/nz/news/article.cfm?c_id=1&objectid=11338028.

19. Interview with Meghan Weeks, October 3, 2014.

20. Peter Landesman, "A 20th-Century Master Scam," *New York Times,* July 18, 1999, retrieved February 2, 2015, http://www.nytimes.com/1999/07/18/magazine/a-20th-century-master-scam.html.

21. "Over 50 Percent of Art Is Fake," *Artnet News,* October 13, 2014, retrieved October 14, 2014, http://news.artnet.com/in-brief/over-50-percent-of-art-is-fake-130821.

22. "Authentication Research Service," International Foundation for Art Research, retrieved October 4, 2014, http://www.ifar.org/authentication.php.

23. Peter Plagens and Yahlin Chang, "Van Gogh or No Gogh? Scholars Have New Doubts about Some Multimillion-dollar Paintings: But They Hope Nobody's Listening," *Newsweek,* July 21, 1997, 72.

24. Nicholas Eastaugh and Jilleen Nadolny, "The Analytical Results of a Group of Beltracchi Forgeries," in *Dev Fall Beltracchi und die Folgen,* ed. Henry Keazor and Tina Ocal (Berlin: DeGruyter, 2014), 66.

25. Ibid., 60.

26. Ibid., 60-61.

27. Kenneth Polk and Duncan Chappell, "Fakes and Deception: Examining Fraud in the Art Market," in *Art and Crime: Exploring the Dark Side of the Art World,* ed. Noah Charney (New York: Praeger, 2009), 81.

CHAPTER 1: THE FORGER

1. "Interview with Wolfgang Beltracchi: Confessions of a Genius Art Forger," *Spiegel Online International,* March 9, 2012, retrieved June 28, 2014, http://www.spiegel.de/international/germany/spiegel-interview-with-wolfgang-beltracchi-confessions-of-a-genius-art-forger-a-819934.html.

2. James Gardner, "The Evil of Banality: On the Nazi Perversion of Art," *Weekly Standard* 19, no. 32 (May 5, 2014).

3. Michael Sontheimer, "The Flechtheim Paintings: Inside Germany's Most Complicated Art Restitution Battle," *Spiegel Online International,* July 5, 2012, retrieved August 20, 2013, http://www.spiegel.de/international/germany/flechtheim-heirs-wage-restitution-battle-with-german-museums-a-841477.html.

4. Ibid.

5. Stefan Koldehoff, "Mit Deutschen Grüßen," *Die Welt,* June 30, 2010, retrieved August 21, 2013, http://www.welt.de/welt_print/kultur/article8233173/Mit-deutschen-Gruessen.html.

6. Joshua Hammer, "The Greatest Fake-Art Scam in History?" *Vanity Fair,* October 10, 2012, retrieved October 5, 2014, http://www.vanityfair.com /culture/2012/10/wolfgang-beltracchi-helene-art-scam.

7. Alexander Forbes, "Werner Spies Breaks His Silence Regarding Max Ernst Forgeries," *Berlin Art Brief* (blog), *Art Info,* February 15, 2012, re-trieved June 22, 2014, http://blogs.artinfo.com/berlinartbrief/2012/02/15 /werner-spies-breaks-his-silence-regarding-max-ernst-forgeries/.

8. Sven Robel and Michael Sontheimer, "The $7 Million Fake: Forgery Scan-dal Embarrasses International Art World," *Spiegel Online International,* June 13, 2011, retrieved June 22, 2014, http://www.spiegel.de/international /zeitgeist/the-7-million-fake-forgery-scandal-embarrasses-international -art-world-a-768195.html; Hammer, "The Greatest Fake-Art Scam in History?"

9. Hammer, "The Greatest Fake-Art Scam in History?"

10. Ibid.

11. Christie's auction catalog, Sale 5477, German and Austrian Art '95; re-trieved June 24, 2014, http://www.christies.com/LotFinder/lot_details.aspx ?intObjectID=278705.

12. Stephanie D'Alessandro, ed., *German Expressionist Prints: The Marcia and Granvil Specks Collection* (New York: Hudson Hills, 2004), 82.

13. Lempertz Highlights Auction 896, November 29, 2006, retrieved June 26, 2014, http://www.lempertz.eu/85+M5e3a8585a64.html.

14. Christie's auction catalog, Sale 5477.

15. Nicholas Eastaugh, e-mail interview, July 7, 2014.

16. "Looking Deeper into the Material of Art," Art Access & Research Biogra-phies, retrieved June 23, 2014, http://artaccessresearch.com/biographies/.

17. Paraic O'Brien, "Wolfgang Beltracchi: Portrait of the Artist as a Con Man," *Channel 4 News* (UK), April 16, 2014, retrieved June 28, 2014, https://www .youtube.com/watch?v=zz6YXjSHFOI.

18. "Investigators Zero in on Massive Art Forgery Scandal," *Spiegel Online In-ternational,* November 5, 2010, trans. from the German by Jan Liebelt; re-trieved June 26, 2014, http://www.spiegel.de/International/zeitgeist/the -hippy-and-the-expressionists-investiagors-zero-in-on-massive-art-forgery -scandal-a-726982.html.

19. Hammer, "The Greatest Fake-Art Scam In History?"

20. Tony Paterson, "Time Runs out for Germany's Master Forgers," *Indepen-dent,* October 26, 2011, retrieved February 2, 2015, http://www.independent .co.uk/arts-entertainment/art/news/time-runs-out-for-germanys-master -forgers-2375970.html.

21. After some discussion with the author, Wolfgang Beltracchi opted not to par-ticipate in an interview for this book.

22. "Confessions of a Genius Art Forger."

23. Ibid.

24. Ibid.

25. Hammer, "The Greatest Fake-Art Scam in History?"

26. Clare Finn, "The Devil in the Detail," *Apollo* 179, no. 616 (January 1, 2014): 50.

27. "Confessions of a Genius Art Forger."

28. Hammer, "The Greatest Fake-Art Scam in History?"

29. "The Man Behind the False 'Werner Jagers' Art Collection Confessed the Forg-ery," press release, Artvera, September 30, 2011, retrieved February 2, 2015, http://webcache.googleusercontent.com/search?q=cache:FDQRODLK

03kJ:www.artveras.com/upload/press_release/1317912737_PR_Forgery_09
_30_11.pdf+&cd=1&hl=en&ct=clnk&gl=us.

30. "Confessions of a Genius Art Forger."
31. Jilleen Nadolny, e-mail interview, July 7, 2014.
32. Nicholas Eastaugh and Jilleen Nadolny, "The Analytical Results of a Group of Beltracchi Forgeries," in *Dev Fall Beltracchi und die Folgen,* ed. Henry Keazor and Tina Ocal (Berlin: DeGruyter, 2014), 67.
33. "Confessions of a Genius Art Forger."
34. Julia Michalska, Charlotte Burns, and Ermanno Rivetti, "True Scale of Alleged German Forgeries Revealed," *The Art Newspaper,* Issue 230, December 5, 2011, retrieved February 2, 2015, http://www.theartnewspaper.com/articles/True-scale-of-alleged-German-forgeries-revealed/25235.
35. O'Brien, "Wolfgang Beltracchi: Portrait of the Artist as a Con Man."
36. "Confessions of a Genius Art Forger."
37. Dave Itzkoff, "Forged Painting Was Once in the Collection of Steve Martin, German Police Say," *New York Times,* May 31, 2011, retrieved June 29, 2014, http://artsbeat.blogs.nytimes.com/2011/05/31/forged-painting-was-once-in-collection-of-steve-martin-german-police-say/?_php=true&_type=blogs&_r=0.
38. Alexander Forbes, "Werner Spies Breaks His Silence Regarding Max Ernst Forgeries," *Berlin Art Brief* (blog), *Art Info,* February 15, 2012, retrieved June 22, 2014, http://blogs.artinfo.com/berlinartbrief/2012/02/15/werner-spies-breaks-his-silence-regarding-max-ernst-forgeries/.
39. Eastaugh and Nadolny, "Analytical Results of a Group Of Beltracchi Forgeries," 72.
40. Nicholas Eastaugh, "Learning from Beltracchi," in *Dev Fall Beltracchi und die Folgen,* ed. Henry Keazor and Tina Ocal (Berlin: DeGruyter, 2014), 82.
41. Nicholas Eastaugh, e-mail interview, July 7, 2014.
42. Jilleen Nadolny, e-mail interview, July 7, 2014.
43. Nicolai Hartvig, "Masterminds of Massive Forgery Ring That Snookered Steve Martin Receive Light Sentences after Charming Court and Public," October 28, 2011, retrieved June 29, 2014, Blouin Artinfo, http://www.blouinartinfo.com/news/story/482178/masterminds-of-massive-forgery-ring-that-snookered-steve.
44. Bojan Pancevski, "Artful Dodger Duped the Experts," *The Australian,* February 19, 2014, retrieved February 2, 2015, http://www.theaustralian.com.au/news/world/artful-dodger-duped-the-experts/story-fnb64oi6-1226830839995?nk=fde5e90807280cd2f0486259711885da.
45. Hartvig, "Masterminds of Massive Forgery Ring that Snookered Steve Martin."
46. Michael Sontheimer, "A Cheerful Prisoner: Art Forger All Smiles after Guilty Plea Seals Deal," *Spiegel Online International,* October 27, 2011, retrieved June 29, 2014, http://www.spiegel.de/international/germany/a-cheerful-prisoner-art-forger-all-smiles-after-guilty-plea-seals-deal-a-794454.html.
47. Bob Simon, "The Con Artist," *60 Minutes* (CBS), original air date February 23, 2014, CBS News Transcripts (LexisNexis.com).
48. Simon, "Con Artist."
49. Nicholas Eastaugh and Jilleen Nadolny, via an e-mailed interview, July 7, 2014.
50. Jilleen Nadolny, e-mail interview, October 6, 2014.
51. Pancevski, "Artful Dodger Duped the Experts."

52. Simon, "Con Artist."

53. O'Brien, "Wolfgang Beltracchi: Portrait of the Artist as a Con Man."

54. Ibid.

55. Eastaugh and Nadolny, "The Analytical Results of a Group of Beltracchi Forgeries," 68.

56. Nadolny, e-mail interview, July 7, 2014.

CHAPTER 2: THE BROKER

1. Patricia Cohen, "A Gallery That Helped Create the American Art World Closes Shop after 165 Years," *New York Times,* November 30, 2011, http://www.nytimes.com/2011/12/01/arts/design/knoedler-art-gallery-in-nyc-closes-after-165-years.html?_r=0.

 2. Faustino Quintanilla, "Jaime Andrade: A Life for Art," retrieved July 2, 2014, http://www.qcc.cuny.edu/artgallery/exhibitDetail.asp?exhibitID=48.

 3. Ibid.

 4. "David Herbert profile," from Civil Complaint: Domenico De Sole and Eleanore De Sole v. Knoedler Gallery, LLC D/B/A Knoedler & Company, and Ann Freedman, 12 CIV 2313, US District Court (S.D.N.Y. March 28, 2012).

 5. Quintanilla, "Jaime Andrade."

 6. Civil Complaint: Frank Fertitta III and Evelyn Maclean v. Knoedler Gallery, LLC et al., 14 CV 2259, US District Court (S.D.N.Y. April 1, 2014).

 7. Dune Lawrence and Wenxin Fan, "The Other Side of an $80 Million Art Fraud: A Master Forger Speaks," *Bloomberg News,* December 19, 2013, retrieved July 1, 2014, http://www.businessweek.com/articles/2013-12-19/the-other-side-of-an-80-million-art-fraud-a-master-forger-speaks.

 8. Ibid.

 9. Sarah Maslin Nir, Patricia Cohen, and William K. Rashbaum, "Struggling Immigrant Artist Tied to $80 Million New York Fraud," *New York Times,* August 16, 2013. http://www.nytimes.com/2013/08/17/nyregion/struggllng-lmmigrant-artist-tied-to-80-million-new-york-fraud.html?pagewanted=all.

10. Sealed Indictment: United States v. Jose Carlo Bergantinos, Jesus Angel Bergantinos, and Pei Shen Qian, 14 CRIM 217 (S.D.N.Y. March 31, 2014).

11. Ibid.

12. Michael Shnayerson, "A Question of Provenance," *Vanity Fair,* May 2012, retrieved July 4, 2014, http://www.vanityfair.com/culture/2012/05/knoedler-gallery-forgery-scandal-investigation.

13. Patricia Cohen, "Artist's Family Says Gallery Ignored Warning of Fakes," *New York Times,* May 6, 2012, retrieved July 4, 2014, http://www.nytimes.com/2012/05/07/arts/design/knoedler-now-in-dispute-over-diebenkorn-drawings.html?pagewanted=all; Civil Complaint: Domenico De Sole and Eleanore De Sole v. Knoedler Gallery et al., 12 CIV 2313.

14. Civil Complaint: *De Sole and De Sole.*

15. Amended Civil Complaint and Demand for Jury Trial: John D. Howard v. Ann Freedman et al., 12 CV 5263, US District Court (S.D.N.Y. October 21, 2013).

16. Declaration of Ann Freedman: *De Sole and De Sole.*

17. Civil Complaint: *De Sole and De Sole.*

18. Ibid.

19. Museum of Modern Art, s.v. "About This Artist: Robert Motherwell," Museum of Modern Art website (source: Oxford University Press), 2009, retrieved July 5, 2014, http://www.moma.org/collection/artist.php?artist_id=4126.

20. Letter from Morgan Spangle to Julian Weissman, February 15, 2007; Complaint: Killala Fine Art Limited v. Julian Weissman et al. 11 CIV 0702, US District Court (S.D.N.Y. February 1, 2011).

21. James Panero, "Behind the Veil: Questions about Art Authentication," *Wall Street Journal,* March 23, 2011, retrieved July 5, 2014, http://online.wsj.com /news/articles/SB10001424052748704608504576208622894968298.

22. Laura Gilbert, "'Document Dump' Reveals New Details in Knoedler Case," *Art Newspaper,* October 8, 2014, retrieved October 9, 2014, http://www .theartnewspaper.com/articles/Document-dump-reveals-new-details-in -Knoedler-case/35881.

23. Civil Complaint: *De Sole and De Sole.*

24. Ibid.

25. Ibid.

26. Shnayerson, "A Question of Provenance."

27. Letter from Jack Flam to Julian Weissman, February 17, 2009; Complaint: Killala Fine Art Limited v. Julian Weissman et al. 11 CIV 0702, US District Court (S.D.N.Y. February 1, 2011).

28. Shnayerson, "A Question of Provenance."

29. Civil Complaint: Lagrange v. Knoedler, Civil Complaint: Pierre Lagrange et al. v. Knoedler Gallery, LLC, et al. 11 CIV 8757, US District Court (S.D.N.Y, December 1, 2011).

30. First Amended Complaint: Pierre Lagrange et al. v. Knoedler Gallery et al., January 17, 2012.

31. Civil Complaint: Lagrange v. Knoedler, 11 CIV 8757, (S.D.N.Y. December 1, 2011).

32. Ibid.

33. Settlement Agreement and Mutual Release, Killala Fine Art Limited v. Julian Weissman, et al.11 CIV 0702, U.S. District Court (S.D.N.Y October 6, 2011).

34. Cohen, "A Gallery That Helped Create the American Art World Closes Shop after 165 Years."

35. Ibid.

36. Rosenberg v. Seattle Art Museum, 42 F. Supp. 2d 1029 (W.D. Wash, March 29, 1999), http://law.justia.com/cases/federal/district-courts/FSupp2/42/10 29/2501685/, retrieved July 9, 2014.

37. Judith H. Dobrzynski, "Seattle Museum Is Sued for a Looted Matisse," *New York Times,* August 4, 1998, retrieved July 9, 2014, http://www.nytimes .com/1998/08/04/arts/seattle-museum-is-sued-for-a-looted-matisse.html.

38. Sheila Farr, "Seattle Gets Pick of Paintings after Matisse Loss," *Seattle Times,* October 13, 2000, retrieved July 9, 2014, http://community.seattletimes.nw source.com/archive/?date=20001013&slug=4047641.

39. Adam Gorlick, "Oil Painting Returned to Italy," *Bangor Daily News,* June 25, 2001, B4.

40. James Martin, Orion Analytical LLC, Orion Project No. 1745. Domenico De Sole et al. v. Knoedler Gallery et al. 12 CIV 2313, U.S. District Court (S.D.N.Y. March 28, 2012).

41. Ibid.

42. Sealed Indictment: *Bergantinos.*
43. Federal Bureau of Investigation Press Release, "Art Dealer Pleads Guilty in Manhattan Federal Court to $80 Million Fake Art Scam, Money Laundering, and Tax Charges," September 16, 2013, http://www.fbi.gov/newyork /press-releases/2013/art-dealer-pleads-guilty-in-manhattan-federal-court-to -80-million-fake-art-scam-money-laundering-and-tax-charges.
44. Federal Bureau of Investigation Press Release, "Three Defendants Charged in Manhattan Federal Court in Connection With $33 Million Art Fraud Scheme," April 21, 2014, http://www.fbi.gov/newyork/press-releases/2014 /three-defendants-charged-in-manhattan-federal-court-in-connection-with -33-million-art-fraud-scheme.
45. Lawrence and Fan, "Other Side of an $80 Million Art Fraud."
46. Jon Swaine, "Artist at Centre of Multimillion Dollar Forgery Scandal Turns Up in China," *Guardian,* April 22, 2014, retrieved October 13, 2014, http:// www.theguardian.com/artanddesign/2014/apr/22/forged-art-scandal -new-york-artist-china-spain.
47. Lawrence and Fan, "Other Side of an $80 Million Art Fraud."
48. Patricia Cohen, "Note to Forgers: Don't Forget the Spell Check," *New York Times,* June 11, 2014, retrieved July 20, 2014, http://mobile.nytimes .com/2014/06/12/arts/design/note-to-forgers-dont-forget-the-spell-check .html?_r=0.
49. Declaration of Ann Freedman: *De Sole and De Sole.*
50. Kate Lucas, "Former Knoedler President Ann Freedman Sues New York Dealer over Comments in Article on Knoedler Scandal," *Art Law* (blog), Grossman LLP, September 17, 2013, retrieved August 31, 2014, http://gross manllp.com/art-law-blog/2013/09/former-knoedler-president-ann-freed man-sues-new-york-dealer-over-comments-in-article-on-knoedler-scandal/.
51. Ibid.
52. Ann Freedman v. Marco Grassi, Supreme Court of the State of New York, County Suffolk, Complaint. September 11, 2013. http://www.scribd.com /doc/167631606/Freedman-Defamation-Complaint; Retrieved August 31, 2014.
53. Gilbert, "'Document Dump.'" N.B. The Art Newspaper reported that the former agent was "retained by either Freedman or Knoedler."
54. As of the date of publication, civil cases filed by and against Ann Freedman and the Knoedler Gallery related to the Rosales matter were still pending.

CHAPTER 3: THE ART PONZI SCHEME

1. James Panero, "An Old Master in Ruins," *New York Magazine,* March 31, 2008, http://nymag.com/news/features/45324/.
2. Ibid.
3. Will Bennett, "Picture Sold for £75,000 'Is Caravaggio Worth Millions,'" *Telegraph,* July 14, 2004, retrieved August 7, 2014, http://www.telegraph .co.uk/news/uknews/1466943/Picture-sold-for-75000-is-Caravaggio-worth -millions.html.
4. Ibid.
5. "'Caravaggio' Painting Sparks a Row," *BBC News,* July 14, 2004, retrieved August 6, 2014, http://news.bbc.co.uk/go/pr/fr/-/2/hi/entertainment/3894 605.stm.

6. Martin Gayford, "How Caravaggio Saw in the Dark," *Telegraph,* July 13, 2010, retrieved August 7, 2014, http://www.telegraph.co.uk/culture/art/art-features/7887249/How-Caravaggio-saw-in-the-dark.html.

7. Mina Gregori, *The Age of Caravaggio* (New York: Metropolitan Museum of Art, 1985), 18.

8. "Caravaggio Painting Found in an Attic Now Fully Restored and Worth £70m," *Mail Online* (*Daily Mail*), October 18, 2006, retrieved August 7, 2014, http://www.dailymail.co.uk/news/article-411248/Caravaggio-painting-attic-fully-restored-worth-70m.html.

9. Sarah Portlock, "Caravaggio to the Rescue?" *New York Sun,* October 16, 2007, retrieved August 7, 2014, http://www.nysun.com/arts/caravaggio-to-the-rescue/64600/.

10. "The Art of the Steal," *American Greed,* CNBC, season 5, episode 11, original airdate April 6, 2011.

11. Ibid.

12. Ibid.

13. Panero, "An Old Master in Ruins."

14. John McEnroe, *You Cannot Be Serious* (New York: Berkley, 2002), Kindle edition.

15. Panero, "An Old Master in Ruins."

16. Dan Duray, "Raging Bulls of the Renaissance Scam: Larry Salander's Dupes Clash in Court," *New York Observer,* March 23, 2011, retrieved August 6, 2014, http://observer.com/2011/03/raging-bulls-of-the-renaissance-scam-larry-salanders-dupes-clash-in-court/.

17. Eileen Kinsell, "Untangling the Salander Mess," *ARTnews,* July 1, 2010, retrieved August 6, 2014, http://www.artnews.com/2010/07/01/untangling-the-salander-mess/; Melissa Grace and Tracy Connor, "Tennis Great John McEnroe Helps Nab Art Dealer Lawrence Salander, Who Was Indicted For Fraud," *New York Daily News,* March 26, 2009, retrieved August 10, 2014, http://www.nydailynews.com/news/crime/tennis-great-john-mcenroe-helps-nab-art-dealer-lawrence-salander-indicted-fraud-article-1.370014.

18. "Art of the Steal," *American Greed.*

19. Caroline Kinneberg, "Profile: Salander–O'Reilly Galleries," *New York Magazine,* retrieved August 9, 2014, http://nymag.com/listings/attraction/Salander-O-Reilly/.

20. Ginger Adams Otis, "His Exhibit of Goyas, Pollocks, and 'Ponzis,'" *New York Post,* October 28, 2007, 6.

21. Panero, "An Old Master in Ruins."

22. Auction Results, "Important American Paintings, Drawing and Sculpture," Sale 2058, Lot 28, December 4, 2008, retrieved August 9, 2014, http://www.christies.com/lotfinder/drawings-watercolors/stuart-davis-egg-beater-5154189-details.aspx.

23. "Biography: Stuart Davis," adapted from *Eye,* GHL; American Art at the Phillips Collection; retrieved August 9, 2014, http://www.phillipscollection.org/research/american_art/bios/davis_s-bio.htm.

24. The facts surrounding Salander's dealings with the collection of Stuart Davis come from the complaint filed by the plaintiff in Earl Davis v. Salander-O'Reilly Galleries LLC et al., 07 CV 4165 (S.D.N.Y. May 29, 2007).

25. Earl Davis v. Salander-O'Reilly Galleries LLC et al., 07 CV 4165 (S.D.N.Y. May 29, 2007).

26. Helen O'Neill, "Former Gallery Owner Larry Salander: The Art World's Bernie Madoff, and His Deceptions," artdaily.org, retrieved August 10, 2014, http://artdaily.com/news/42014/Former-Gallery-Owner-Lawrence-Salander–The-Art-World-s-Bernie-Madoff–and-His-Deceptions-#.U-fGP2Md_wI.

27. O'Neill, "Art World's Bernie Madoff"; "Art of the Steal," *American Greed.*

28. Philip Boroff, "Deniro Testifies against Dealer Accused of Stealing Dad's Art," *Bloomberg,* March 19, 2011, retrieved August 10, 2014, http://www.bloomberg.com/news/2011-03-04/robert-de-niro-to-testify-as-ex-salander-employee-starts-trial-for-fraud.html.

29. Ibid.

30. Philip Boroff, "Judge Threatens to Put Convicted Dealer Leigh Morse Behind Bars Again," *Artnet News,* December 12, 2014, http://news.artnet.com/market/judge-threatens-to-put-convicted-dealer-leigh-morse-behind-bars-again-196276, retrieved December 31, 2014.

31. Grace and Connor, "Tennis Great John McEnroe Helps Nab Art Dealer Lawrence Salander."

32. Panero, "An Old Master in Ruins."

33. District Attorney-New York County News Release re: Lawrence B. Salander, District Attorney—New York County, March 26, 2009, retrieved August 6, 2014, http://davideubank.wordpress.com/2009/03/27/big-art-big-theft-the-lawrence-b-salander-indictment/.

34. E-mail from Larry Salander to Maurice Katz, June 14, 2007; MSNBC's American Greed website, retrieved August 10, 2014, http://msnbcmedia.msn.com/i/CNBC/Sections/CNBC_TV/CNBC_US/Shows/_Documentaries_Specials/American_Greed/Season_05/Episode_47/Cover/AGS5_E47C1_Salander_Katz_email.pdf.

35. Panero, "An Old Master in Ruins."

36. Otis, "His Exhibit of Goyas, Pollocks, and Ponzis," 6.

37. Melissa Grace and Corky Siemaszko, "Art Scammer Gets 6 Yrs. in Slammer," *New York Daily News,* August 4, 2010, 12.

38. Philip Boroff and Karen Freifeld, "Distraught Salander, Sentenced to Up to 18 Years, Says Sorry," *Bloomberg,* August 4, 2010, retrieved August 10, 2014, http://www.bloomberg.com/news/2010-08-03/art-dealer-salander-gets-up-to-18-years-for-defrauding-investors-clients.html.

39. Thomas Zambito, "Dead Man Walking? Bernie Madoff to Be Sentenced Monday," *New York Daily News,* June 29, 2009, retrieved August 10, 2014, http://www.nydailynews.com/news/money/dead-man-walking-bernie-madoff-sentenced-monday-article-1.373462.

40. Helen O'Neill, "Victims of Art Fraud Describe Personal, Financial Toll," *Washington Post,* October 24, 2010, E04.

CHAPTER 4: THE TRUSTING ARTIST

1. "Remarks by the President Honoring the Recipients of the 2010 Medal of Freedom," February 15, 2011, White House, Office of the Press Secretary, retrieved July 12, 2014, http://www.whitehouse.gov/the-press-office/2011/02/15/remarks-president-honoring-recipients-2010-medal-freedom.

2. Jasper Johns, *Flag* gallery label text, Museum of Modern Art, retrieved July 12, 2014, http://www.moma.org/collection/object.php?object_id=78805.

3. Museum of Modern Art, *MoMA Highlights* rev. ed. (New York: Museum of Modern Art, 1999), 232.

4. Anne Umland, Jasper Johns's *Flag,* audio program excerpt, MoMA: Collection, 2008, 420, retrieved July 12, 2014, http://www.moma.org/collection/object.php?object_id=78805.

5. Nina Siegal, "Private View," *Artnet,* retrieved July 12, 2014, http://www.artnet.com/Magazine/features/siegel/siegal7-30-04.asp.

6. Alanna Martinez, "Sotheby's to Sell $20M Jasper Johns 'Flag' at Fall Contemporary Art Auction," *New York Observer,* September 23, 2014, retrieved October 10, 2014, http://observer.com/2014/09/sothebys-to-sell-jasper-johns-flag-at-fall-contemporary-art-auction/.

7. Ibid.

8. Siegal, "Private View."

9. The story of the crimes against Johns related to *Flag,* Ramnarine, and other foundries, comes in large measure from his sworn courtroom testimony provided during direct examination in United States v. Brian Ramnarine, S1 12 CR 826 (JGK) (S.D.N.Y. January 23, 2014).

10. Vanessa Hoheb biography, "Bio," Hands Across Time, n.d., retrieved July 12, 2014, http://www.handsacrosstime.com/bio/.

11. Testimony of Jasper Johns: *Ramnarine.*

12. The spelling of the collector's name appears as Sewdutt Harpul in federal court transcripts. However, the Wall Street Journal has reported that this individual's true name is Sendupt Harpaul.

13. Testimony of Sarah Taggart: *Ramnarine.*

14. Brendan O'Connor, "Who's Looking Out For Jasper Johns?" *The Awl,* April 10, 2014, retrieved October 13, 2014, http://www.theawl.com/2014/04/whos-looking-out-for-jasper-johns.

15. Testimony of Jasper Johns: *Ramnarine.*

16. Ibid.

17. Michael Findlay, "Authenticity, Connoisseurship and the Art Market," Lecture, International Seminar on the Authentication of Artworks and the Prevention of Forgery, Figueres, Spain, June 19–21, 2011).

18. Vanita Salisbury, "Kenny Scharf Used to Take Home Turkey Chunks from Work," *New York Magazine,* September 11, 2013, retrieved July 12, 2014, http://nymag.com/daily/intelligencer/2013/09/kenny-scharf-21-questions.html.

19. Jim O'Grady, "At Foundry, A 'Great Artisan,' Perhaps a Little Too Great," *New York Times,* October 27, 2007, sec. 14, 6.

20. Ibid.

21. Testimony of Saint Clair Cemin: *Ramnarine,* January 22, 2014.

22. Transcript of decision by Judge John G. Koeltl: *Ramnarine,* January 14, 2014.

23. Testimony of Saint Clair Cemin: *Ramnarine.*

24. Ibid.

25. Robert Brodsky, "Phony Sculptor Cuts a Plea," *Queens Chronicle,* March 6, 2003, retrieved July 10, 2014, http://www.qchron.com/editions/central/phony-sculptor-cuts-a-plea-brian-ramnarine-avoids-prison-will/article_2a3a9b4c-73ab-5982-b23b-211338d233b8.htmlq.

26. O'Grady, "At Foundry, a 'Great Artisan.'"

27. Indictment: *Ramnarine,* November 14, 2012.

28. Sentencing Submission by United States as to Brian Ramnarine, June 24, 2014: *Ramnarine,* November 14, 2012.

29. Ibid.

30. Matthew Rose, "James Meyer's Ironic Pentameter: A Sunny Massacre of Innocence," James A. Meyer website, n.d., retrieved July 15, 2014, http://www.jamesmeyerart.com/matthew_rose_interview.html.

31. Ibid.

32. Patricia Cohen, "Jasper Johns Assistant Charged with Stealing the Artist's Work," *New York Times,* August 15, 2013, retrieved July 15, 2014, http://artsbeat.blogs.nytimes.com/2013/08/15/jasper-johns-assistant-charged-with-stealing-the-artists-work/?_php=true&_type=blogs&_r=0.

33. "Group Shows and Collections," James A. Meyer website, retrieved July 15, 2014, http://www.jamesmeyerart.com/shows_and_collections.html.

34. Rose, "James Meyer's Ironic Pentameter."

35. Calvin Tomkins, *Lives of the Artists* (New York: Henry Holt, 2008), 183.

36. Rose, "James Meyer's Ironic Pentameter."

37. U.S. Attorney's Office, Southern District of New York and FBI New York Press Office, "Former Studio Assistant to Jasper Johns Charged in Manhattan Federal Court in $6.5 Million Scheme to Sell Stolen Johns Works," Federal Bureau of Investigation website, August 15, 2013, retrieved July 15, 2014, http://www.fbi.gov/newyork/press-releases/2013/former-studio-assistant-to-jasper-johns-charged-in-manhattan-federal-court-in-6.5-million-scheme-to-sell-stolen-johns-works.

38. Jennifer Maloney, "Jasper Johns's Assistant Pleads Guilty to Art Theft," *Wall Street Journal,* August 27, 2014, http://www.wsj.com/articles/jasper-johnss-assistant-james-meyer-pleads-guilty-to-art-theft-1409177522; retrieved December 31, 2014.

39. Civil Complaint: Kolodny v. Meyer et al., 14 CV 3354 (S.D.N.Y. May 8, 2014). As of the date of publication, the civil suit *Frank Kolodny v. James Meyer, Fred Dorfman, and Dorfman Projects LLC* (May 2014) was still pending in federal court.

40. Civil Complaint: *Kolodny.*

41. "Exhibitions: Jasper Johns: Regrets," Museum of Modern Art website, March 15, 2014, retrieved July 18, 2014, http://www.moma.org/visit/calendar/exhibitions/1463.

42. Julie L. Belcove, "Regrets Belong to Everybody, Don't They?" *FT Magazine,* February 14, 2014, retrieved July 18, 2014, http://www.ft.com/intl/cms/s/2/65e763c8-9444-11e3-a0e1-00144feab7de.html#axzz37qYR51ZX.

CHAPTER 5: THE INHERITOR

1. Sally M. Promey, "John Singer Sargent's *Triumph of Religion* at the Boston Public Library," Art and Architecture—Descriptions, retrieved on September 27, 2013, http://www.bpl.org/central/sargenttriumph.htm.

2. "The Murals," n.d., Boston Public Library website, retrieved October 16, 2013, http://www.sargentmurals.bpl.org/white_site/murals/04_legacy.html.

3. "Description and Inspiration," Boston Public Library website, retrieved October 18, 2013, http://www.sargentmurals.bpl.org/white_site/murals/03_description.html.

4. "Description and Inspiration," Boston Public Library website, retrieved October 18, 2013, http://www.sargentmurals.bpl.org/white_site/murals/10_description.html.

5. Narayan Khandekar, Gianfranco Pocobene, and Kate Smith, *John Singer Sargent's* Triumph of Religion *at the Boston Public Library: Creation and Restoration* (Cambridge: Harvard Art Museum, 2009), 39.

6. "Marouflage Technique" and "Installation," Boston Public Library website, retrieved October 16, 2013, http://www.sargentmurals.bpl.org/white_site/re storation/03_tech.html, http://www.sargentmurals.bpl.org/white_site/restor ation/04_tech.html, and http://www.sargentmurals.bpl.org/white_site/rest oration/05_tech.html.

7. Khandekar, Pocobene, and Smith, *John Singer Sargent's* Triumph of Religion.

8. Douglass Shand-Tucci, *The Crimson Letter: Harvard, Homosexuality, and the Shaping of American Culture* (New York: St. Martin's Griffin, 2004), 126.

9. Ibid.

10. "Crime Alert," n.d., Los Angeles Police Department, City of Los Angeles: Vilas V. Likhite, Fraud and Fake Art Sales, retrieved October 8, 2013, http://www .docstoc.com/docs/109659265/Vilas-V-Likhite-Fraud-and-Fake-Art-Sales.

11. Jeanne Schinto, "The Artful Dodger," *Boston Magazine,* June 2005, http:// www.bostonmagazine.com/2006/05/the-artful-dodger/print/.

12. "Crime Alert."

13. Arthur Hughes, excerpt from chronology, Cape Cod Artists' Registry website, retrieved October 8, 2013, http://www.capecodartistsregistry.com/ccar _%20web_pages/littlefield_william.html.

14. Interview with a law enforcement source, October 2013.

15. "Crime Alert."

16. "The Art of Fraud," *American Greed,* CNBC, season 2, episode 10, original airdate February 20, 2008.

17. Kevin Duffy, "Picasso Drawing Called Fake, But Lawsuit Real," *Atlanta Journal-Constitution,* May 22, 2007, 1D.

18. Daniel Grant, "Suit Filed over Picasso Drawing," *Maine Antique Digest,* March 2006, retrieved October 7, 2013, http://www.mtllp.com/index/suit -filed-over-picasso-drawing.

19. Danielle Rahm, "Lack of Authenticating Expert Renders Valuable Artwork Practically Worthless," *Forbes,* May 16, 2013, retrieved October 7, 2013, http://www.forbes.com/sites/daniellerahm/2013/05/16/lack-of-authenticat ing-expert-renders-valuable-artwork-practically-worthless/.

20. Affidavit, United States v. Luigi Cugini, 10-MJ-08215, U.S. District Court (S.D. of FLA, August 19, 2010).

21. Motion for Return of Seized Property: Cugini v. United States, 10-80122 CR Ryskamp, September 21, 2012.

22. Ibid.

23. Order Denying as Moot Motion for Return of Seized Property: USA v. Cugini, 10-80122 CR Ryskamp, October 2, 2012.

24. Motion for the Termination of Supervised Release: Cugini v. USA. 10-80122 CR Ryskamp/Hopkins, September 5, 2013.

CHAPTER 6: THE CAPTOR

1. Hillarie M. Sheets, "Parting With the Family Van Gogh," *New York Times,* April 22, 2006, retrieved May 4, 2014, http://www.nytimes.com/2006/04 /22/arts/design/22gogh.html?pagewanted=print&_r=0.

2. John Steinert, "The Impassioned Reader: Literature in the Life and Art of Vincent Van Gogh," as posted in the "Lot Notes" from the sale and purchase

of *L'Arlésienne, Madame Ginoux,* retrieved May 4, 2014, http://www.chris
ties.com/lotFinder/lot_details.aspx?intObjectID=4701806.

3. Sheets, "Parting With the Family Van Gogh."

4. Gretchen Voss, "The Lost Cezanne," *Town & Country,* June/July 2011, 124.

5. D. H. Lawrence, *Art and the Dread of the Instincts,* in *The Nature of Art,*
eds. John Gassner and Sidney Thomas (New York: Crown Publishers, 1964)
92, as abstracted from "Introduction to His Paintings," published in *Phoenix*
(New York: Viking Press, 1936).

6. Joyce Medina, *Cezanne and Modernism: The Poetics of Painting* (New York:
State University of New York, 1985), 83.

7. From Unclassified FBI File on the investigation into the art theft at the Bak-
win residence, #87-BS-96614, Section 1 (982185), obtained from FBI ar-
chives via Freedom of Information Act.

8. Direct examination of Michael Bakwin: United States v. Robert Mardirosian,
07-10075-MLW, U.S. District Court of Massachusetts, September 8, 2008,
page 60.

9. Ibid., page 59.

10. Sabine C. Hirschauer, "The Lost Art of Crime," *Daily Press* (Virginia), March
8, 2006, A4.

11. From Unclassified FBI File 87-BS-96614, Section 1 (982185).

12. Commonwealth v. Brian K. Matchett, 386 Mass. 492. October 6, 1981–June
14, 1982, Berkshire County, 493–497.

13. "Artist Bio: Romard," Royal Gallery, n.d., retrieved May 5, 2014, http://
www.royalgalleryri.com/content/artist-bio-romard.

14. Commonwealth v. David Garabedian, 399 Mass. 304. September 10, 1986–
February 25, 1987, Middlesex County; Associated Press, "Jurors Reject Pes-
ticide Defense in Woman's Death," *Santa Cruz Sentinel,* February 8, 1984.
Page 52.

15. "Art Theft," Federal Bureau of Investigation website, retrieved May 17, 2014,
http://www.fbi.gov/about-us/investigate/vc_majorthefts/arttheft.

16. Direct examination of Julian Radcliffe: *Mardirosian.*

17. Ibid.

18. Ibid.

19. Ibid.

20. Ibid.

21. Direct examination of Michael Bakwin: *Mardirosian,* August 12, 2008.

22. Michel Strauss, *Pictures, Passions and Eye: A Life at Sotheby's* (London: Halban
Publishers, 2011), eBook, Chapter 15.

23. Ibid.

24. Ibid.

25. Ibid.

26. Cross-examination of Michael Bakwin: *Mardirosian,* August 12, 2008; af-
fidavit of Michael Bakwin: *Mardirosian.*

27. Direct examination of Julian Radcliffe: *Mardirosian.*

28. Indictment: *Mardirosian.*

29. Voss, " Lost Cezanne," 127, 152.

30. Affidavit of Geoffrey J. Kelly, Special Agent, Federal Bureau of Investigation,
May 4, 2006 in *Mardirosian.*

31. Geoffrey Kelly, e-mail interview, August 18, 2014.

32. Jonathan Mitchell, interview, May 12, 2014, New Bedford, Massachusetts.

33. Ibid.

34. "Falmouth Police Seek Suspect after Drugs, Guns Seized," *Cape Cod Today,* February 9, 2007, retrieved June 7, 2014, http://www.capecodtoday.com/art icle/2007/02/09/14300-bus-crash-suspect-sought-after-drugs-firearms-seiz ed-overturned-car-prompts.

35. Ryan DiSantis, e-mail interview, September 22, 2014.

36. Mitchell, interview.

37. DiSantis, e-mail interview.

38. Voss, "Lost Cezanne," 152.

39. Kelly, e-mail interview.

CHAPTER 7: THE DOUBLE DEALER

1. Multiple attempts to contact Ely Sakhai for an interview for this book were made through his social media profiles to no avail.

2. Barry Fitzgerald and Caroline Overington, "Strait Man Paints Dubious Oil Picture," *Sydney Morning Herald* (Australia), December 1, 2004, Business section, 23.

3. "ICE Returns Painting Stolen during Holocaust," press release, Immigration and Customs Enforcement, December 1, 2009, retrieved August 21, 2014, ice.gov/news/releases/0912/091201brussels.htm.

4. Christie's Lot Notes, "Sale 2864, Lot 69, *Anto Carte,*" Impressionist and Modern Art sale, Christie's, May 24, 2011, retrieved August 25, 2014, http://www.christies.com/lotfinder/paintings/anto-carte-nude-5434675-details.aspx.

5. Noah Lederman, "Undercover Avenger," *Jerusalem Post,* July 9, 2010, retrieved August 26, 2014, http://www.jpost.com/Features/Magazine-Features/Under cover-avenger.

6. Ibid.

7. Ibid.

8. Christopher Marinello, e-mail interview, September 30, 2014.

9. "The Art of Double Dealing," *Masterminds,* truTV, episode 51, original air-date September 29, 2007.

10. Michael Day, "Modigliani 'Expert' Accused of Being Art's Biggest Fraud," *The Independent,* January 23, 2013, retrieved August 28, 2014, http://www.independent.co.uk/arts-entertainment/art/news/modigliani-expert-accused-of-being-arts-biggest-fraud-8463883.html.

11. "Christian Parisot Arrested: Modigliani Institute President Involved in Forgery Investigation," *The Huffington Post,* January 14, 2013, http://www.huffingtonpost.com/2013/01/14/modigliani-institute-president-christian-parisot-arrested-in-forgery-investigation_n_2472622.html; retrieved December 31, 2014. Parisot has an appeal pending from this conviction.

12. "The Art of Double Dealing," *Masterminds.*

13. Jane A. Levine, "Case Study of Federal Criminal Investigation and Prosecution Involving Art Forgery," paper presented to ABA Panel, "Fakes & Forgeries: Problems for the International Trade in Art Works," April 6, 2006, 4, http://apps.americanbar.org/intlaw/calendar/spring2006/papers/Levine_221.pdf.

14. "The Art of Double Dealing," *Masterminds.*

15. Clive Thompson, "How to Make a Fake," *New York Magazine,* n.d., retrieved August 30, 2014, http://nymag.com/nymetro/arts/features/9179/.

16. "The Art of Double Dealing," *Masterminds.*

17. Ibid.
18. Robert Mendick, "I Churn out Lowrys to Sell on eBay for Thousands, Amateur Artist Admits," *Telegraph,* July 6, 2014, retrieved October 4, 2014, http://www.telegraph.co.uk/news/uknews/10948800/I-churn-out-fake -Lowrys-to-sell-on-eBay-for-thousands-amateur-artist-admits.html.
19. Memorandum Order: Takeuchi v. Sakhai, 05 Civ. 6925 (JSR), at 2 (S.D.N.Y., January 16, 2006).
20. Affidavit in Support of Motion for Summary Judgment: Takeuchi v. Sakhai, 05 CIV 6925 (JSR) at 2 (S.D.N.Y., January 16, 2006).
21. Ibid. *Author's note:* Corrections to the ellipses have been made to this excerpt, as the original document uses six dots rather than the standard three.
22. Ibid.
23. Memorandum Order: *Takeuchi.*
24. Ibid.
25. Levine, "Case Study of Federal Criminal Investigation and Prosecution Involving Art Forgery," 5.
26. Sylvie Crussard, e-mail interview, September 8, 2014.
27. Ibid.
28. Thompson, "How to Make a Fake."
29. Will Bennett, "Two Versions of Gauguin Work on Sale at Same Time," *Telegraph,* March 12, 2004, retrieved September 7, 2014, http://www.tele graph.co.uk/news/worldnews/northamerica/usa/1456587/Two-versions-of -Gauguin-work-on-sale-at-same-time.html.
30. "The Art of Double Dealing," *Masterminds.*
31. Ibid.
32. Notice of Annual Meeting of Stockholders to be held November 12, 2004, Australian-Canadian Oil Royalties Ltd., retrieved September 14, 2014, http://www.sec.gov/Archives/edgar/data/1061288/000106128804000005 /proxy_statement.txt.
33. Levine, "Case Study of Federal Criminal Investigation and Prosecution Involving Art Forgery," Page 5.

CHAPTER 8: THE BAIT AND SWITCH

1. Gabrielle Schickler, "Faberge and Forbes: A History of Collecting," *Forbes,* January 8, 2004, retrieved July 21, 2014, http://www.forbes.com/2004/01/08 /cz_gs_0108fabergehistory.html.
2. Arthur Lubow, "Malcolm Forbes," *People,* July 19, 1982, retrieved July 20, 2014, http://www.people.com/people/archive/article/0,20082678,00.html.
3. David Hay, "Jacks of All Trades," *Elements of Style Living,* December 2005, retrieved July 20, 2014, http://www.apelocruz.com/in-media.html.
4. The description of Cruz's involvement in Khan's scheme comes from the Federal Sentencing Memorandum: United States v. Tatiana Khan, CR-10-00152-R (C.D. Cal.)
5. Defendant Tatiana Khan's Objection to the Pre-sentence Report and Sentencing Position Paper: *Khan.* October 4, 2010.
6. Throughout the documents outlining the criminal investigation and court proceedings related to Khan, the identities of her victims were protected and typically referred to as "J.K." and "V.S." In the affidavit of FBI special agent Linda English, the names "Jack" and "Vic" are referenced as clients of Khan's; hence, the use of these names to identify these individuals.

7. *Khan,* op. cit. Subsequent unattributed quotes are from this source.

8. Government's Revised Combined: (1) Response to Defendant's Objections to the Pre-sentence Report; and (2) Position re Sentencing; Declaration of Ranee A. Katzenstein; Exhibits: *Khan.*

9. Enrique Mallen, ed. On-line Picasso Project, Sam Houston State University, retrieved 2014, https://picasso.shsu.edu/.

10. Enrique Mallen, director and editor of On-line Picasso Project, e-mail interview, July 28, 2014.

11. Ibid.

12. Affidavit of FBI Special Agent Linda English: *Khan.*

13. Ibid.

14. Mallen, e-mail interview.

15. Mallen, On-line Picasso Project.

16. George Stolz, "Authenticating Picasso," *ARTnews,* January 2, 2013, retrieved July 27, 2014, http://www.artnews.com/2013/01/02/authenticating-picasso/.

17. Ibid.

18. Rob Cooper, "Picasso Is the Most Often Stolen Artist in the World with More Than 1,000 Pieces of His Work Missing," *Daily Mail,* January 27, 2012, retrieved July 27, 2014, http://www.dailymail.co.uk/news/article-2092698 /Pablo-Picasso-stolen-artist-world-1k-pieces-work-missing.html.

19. For an excellent telling of Picasso as a suspect in the theft of the Mona Lisa, see R. A. Scotti's *Vanished Smile: The Mysterious Theft of Mona Lisa.*

20. Joshua Knelman, *Hot Art: Chasing Thieves and Detectives Through the Secret World of Stolen Art* (Canada: Douglas &McIntyre, 2011), 10–11.

21. Linda English, interview with author, August 29, 2014.

22. Ibid.

23. Ibid.

24. Ibid.

25. Ibid.

26. Ibid.

27. Ibid.

28. "West Hollywood Antiques Dealer Faces Charges of Selling Fake Picasso Drawing for $2 Million," press release no. 10-003, U.S. Attorney's Office, Central District of California, January 8, 2010, http://www.justice.gov /usao/cac/Pressroom/pr2010/003.html.

29. Defendant Tatiana Khan's Objections to the Pre-sentence Report and Sentencing Position Paper: *Khan,* October 4, 2010.

30. Mark Mermelstein, Mary Kelly Persyn, and Harry J. Moren, "Strategic Remedies for Cybercrime Victims," *Journal of Internet Law* 16, no. 12 (June 2013): 24, retrieved from Orrick Law Firm website, July 26, 2014, http:// www.orrick.com/Events-and-Publications/Documents/Strategic-Remedies -For-Cybercrime-Victims.pdf.

CHAPTER 9: THE PRINTMAKER

1. Michael Granberry, "Celebrate Chagall at Passover," Art Notes, *Dallas Morning News,* March 24, 2013, Arts & Life section, E04.

2. "Pope Francis: 20 Things You Didn't Know," *Telegraph,* March 14, 2013, retrieved July 31, 2014, http://www.telegraph.co.uk/news/orldnews/the-pope /9931413/Pope-Francis-20-things-you-didnt-know.html.

3. Marc Chagall, *My Life,* trans. Elisabeth Abbott (Boston: Da Capo Press, 1994), 17.

4. Benjamin Harshav, *Marc Chagall and His Times* (Redwood City, CA: Stanford University Press, 2003), 827.

5. Christie's Auction Results, Sale 2475, Lot 20, 25-26 October 2011, New York, Rockefeller Plaza, retrieved July 31, 2014, http://www.christies.com/lot finder/prints-multiples/marc-chagall-the-story-of-exodus-leon-5488965-de tails.aspx.

6. Hillel Levin, "Confessions of Art Fraud King Michael Zabrin," *Chicago,* October 25, 2011, retrieved August 2, 2014, http://www.chicagomag.com /Chicago-Magazine/November-2011/Confessions-of-Art-Fraud-King-Mich ael-Zabrin/.

7. Decision, United States v. Hilda Amiel et al, Nos. 1021, 1022 and 751, U.S. Court of Appeals, (2nd Cir., September 5, 1996).

8. Lee Catterall, *The Great Dalí Art Fraud and Other Deceptions* (Fort Lee, NJ: Barricade Books, 1992), 343–44.

9. Definitions of the three categories of lithographs and serigraphs are derived from United States v. Donald Austin, no. 94-2541 (7th Cir. May 5, 1995).

10. Selwyn Raab, "Fighting Fake Art: Victims' Shame and Muddled Law; Where the Art Is Selling," Metropolitan Desk, *New York Times,* July 23, 1987, B1.

11. Francis X. Clines, "Van Gogh Sets Auction Record: $39.9 Million," *New York Times,* March 31, 1987, retrieved August 2, 2014, http://www.nytimes .com/1987/03/31/arts/van-gogh-sets-auction-record-39.9-million.html.

12. Raab, "Fighting Fake Art."

13. Douglas C. McGill, "Fake Art Prints: Big Business Getting Bigger," Metropolitan Desk, *New York Times,* July 22, 1987, A1.

14. Ibid.

15. Mary Abbe Martin, "Art Experts Flummoxed by Fake Salvador Dalí Prints," *Telegraph,* August 13, 1987, 29.

16. Ibid.

17. McGill, "Fake Art Prints."

18. United States v. Hilda Amiel et al., nos. 1021, 1022, and 751, dockets 95-1286, 95-1287, and 95-1288 (2nd. Cir. September 5, 1996).

19. The details and the quotes about the fraud perpetrated by the Amiels under Hilda, Kathryn, Joanne, and Sarina are derived from the evidence presented at trial as set forth in *Amiel.*

20. Kniebihler's testimony as described in judges' decision in *Amiel.*

21. Ibid.

22. Ibid.

23. Catterall, *The Great Dalí Art Fraud and Other Deceptions,* 353.

24. Robert E. Kessler, "The Artful Dodgers? 4 Arrested in Huge Counterfeit Print Ring in Island Park," *Newsday* (New York), January 31, 1992, 5.

25. United Press International, "Government Investigating Fake Art Chain," *Washington News,* January 30, 1992.

26. Susan Cohen, "The Art of the Bogus," *Washington Post Magazine,* July 18, 1993, W18.

27. Charles Storch, "Foiled by Fakes: Donald Austin's Trial Showed that as a Dealer in Forged Art Prints, He Was a Pretty Good Ex-Barber," Tempo, *Chicago Tribune,* November 1, 1993, C1.

28. Ibid.

29. Terry Pristin, "Claremont Man Charged with Forging Artwork," Metro, *Los Angeles Times,* August 5, 1989, 1.

30. Levin, "Confessions of Art Fraud King Michael Zabrin."

31. Catterall, *The Great Dalí Art Fraud and Other Deceptions,* 346–47.

32. Ibid., 354–57.

33. Levin, "Confessions of Art Fraud King Michael Zabrin."

34. Ibid.

35. Details of the crimes for which Zabrin, Amiel Jr., and the others were convicted are from Michael Zabrin's Sentencing Memorandum and Government's Response to Defendant's Sentencing Memorandum: United States v. Michael Zabrin, 07 CR 521-5 (N.D. Ill., East. Div.); and Superseding Indictment: United States v. James Kennedy and Leon Amiel, Jr., 08 CR 009 (N.D. Ill., East. Div.)

36. Government's Response to Defendant's Sentencing Memorandum: *Zabrin,* 4.

37. Ibid.

38. "Selling Fake Art Gets Man Two Years," *Chicago Tribune,* June 16, 2011, 6.

CHAPTER 10: THE TELESCAM

1. "About Us," Fine Art Treasures website, retrieved August 5, 2014, www.fine arttreasures.net/about_us.htm, from https://web.archive.org/web/20070625 054821/http://finearttreasures.net/.

2. Ibid.

3. Daniel Grant, "Ink-Jet Art Runs Gamut from Low Brow to High Class," *Baltimore Sun,* January 25, 1999, retrieved August 11, 2014, http://articles .baltimoresun.com/1999-01-25/entertainment/9901250193_1_giclee-ink-jet -prints-jet-printer.

4. John O'Brien, "About," website, n.d., retrieved August 11, 2014, http://www .johnobrienartist.com/pages/about.html.

5. "Fine Arts Treasury Gallery," *American Greed,* CNBC, season 6, episode 8, original airdate March 14, 2012.

6. Ibid.

7. Ibid.

8. J. Michael Kennedy, "Not a Pretty Picture: Lured By Hopes of Riches from A New Reproduction Process, Artists Say They Were Scammed When Unauthorized Copies Flooded the Market," *Los Angeles Times,* January 18, 2007, A1.

9. Park West Gallery Website, "Art Auctions," http://www.parkwestgallery.com /art-auctions.

10. Jori Finkel, "Art Auctions on Cruise Ships Lead to Anger, Accusations and Lawsuits," *New York Times,* July 16, 2008, retrieved August 13, 2014, http:// www.nytimes.com/2008/07/16/arts/design/16crui.html?ref=opinion.

11. Albert Scaglione, "Auctions in the Art World," letter to the editor, *New York Times,* August 9, 2008, retrieved August 13, 2014, http://www.nytimes .com/2008/08/10/opinion/l10auction.html?_r=1&oref=slogin.

12. Paul Motter, "Guide to Cruise Ship Art Auctions," Fox News, September 27, 2013, retrieved August 13, 2014, http://www.foxnews.com/travel/2013 /09/27/guide-to-cruise-ship-art-auctions/.

13. Kelly Cramer, "The Art of Piracy," *Broward Palm Beach New Times,* November 9, 2006, retrieved August 13, 2014, http://www.browardpalmbeach .com/2006-11-09/news/the-art-of-piracy/full/.

14. Wendy Thomas Russell, "Cruise Line Lawsuit Takes Attorney into Uncharted Waters," *Daily News,* April 13, 2008, retrieved February 2, 2015, http://www .thefreelibrary.com/CRUISE+LINE+LAWSUIT+TAKES+ATTORNEY+I NTO+UNCHARTED+WATERS+LEGAL%3A . . . -a0177971849.

15. Ibid.

16. Kennedy, "Not a Pretty Picture."

17. "Fine Arts Treasury Gallery," *American Greed.*

18. Ibid.

19. U.S. Attorney's Office, Central District of California, Press Release, "La Canada Woman Sentenced to Seven Years in Prison for Selling Millions of Dollars of Fake Art through Nationwide TV Art Auction Program," April 6, 2010.

20. The story of Myron and Mary Temchin comes from a signed document prepared by the pair as part of their report of the fraud, "Fraud in Advertising and Selling Fine Art on Television Report by Myron and Mary Temchin from Memory 12/8/05," CNBC, retrieved August 13, 2014, http://msnbcmedia .msn.com/i/CNBC/Sections/CNBC_TV/CNBC_US/Shows/_Documen taries_Specials/American_Greed/Season_06/Episode_57/Cover/SKMBT _C45212021009480.pdf, and from "Fine Arts Treasury Gallery," *American Greed.*

21. "Fine Arts Treasury Gallery," *American Greed.*

22. "Fraud in Advertising and Selling Fine Art on Television."

23. Ibid.

24. Ibid.

25. Visual Arts and the Law 11th Annual Conference, registration pamphlet, faculty listing, retrieved August 13, 2014, http://www.cle.com/upcoming /PDFs/SFOART09.pdf.

26. "Fine Arts Treasury Gallery," *American Greed.*

27. Ibid.

28. Declarations of Justin Lundberg and William H. Woodard: Fine Art Network, Inc. v. James Mobley et al., case no. LC073854, Superior Court of the State of California, County of Los Angeles, Northwest District.

29. Declaration of Thomas E. Keith: Charlene Mitchell v. Kristine Eubanks et al., case no. EDCV 06-48 RSWL(FMOx) (C.D. Cal.).

30. "Fine Arts Treasury Gallery," *American Greed;* "Web Extras, Forged Certificates," retrieved February 2, 2015, http://video.cnbc.com/gallery/?video =3000078145.

31. Ibid.

32. United States v. Kristine Eubanks, CR No. 07-00154 (C.D. Cal.).

33. Kennedy, "Not a Pretty Picture."

34. "Fine Arts Treasury Gallery," *American Greed.*

35. U.S. Attorney's Office, Central District of California, "La Canada Woman Sentenced to Seven Years in Prison."

36. Cramer, "The Art of Piracy."

37. "Fine Arts Treasury Gallery," *American Greed.*

CHAPTER 11: THE INTERNET

1. Lauren Indvik, "Forrester: U.S. Online Retail Sales to Hit $370 Billion by 2017," Mashable.com, March 12, 2013, retrieved September 14, 2014, http:// mashable.com/2013/03/12/forrester-u-s-ecommerce-forecast-2017/.

2. "Number of Internet Users Worldwide Approaching 3 Billion," *VOA News,* May 6, 2014, retrieved September 14, 2014, http://www.voanews.com/content/number-of-internet-users-worldwide-approaching-3-billion/1908968.html.

3. Ryan Moore, eBay's lead manager for business communication, e-mail interview, September 28, 2014.

4. eBay auction for Ferrari F12 Berlinetta, retrieved September 14, 2014, http://www.ebay.com/itm/Ferrari-Other-F12berlinetta-F12-Berlinetta-Tailor-Made-Matte-Alcantara-High-Grip-Carbon-Fiber-LED-/181508686346?forcerrptr=true&hash=item2a42c2c20a&item=181508686346&pt=US_Cars_Trucks.

5. eBay auction, Canada art 1875 historical RCMP oil painting, retrieved September 14, 2014, http://www.ebay.com/itm/CANADA-ART-1875-HISTORICAL-RCMP-OIL-PAINTING-D-C-GROSE-AMERICAN-CANADIAN-INDIAN-/290507191333?pt=Art_Paintings&hash=item43a393f425.

6. eBay auction, *The Evangelist Matthew* oil painting, retrieved September 14, 2014, http://www.ebay.com/itm/The-Evangelist-Matthew-Oil-painting-attributed-to-Rembrandt-van-Rijn-/171358701959?pt=Art_Paintings&hash=item27e5c64987.

7. Search conducted on September 15, 2014, at 2034 hours EST.

8. "L. S. Lowry—His Life and Career," The Lowry, retrieved September 15, 2014, http://www.thelowry.com/ls-lowry/his-life-and-work/.

9. Robert Mendick and Claire Duffin, "Rogue's Gallery of Fake Art on eBay," *Telegraph,* June 29, 2014, retrieved September 16, 2014, http://www.telegraph.co.uk/culture/art/10933016/Rogues-gallery-of-fake-art-on-eBay.html; Neil Atkinson, "Fake Ashley Jackson Pictures Offered for Sale on eBay," *Huddersfield Daily Examiner,* June 30, 2014, retrieved September 15, 2014, http://www.examiner.co.uk/news/west-yorkshire-news/fake-ashley-jackson-pictures-offered-7347378.

10. Robert Mendick, "I Churn Out Fake Lowrys to Sell on eBay for Thousands, Amateur Artist Admits," *Telegraph,* July 6, 2014, retrieved September 16, 2014, http://www.telegraph.co.uk/news/uknews/10948800/I-churn-out-fake-Lowrys-to-sell-on-eBay-for-thousands-amateur-artist-admits.html.

11. Atkinson, "Fake Ashley Jackson Pictures Offered for Sale on eBay."

12. Details of the criminal scheme of Michael Little come from the Complaint of Violation in United States v. Michael Little, no. MJ13-211 (W.D. Wash. April 23, 2013).

13. Complaint: United States v. Michael Little, MJ 13 211 (W.D.W.S April 23, 2013).

14. Ibid.

15. Ibid.

16. Levi Pulkkinen, "Dealer of Chihuly Fakes Sentenced," *Seattle Post-Intelligencer,* November 20, 2013, retrieved September 22, 2014, http://www.seattlepi.com/local/article/Dealer-of-Chihuly-fakes-sentenced-4994503.php.

17. U.S. Attorney's Office, Western District of Washington, Press Release, "Renton Man Who Sold Fake Dale Chihuly Art Online Sentenced to Five Months in Prison for Wire Fraud," November 20, 2013.

18. Sealed Complaint: United States v. John Re, 14 MAG 1391 (S.D.N.Y. June 19, 2014).

19. Chary Southmayd, "USS Deep Quest & John Re," *John Re—NY Art Expert* (blog), April 28, 2009, retrieved September 20, 2014, http://sentient123 .wordpress.com/.

20. Jennifer Gould Keil, "Painter Charged with Making Fake Jackson Pollock Paintings," *New York Post,* July 1, 2014, retrieved September 20, 2014, http://nypost.com/2014/07/01/painter-charged-with-making-fake-jackson -pollock-paintings/.

21. "John Re Art Connaisseur [*sic*]," blog entry, nicolehadley.wordpress.com, May 9, 2009, retrieved September 20, 2014.

22. Sealed Complaint: United States v. John Re, 14 MAG 1391 (S.D.N.Y. June 19, 2014)

23. Information related to the Sedona affidavit is from the Sealed Complaint: *Re.*

24. Ibid.

25. Ibid.

26. Ibid.

27. Ibid.

28. Ibid.

29. Ibid.

30. Ibid.

31. Ibid.

32. Ibid.

33. "Other Terms," eBay Help, n.d., retrieved September 21, 2014, http://pages .ebay.com/help/buy/bidding-overview.html.

34. "What Are the Guidelines?" eBay Authenticity Disclaimers, n.d., retrieved September 21, 2014, http://pages.ebay.com/help/policies/authenticity-discla imers.html.

35. "California Bar Journal Discipline Summaries: Kenneth Andrew Walton," State Bar of California, February 8, 2002, retrieved September 15, 2014, http://members.calbar.ca.gov/fal/Member/Detail/192272.

36. Ibid.

37. Judith H. Dobrzynski, "Online Bid Soars to $135,805, Provenance Not Guaranteed," *New York Times,* May 9, 2000, retrieved September 21, 2014, http:// www.nytimes.com/2000/05/09/business/online-bid-soars-to-135805-prov enance-not-guaranteed.html.

38. "California Bar Journal Discipline Summaries: Kenneth Andrew Walton."

39. Dobrzynski, "Online Bid Soars to $135,805, Provenance Not Guaranteed."

40. Judith H. Dobrzynski, "FBI Opens Investigation of eBay Bids," *New York Times,* June 7, 2000, retrieved September 21, 2014, http://www.nytimes.com /2000/06/07/business/fbi-opens-investigation-of-ebay-bids.html.

41. Dan Glaister, "A Brush with the Law," *Guardian,* August 1, 2006, retrieved September 21, 2014, http://www.theguardian.com/artanddesign/2006/aug /02/art.crime.

42. R. V. Scheide, "Prisoner of Love," newsreview.com, April 25, 2002, retrieved September 15, 2014, http://www.newsreview.com/reno/prison-of-love/conte nt?oid=17922.

43. Glaister, "A Brush with the Law."

44. "The Internet Crime Complaint Center Receives 3 Millionth Complaint," press release, Internet Crime Complaint Center, May 19, 2014, retrieved July 20, 2014, http://www.ic3.gov/media/2014/140519.aspx.

45. Lizzie Crocker, "Why eBay Is an Art Forger's Paradise," Beaststyle, *Daily Beast,* August 18, 2014, retrieved September 22, 2014, http://www.thedaily beast.com/articles/2014/08/19/why-ebay-is-an-art-forgers-paradise.html.

46. Moore, e-mail interview.

47. Crocker, "Why eBay Is an Art Forger's Paradise."

48. Moore, e-mail interview.

49. "More Resources—Law Enforcement," eBay, n.d., retrieved September 22, 2014, http://pages.ebay.com/SECURITYCENTER/LawEnforcementCent er.html.

EPILOGUE

1. "Russian Art Expert to Remain under House Arrest in Divisive Fraud Case," Russian Legal Information Agency, September 16, 2014, retrieved October 14, 2014, http://rapsinews.com/news/20140916/272120006.html.

 2. "Fake Picasso Anyone? Austrian Police Search for Fraud Victims," Reuters, September 16, 2014, retrieved October 14, 2014, http://af.reuters.com/article /oddlyEnoughNews/idAFKBN0HB1K220140916.

 3. Pia Akerman, "Legal Groups Urged to Join Seizure Challenge in 'Art Fraud' Case," *The Australian,* September 29, 2014, retrieved October 14, 2014, http:// www.theaustralian.com.au/business/legal-affairs/legal-groups-urged-to -join-seizure-challenge-in-art-fraud-case/story-e6frg97x-1227073249704?nk =c89ef30e01c4075216d01ed476c3a6ae.

 4. Amanda Williams, "Secret Work of a Master Forger: Sketches of Artist Who Duped Dealers and Galleries for Decades to Be Auctioned," *Daily Mail On-line,* October 14, 2014, retrieved October 14, 2014, http://www.dailymail .co.uk/news/article-2792288/secret-work-master-forger-sketches-artist -duped-dealers-galleries-decades-auctioned.html.

 5. Kurt Bayer, "Art Forger's Masterpiece in City Sale," *New Zealand Herald,* October 4, 2014, retrieved October 14, 2014, http://www.nzherald.co.nz/nz /news/article.cfm?c_id=1&objectid=11336716.

 6. Hendrik Hansson, "International Art Forgery Ringleaders Charged," *Artnet News,* September 16, 2014, retrieved October 14, 2014, http://news.artnet .com/in-brief/international-art-forgery-ringleaders-charged-103625.

SELECTED BIBLIOGRAPHY

Catterall, Lee. *The Great Dali Fraud and Other Deceptions.* New Jersey: Barricade Books, 1992.

Charney, Noah, ed. *Art and Crime: Exploring the Dark Side of the Art World.* New York: Praeger, 2009.

Gassner, John and Sidney Thomas, eds. *The Nature of Art.* New York: Crown Publishers, 1964.

Gregori, Mina. *The Age of Caravaggio.* New York: Metropolitan Museum of Art, 1985.

Irving, Clifford. *Fake! The Story of Elmyr de Hory, the Greatest Art Forger of Our Time.* New York: McGraw-Hill, 1969.

Khandekar, Narayan, Gianfranco Pocobene and Kate Smith. *John Singer Sargent's Triumph of Religion at the Boston Public Library: Creation and Restoration.* Cambridge: Harvard Art Museum, 2009.

Knelman, Joshua. *Hot Art: Chasing Thieves and Detectives Through the Secret World of Stolen Art.* Canada: Douglas &McIntyre, 2011.

Lopez, Jonathan. *The Man Who Made Vermeers.* Orlando: Harcourt, 2009.

Tomkins, Calvin. *Lives of the Artists.* New York: Henry Holt, 2008.

INDEX

O'Keeffe, Georgia, 196
O'Kelly, Michael, 8
O'Kelly, Paraic, 30
Old Masters, 9, 26, 35, 64, 151–52
Orion Analytical, 55–56
Ossorio, Alfonso, 42
Oustinoff, Elizabeth, 103–4, 108–9

Panero, James, 63, 70
Parisot, Christian Gregori, 146
Parsons, Betty, 38
Pearlman, Alexander, 73
Perenyi, Ken, 8
Picasso, Pablo
 Austin and, 186
 Bakwins and, 114–16, 120
 Bullfight, The, 201
 on Cezanne, 116
 Convertine case and, 179
 Cugini and, 101, 106–7, 110
 Jägers collection and, 18
 Khan and, 160–71, 173
 Kifer and Sexton and, 198
 La Femme au Chapeau Bleu (The Woman in the Blue Hat), 162–63, 165, 168, 170
 Nazis and, 141
 Personage Endormi et Femme Accroupie, 106
 private collectors and, 22, 73
 Temchins and, 200–3
 Trois Femmes, 200
 USPIS and, 183–84
 Visage de faune (Pour Leon Amiel), 177
 widespread forgeries of, 150, 229
 Zabrin and, 188, 190
Polk, Kenneth, 12
Pollock, Jackson
 Arabesque, 38
 difficulty in detecting forgeries of, 151–52
 Freedman and, 51–53, 59–60
 Herbert and, 38
 Knoedler & Company and, 44–45, 49–51
 Lagrange and, 51–53, 59
 Likhite and, 104
 Qian and, 41, 57
 Re and, 217–21
 Untitled 1950, 50

Pollock-Krasner Foundation. 50, 52
provenance, explained, 6–7

Qian, Pei-Shen, 39–41, 56–59

Raman spectroscopy, 11, 55
Ramnarine, Brian, 83–92, 96
Ratcliffe, Thomas G. Jr., 105
Rauschenberg, Robert, 81–82, 195
Re, Jovian "John," 217–21
Reed, Victoria, 10
Rembrandt, 11, 34, 64, 66, 101, 149–55, 158, 175, 211
Remington, Frederic, 196
Renoir, Pierre-Auguste, 146, 149, 164
Richards, Jason, 103–4, 108–10
Richardson, E.P., 2
Robertson, Ted, 88
Rockefeller family, 37
Rockwell, Norman, 115, 196
Rosales, Glafira, 39, 41–45, 47, 63
Rosenberg, Paul, 54
Roten, Damien, 108
Rotes Bild mit Pferden (Red Picture with Horses, Campendonk*),* 22–25, 28–30, 32
Rothko, Mark, 38, 41, 45–46, 49, 55–57, 59, 61

Safer, Morley, 7
Sakhai, Ely, 139–41, 143–58
Salander, Larry, 63–78, 242n24
Salander-O'Reilly Gallery, 67, 69, 72–73, 75–76, 78
Salvador Dalí Museum (St. Petersburg, FL), 180
Sargent, John Singer, 97–103, 108–10
Savona, Meredith, 217–21
Scharf, Kenny, 85–86, 89–90
Scully, Sean, 45
sculptures, 8, 81–91, 114, 163, 175, 214–15
Seattle Art Museum (SAM), 54
Sexton, Joyce, 198
Simpson, George, 2
Slatkin, Reed, 168
Smithsonian American Art Museum, 67
Smithsonian Institution's Museum Conservation Institute, 142
Solomon R. Guggenheim Museum, 6